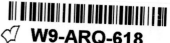

W9-ARQ-618

How To Use The ZONE SYSTEM For Fine B&W Photography

John P. Schaefer

Contents

Photography: John P. Schaefer unless otherwise credited

NOTICE: The information contained in this book is true and complete to the best of our knowledge. All recommendations are made without any guarantees on the part of the author or HPBooks. The author and publisher disclaim all liability in connection with the use of this information.

Published by HPBooks, A division of Price Stern Sloan, Inc.
360 North La Cienega Boulevard, Los Angeles, California 90048
ISBN: 0-89586-141-0 Library of Congress Catalog No. 82-83784
©1983 HPBooks, Inc. Printed in USA
9 8 7 6 5 4 3

Introduction

Because it's so easy to make a passably acceptable photograph, black-and-white (b&w) photography is a deceiving art form. To create a b&w photograph that's a work of art, you need both vision and craftsmanship. Photographic technique can be learned in short order. To become a master photographer you must have patience and a commitment to pursue photography seriously.

WHAT IS A PHOTOGRAPH?

A photograph is a two-dimensional representation—a print—of an idea, an emotion, or an experience. If the print is to be anything more than a routine record, the message it contains should be delivered with eloquence.

The space you use to deliver the message is limited to a few square inches of paper surface. However, the moods conveyed, the insights to the human condition, the interpretations of the beauty or shortcoming of our lives and world are limitless.

Because of these restrictions to two dimensions and to shades of gray, you must make every element of your photograph count. Use space effectively so the viewer deals with the important themes and elements within the photograph in an unambiguous way. Use lines and light to guide the viewer's eye to important areas. Most important, shading and tonality are the tools you must use to convey emotion and compel the viewer to study the image again and again. Great photographs are those that convey emotions concisely.

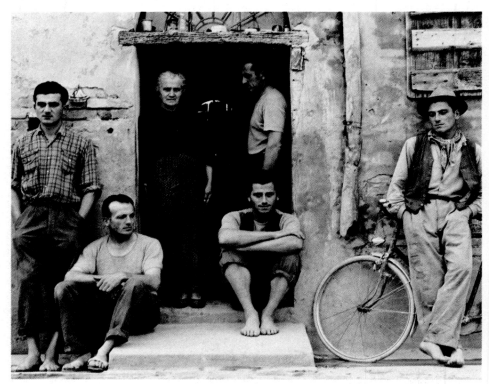

Photographs have amazing versatility and power. They can depict the human condition, record nature beautifully or represent abstract symbols. For your photos to do any of these, they should be carefully crafted. This book shows you how.
The Family, Luzzara, Italy, 1953, © 1955, 1971, 1976 The Paul Strand Foundation, as published in Paul Strand: *Sixty Years of Photographs,* Aperture, Millerton, 1976.

THE GOAL OF THIS BOOK

In this book, I assume that you are familiar with your camera and elementary photographic processes: How to use a light meter, how to develop film, and how to make a b&w print. I review each of these topics in detail to help you clarify your thinking and refine your skills. By following the procedures I describe, you should be able to analyze and solve most common photographic problems. More important, the quality of your b&w prints will markedly improve.

I believe that anyone willing to pursue photography seriously and take more than a passive interest in art and the surrounding world can become a good photographer. The goal is to produce images that

Toadstool and Grasses, Maine, 1928, © 1950, 1971, 1977 The Paul Strand Foundation, as published in Paul Strand: *Time in New England,* Aperture, Millerton, 1976.

bring lasting personal satisfaction.

If you are just beginning photography, you may find its new vocabulary and variables intimidating. But, as with the study of any new language, a basic vocabulary and rules for usage are necessary. After a little while, the terms become familiar. In photography, you must learn to deal with the choice of camera and film, exposure settings, and developer choice and processing conditions, including print toning and mounting.

For the struggling amateur as well as the experienced professional, each variable represents a possibility of going astray and ruining a potentially good photograph. However, with a little effort, you can control these variables and use them to your advantage. Tests described and illustrated in this book make the variables work *for* you.

Too many photographers shy away from doing basic tests and evolving a systematic method of working. They are intimidated by the technical aspects of photography. They misjudge both the simplicity and complexity of making a fine b&w print. Yet it would be unthinkable to aspire to be a painter before learning how to draw. Making fine b&w photographs demands more effort than buying a good camera and reading the instructions packaged with the materials you use.

There is no *best way* of making a photograph. Each of the great photographers uses a highly individualized approach, based on years of observation and patient, systematic experimentation. What they have in common is an understanding of their tools and materials. The simple and straightforward tests described in this book will give you similar knowledge. You can do them with equipment readily available in most darkrooms. Doing them carefully eliminates disappointing, unprintable negatives—and those printable negatives that produce uninspiring prints.

When you use a well-reasoned, systematic approach, each step in the chain of events from the conception of a photograph to the final print "fine-tunes" the previous action. Too often, photographers attempt to correct a previous error, such as in negative exposure or development, in a subsequent operation such as printing. However, when you have proper control over exposure and development, you are able to make photographs that are limited only by the bounds of your imagination—not by your skill in handling the mechanical aspects of photography.

Learning correct working habits at the beginning is worth the extra effort. You will be repaid many times over in savings of time, money, and the quality of your photographs.

1

Previsualization, Composition & The Tonal Scale

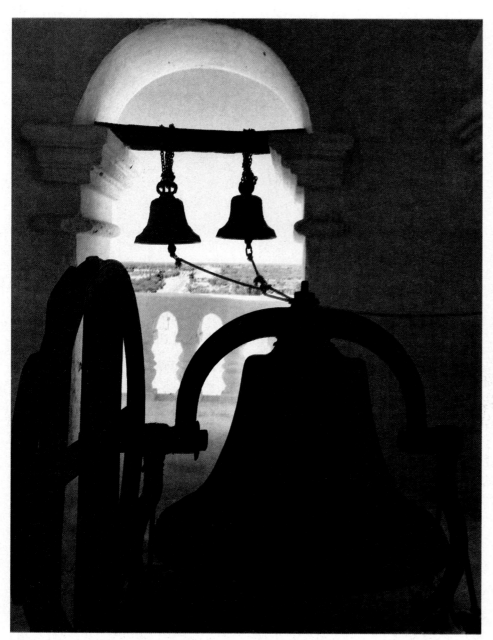

A fine photograph is composed to achieve maximum visual impact. When possible, arrange elements of the photograph to generate an exciting visual interaction. Use the outer parts of the image to contain the viewer's eye and encourage it to return to the central themes, not wander beyond the frame. Symmetry can add interest to a photograph—or dull a potentially interesting picture. As an exercise, mentally shift some of the elements in this photograph and decide if another point of view would have added to or taken away from its composition.

Fine b&w photographs are not the result of a momentary impulse. They are triggered by a recognition that can be traced to the sum of experiences important to you. Even though the act of photographing may seem spontaneous, it is actually being controlled by a subconscious set of personal values. These lead you to respond to particular kinds of subjects, choose a certain viewpoint and create unique compositions.

Most of us begin to take photographs to record *events* or *scenes* that we find interesting. Later, we may begin to realize that our photography has greater potential for expressing *ideas*. At that point it is necessary to alter our photographic thinking process and approach. Until you arrive at that stage, outstanding photographs will be no more than occasional accidents.

PREVISUALIZATION

What I recommend you cultivate is a state of mind that can see the b&w print you want *before* you expose the negative. This technique is traditionally called *previsualization.*

Photographers who work this way analyze a scene and make a conscious or unconscious decision about composition. Subject elements are ordered with an appropriate choice of viewpoint and lens. Exposure conditions are determined to assure that all important areas of the scene will be recorded on film. In addition, subsequent actions such as film processing and negative printing are considered.

Doing It—This sounds far more difficult than it really is, as you'll find out when you *do* it and not just read about it. If you have a Polaroid camera that produces instant b&w prints, or if your camera accepts a Polaroid back, you can accelerate this learning process.

Select a few simple scenes that are easy to return to and photograph them. Use a variety of filters if you have them. Carefully write down which filter you use for each picture. As soon as you can, *carefully* compare a b&w print of the scene with the scene itself. Instant or commercially processed prints are fine for this purpose. Make sure that the lighting conditions are comparable. Compare the scene and b&w print—don't hesitate to write in details such as color or meter readings on the print surface.

You'll soon find that "seeing" in b&w isn't very difficult and that you are well on your way to mastering previsualization. Your own photographs will be your most effective teachers. I recommend that you use them as much as you can.

COMPOSITION

This is the first step in making a photograph—giving visual order to a subject as seen through the viewfinder. If you are photographing a still life or person, you have a lot of control. You can arrange the subject to your liking and create almost any mood you want with an appropriate interplay between light and shadow. With your choice of lens and location, you can control perspective and generate a feeling of three dimensions in the image.

With more complex subjects, such as landscapes or people in action, the same variables exist. However, some elements are beyond your control. If you are photographing a mountain, there is little that you can do to control the lighting. You can choose the time of day and the appropriate season, and hope that the weather is reasonable. These limitations require that you be as imaginative as possible when composing scenes.

About Rules—Volumes have been written about composition for both photography and traditional visual arts. Standard rules have evolved, such as never place the horizon in the middle of the picture; the center of interest should not be in the center of the picture; avoid locating dark elements on one side of a picture and light ones on the other. The merits of S-shaped curves to lead the eye into the scene, and the value of diagonal shadows to add dimensional structure are also noted.

Even though all of these observations have some merit, they can be limiting to creative composition. If you follow these rules faithfully, your photographs are likely to be nothing more than reflections of time-worn clichés.

Photography should be artistic expression, not a semi-scientific exercise. *There are no rigid rules of composition that you must follow.* Allow your individuality to express itself.

Look carefully at the scene and analyze which elements are visually important to the photograph you want to create. Consider these questions, for example: Where should I place the main point of interest? If there are several important elements in the scene, what should be their relative placement? Which should I emphasize most? Will the photograph benefit from selective focus—limiting the depth of field—or is extensive depth of field better? Is it possible to avoid large expanses of uninteresting blank spaces? What focal length lens is most appropriate? Are there extraneous elements visible in the viewfinder image that should be eliminated in the photograph?

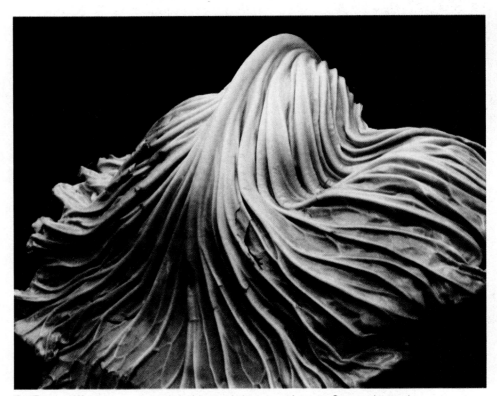

For Edward Weston, even simple subjects had inherent beauty. Composing and photographing it well depends on your ability to see. *Cabbage Leaf, 1931,* © 1981 Arizona Board of Regents, Center for Creative Photography.

Obviously, the list of such questions is unending, proving how much creative control is available. When you photograph, you should give free rein to your own sense of visual esthetics.

Edward Weston once said, "Composition is the strongest way of seeing." Follow this advice and your pictures will begin to bear their own stamp of originality—yours.

One Example—The following may help you to understand one way to approach the photographic process. One morning I photographed an unusual saguaro cactus in the midst of many. It caught my eye because it was about 200 years old. Unfortunately, the location and uniformity of the landscape did not allow isolating and presenting the entire cactus in a way that pleased me.

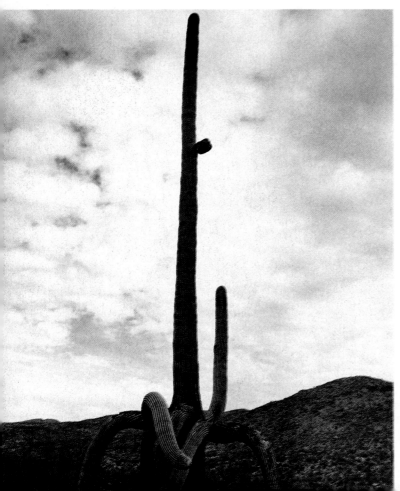

Your first composition is not always going to work out. You may have to consider more before getting the image that conveys your intentions best.

Closer inspection revealed interesting structural details, which I photographed. The strength of the limbs in addition to their great, twisting weight eventually suggested to me the struggle of life in a harsh, inhospitable environment. The cactus seemed heroic.

My best interpretation of this was to photograph it from close to its base, pointing the camera upward. I put a wide-angle lens on my camera and a green filter on the lens to increase the tonal contrast between the cloudy sky and green skin of the plant. I think the final photo conveys what I felt at the time I took the photograph.

This is the final, and best, image I made of the saguaro cactus.

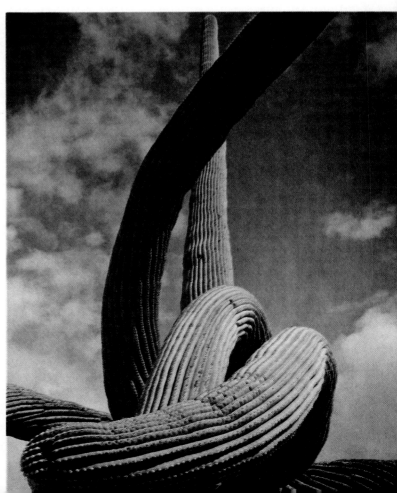

THE TONAL SCALE

A typical b&w photograph contains white and black that correspond to minimum and maximum exposure of the photographic paper. An infinite and continuous array of gray shades represents exposures between these extremes. This is more limiting than what we see every day. In the world around us, objects have properties of color, luminance, and form.

Form and color are easy to understand. *Luminance* is the light reflected or emitted by a subject. It is a measurable quantity. Dark areas have less luminance than light areas. The range of luminance values a subject has—from darkest detail to brightest texture—is sometimes called the *subject brightness range (SBR)*.

Seeing B&W Tones—When you photograph in b&w, you must learn to distinguish between bright colors and brightness. If the visual impact of the scene depends on colors, perhaps a b&w photograph will not produce an effective image. This is often true, even if you use filtration.

A difficult part of previsualization is reducing a scene to an image in which only the brightness of objects—*not* their color—matters. For example, a green tree in front of a red wall will clearly stand out in a color slide. On panchromatic b&w film, however, the tonal values of the two subjects may be virtually the same.

A Kodak Wratten #90 filter is a useful aid in converting a multi-colored, or *polychromatic,* scene into a monochromatic one. You can order it from any photo store. It's available as a thin gel about three inches (75mm) square. To protect the filter from abrasion, mount it between two pieces of thin glass normally used for glass-mounted slides. Tape the edges of the glass together.

When you hold the filter to your eye, you see the relative brightness of the scene essentially unchanged. However, colors are

To get a good idea of the b&w tonal relationships in a scene, view it through a #90 Wratten filter. This filter is mounted between two pieces of glass and taped around the edges.

neutralized. The image you see is colored brown. Tonal values are similar to what you will find in a b&w photograph of the scene made with panchromatic film and no color filters.

If the scene depends primarily on color for impact, it will look very dull and flat through the #90 filter. You may decide that the scene won't produce a satisfying b&w print.

I recommend that you take a #90 filter along when you begin to practice previsualization. Use it to compare b&w prints with actual scenes. You'll find that it helps you learn more quickly.

SEEING ZONES

Rather than attempt to analyze a photograph as continuous shades of gray between black and white, Ansel Adams and others have divided a b&w print into *zones*. In the system I prefer to use, zone 0 is maximum black in a print. Zone IX is the white of the unexposed paper base.

Zone V is called *middle gray*. It corresponds to 18% reflectance of incident light. That is, 18% of the light striking the surface is reflected and 82% is absorbed. An 8x10 inch gray card having this characteristic is made by Kodak and is available from photo stores. I recommend you get one for subsequent tests described in this book.

Each zone represents twice as much brightness as the next lower zone. For example, zone VI is one exposure step brighter than zone V; zone IV has half the luminance of zone V. This makes a gray card a useful reference in the field.

The concept of zones is basic to understanding how a subject will be translated to the b&w print. Make an effort to commit general aspects of these tonalities to memory. You need to be familiar with them if you hope to use your exposure meter correctly, as discussed in Chapter 4.

USING ZONES

Subsequent chapters in this book describe a system of negative exposure and development that produces a negative with well-defined characteristics. You'll learn to meter a scene for the minimal exposure necessary to record all important shadow details. Then you'll develop the negative for a time that will conveniently produce a zone V density in your print for a corresponding zone V area in the scene.

The *Zone System* enables you to control tonal placement in your photographs *however you choose*.

CHARACTERISTICS OF THE 10 ZONES

Zone 0 is the darkest black achievable on paper. It corre-

This gray tone approximately matches that of an 18% gray card, a zone V print density.

sponds to a full exposure of the photographic paper from an unexposed portion of a negative. It is also called *maximum black*.

Zone I represents the *response threshold* of the photographic film to light. Exposure less than that necessary to create zone I has no photographic effect, yielding zone 0. When properly printed, a hint of tonal variation in a black slightly lighter than zone 0 is discernible. But texture is not obvious in zone I.

Zone II is the first sign of detail in the darkest portion of the print. Zone III contains dark subject matter in which structural detail is clearly recognizable. Proper rendition of these zones is usually critical in a fine b&w print because shadows can convey a strong sense of mood or emotion. Precise exposure control is necessary to

capture detail in these areas.

Zones IV, V and VI represent middle-gray values in a print and provide the best opportunity to present clear details. Typical zone IV elements are important shadowed subjects in normal landscapes, such as dark foliage, wood, or stained rocks. Zone V corresponds to the gray on the Kodak Neutral Test Card, which has 18% reflectance. Subjects that are often placed in this region are dark skin, sunlit green foliage, weathered wood, stones and a clear north sky.

Zone VI is the tonal value usually chosen for Caucasian skin. Therefore, it can often serve as a useful guide in the field to evaluate relative subject brightness and to determine exposure. Pale stone, concrete, and wood also fall into this category.

The brighter values of a print fall on zones VII, VIII, and IX. Zone VII is a proper tone for very pale skin and off-white objects, such as sunlit sidewalks and sand. Textured whites, such as snow or whitewashed walls, and detailed highlights most often appear in zone VIII. Zone IX is a brilliant white without discernible texture. Typically, this is paper-base white, the brightest tone possible in a b&w print.

For a critical rendition of objects in the lightest portions of a print—the areas that are the darkest sections of the negative— careful negative exposure *and development* are necessary. This prevents tonal merging, or a print blemished by large, bland, white masses. Looking at a few b&w prints illustrates some of these points.

ZONES IN THE PRINT

See the photo on page 11 of the Mission San Xavier in Tucson, Arizona to see how one print can contain all zones from 0 to IX. I photographed the mission through a dark-green filter to increase the tonal separation between the clouds and blue sky. I used this filter because I knew that it would also darken the light-red facade. Using filters this way is explained in more detail in Chapter 8.

I previsualized the white sunlit walls of the mission on zone VIII. First, I metered the wall with a spot meter. Because the exposure meter is calibrated to recommend an exposure that reproduces an object as a zone V density in the negative, I adjusted the recommended settings. Zone VIII is three steps brighter than zone V, so I set the camera exposure for three steps *more* exposure than the meter recommended. I also considered the filter factor for the dark-green filter (4X) and added two steps more exposure.

After you *place* a single value on the tonal scale this way, all other brightness values automatically

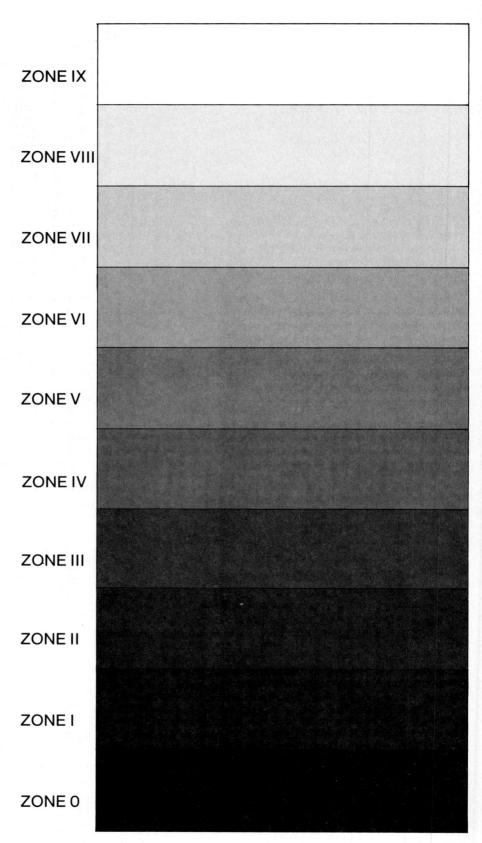

These zones represent shades of gray in the print. Zone V in the print matches the 18% gray card. Describing gray tones this way is a practical way to understand and use them. Because the photographic print does not have a brightness range as extensive as a typical scene, a print zone *is not* twice as bright as the next lower zone. The separation between zones is compressed and relatively constant for mid-gray zones. However, if you can record all zones in the print, the image will look realistic.

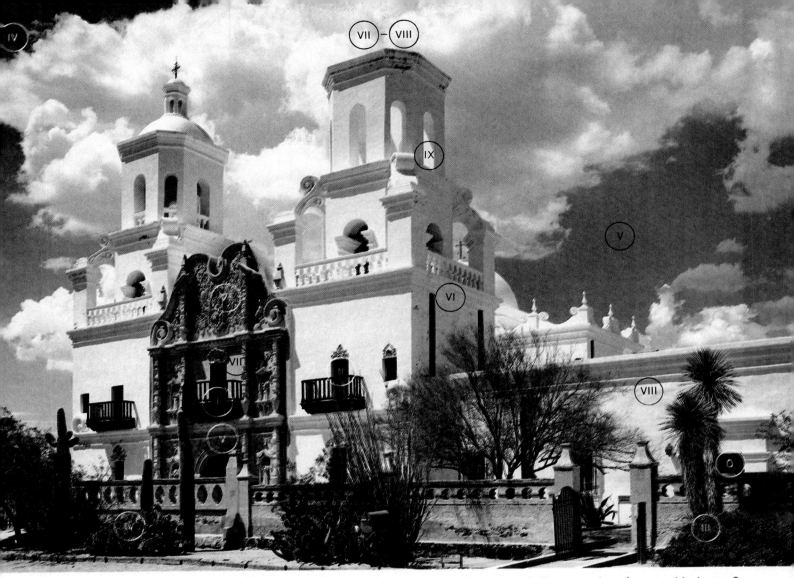

A full-scale print includes white, black and a range of gray tones in between. These can be represented by zone values, from very black zone 0 to paper-base white zone IX.

fall in their appropriate relative positions. These positions depend on their brightness levels.

For example, the shaded walls of this scene were two to three steps darker than the walls in direct light. Therefore, the shaded walls appear on zones VI and V respectively in the print. Similarly, the dark shadowed areas were six steps below the brightness of the sunlit walls, so I knew that they would fall on zone II, which I thought was appropriate.

General-purpose b&w film ex-posed and developed "normally" can record the detail of a seven-zone range—zones II to VIII, inclusive—and yield an easily printable negative.

Because I measured the brightness of all of the *important* elements of the photograph, zones II to VIII, I knew they fell within the film's capabilities. Therefore, I used normal exposure and development of the film. Printing the negative on a grade 2 paper required minimal dodging or burning in.

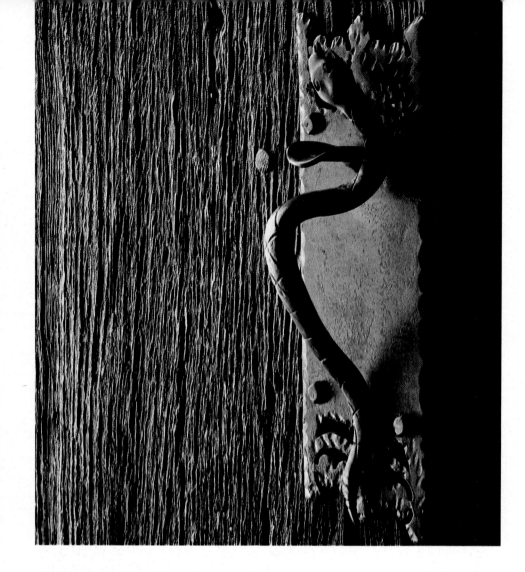

For this image, I underexposed and increased development to increase negative contrast. My purpose was to enhance the effect of texture.

ed on film by *increasing* the normal development time by 100%. This increased the negative density range by increasing negative contrast. In the resultant photograph at left, the highlight on the handle falls on zone IX, and the edge of the door falls on zone I.

This example illustrates two important features of the system of tone control that you'll subsequently learn. *Placement* of the subject on the negative—and subsequently in the print—is determined by exposure control. Negative *contrast* is defined as the ratio of the *negative* density range relative to the corresponding brightness range. It is controlled by the development time you use.

Increasing development time increases negative contrast, and

Another Example—The photograph of the door handle and weathered wood represents a subject requiring detailed rendering of texture. When I ignored the highlight on the back of the metal snake and the very dark shadow areas, the brightness range of the wood and door plate was about two steps. This made it a *low-contrast* scene.

If I chose to treat this as a normal scene, the rough-grained door surface would have been difficult to portray. Its texture would have been lost due to insufficient tonal contrast in the print.

Therefore, I placed the wood surface on zone IV. I metered the wood for a zone V exposure recommendation, then set exposure for one step *less* than recommended.

However, I *expanded* the scene's brightness range as record-

This is a different view of the same door and handle, but this time it was composed and exposed differently. I placed the wood on zone V and gave the film normal exposure and development. Although the two photographs were taken within a few minutes of each other, they are very different because I used different controls. I include it here to show that subject placement is arbitrary and up to you, the photographer. Nature provides the subject matter; it's up to you to interpret it as you think appropriate in your b&w photograph. If you think that the wood should be a different tone, expose and print it that way.

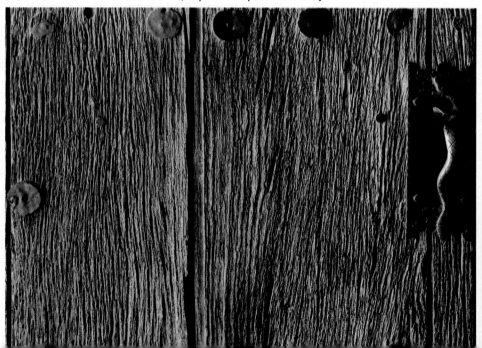

vice-versa. Obviously, controlling negative contrast is a powerful tool when you photograph low-contrast scenes such as this one.

A Landscape Example—The scene of two aspens against a background of shaded fir trees posed a *high-contrast* problem—the brightness range of important details was greater than seven steps. Incorrect exposure of this scene would result in loss of background texture or blocked white highlights on the side of the aspens.

I determined exposure by metering a gray card in the sunlight, placing it on zone VI. That is, I gave the film one more step of exposure than the meter recommended. To reduce contrast in the negative to compensate for the scene's high contrast, I reduced negative development 25% from normal. The resulting negative gave a print both rich and detailed.

Summary—In each of these examples, I faced a specific photographic problem. I devised a special approach for each *after* a careful analysis *in the field*—not during printing. In every case, the outcome was predictable and corresponded to the image that I previsualized before exposure.

In the foregoing discussion, I used many terms without extensive comment. They are all a part of the vocabulary of the Zone System of tone control. I'll explain them in detail in subsequent chapters. The point you should appreciate here is that a variety of controls is available for you to overcome difficult technical challenges. If you do the tests described later, the controls will be yours to use as needed. *And* there will be a striking improvement in the quality of your negatives and prints.

The first step in any creative process is deciding what you want to say or present. From that point on, the best way to express that idea reduces itself to a technical problem. In b&w photography, the Zone System offers you a straightforward approach to solving those problems.

As described in the text, I controlled image contrast of this contrasty scene by relative overexposure and using less-than-normal development.

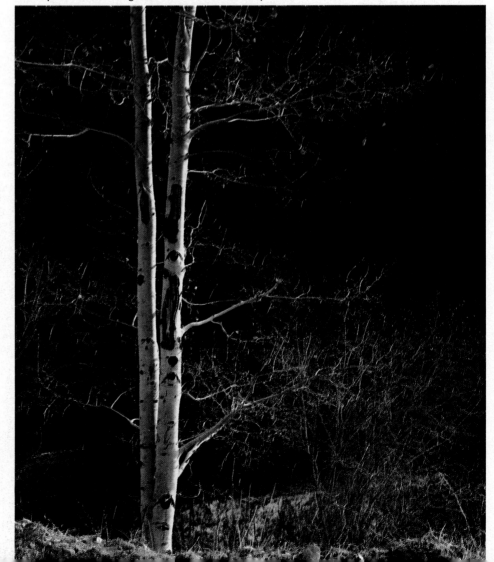

2

Camera Systems

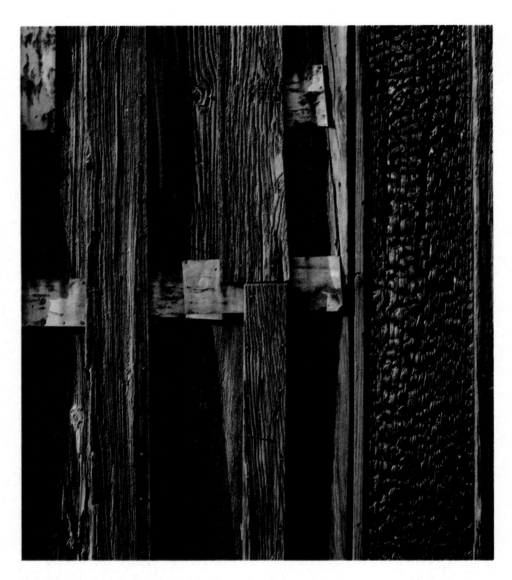

You can make fine prints from negatives of any film format. Doing it requires an understanding of the materials and limitations involved. This print was made from a medium-format negative.

Side lighting emphasizes the grain and texture of the wooden boards. I based exposure on a spot-meter reading of a sunlit portion of the surface and placed it on zone V. Negative development and printing conditions were normal.

A question I've heard more than a few times is, "You make fine pictures. What kind of camera do you use?" My usual answer is, "Whatever was appropriate for the occasion."

Even though both a scalpel and a bread knife are excellent cutting tools, each performs best when used for the purposes for which it was designed. The same is true of cameras. A good general rule is that you should always use a camera that will produce the largest negative that you can make under the circumstances.

Usually, the subject matter dictates the nature of the camera that works best. For example, in sports photography or photojournalism, a 35mm SLR camera is most satisfactory. For portraiture, a medium-format camera will work well. And for landscapes, a view camera is superior. If all other factors are equal, a large negative will always produce superior b&w prints in terms of image definition and tonal gradation than will a small negative. These are critical considerations if you want to make fine b&w prints.

Of course, there are numerous exceptions to these guidelines. Many fine landscapes have been done with 35mm cameras, and action photographs have been captured on 4x5 inch sheet film. Until the 1950s, the 4x5 Speed Graphic (no longer produced) was the standard press camera and was used for a variety of journalistic applications—from sports to portraits. Nonetheless, a 35mm SLR system is best suited for candid, rapid-action situations in which portability and versatility are important. A 4x5 or larger system is superior for relatively stationary subjects.

Most serious photographers ultimately try to build at least two camera systems, permitting work in both small and large formats. The investment required is obviously significant, but substantial savings are possible if you purchase used equipment from known and reliable dealers. Careful thought and research before shopping for camera equipment will pay substantial dividends.

I want to stress that principles of the Zone System are practical with *any* camera system or format. The differences relate to how you choose to apply this approach to b&w tone control, not in the theory of the system. I will make many specific suggestions throughout the book enabling you to deal with special problems that you may encounter, regardless of camera format.

35mm SLR SYSTEMS

If you have decided that a 35mm SLR camera best meets your personal needs, I urge you to consider the purchase of a system camera. Cameras such as those made by Nikon, Canon, Minolta, Olympus, Pentax and others have an array of lenses and accessories designed for various camera bodies. These features add up to good performance, flexibility, and reliability.

Deciding which system is best depends upon your personal needs and preferences. Size, weight, ruggedness, handling ease, metering systems, and lens performance are factors that you should consider, along with cost. With recent advances in lens technology, camera electronics, and improved film characteristics, almost all modern 35mm cameras are fine instruments capable of producing excellent results.

HPBooks produces camera manuals that detail the most popular 35mm camera systems. These are up-to-date, comprehensive compilations of camera system features. Before making a commitment to a particular system, I urge you to read about it first. Choose a camera that will be a pleasure to use, not a chore and a source of frustration.

Advantages Of 35mm SLRs— The major strength of 35mm SLRs is versatility. Because lenses in many focal lengths are available, you can handle almost any imaginable photographic situation. In addition, lenses for 35mm cameras are usually much faster than those available for larger formats. The larger maximum aperture makes them more suitable for available-light photography. Some systems even have tilt-and-shift lenses capable of perspective control.

A quality 35mm SLR with normal, wide-angle and telephoto lenses can be purchased at a reasonable price—usually much cheaper than corresponding larger-format equipment. Because b&w film is relatively inexpensive, the cost-per-image with a 35mm camera is cheaper, too. And, the variety of films available for both b&w and color photography is enormous.

The 35mm SLR has also been adapted for scientific use and can be fitted to both microscopes and telescopes. Accessory bellows and extension tubes make close-up work simple. Built-in, through-the-lens (TTL) metering makes exposure calculation quick and easy. A motor drive is an important accessory for shooting journalistic subjects such as sports.

Disadvantages Of 35mm SLRs— The most serious limitation of a 35mm SLR is that the small image does not always lend itself well to critical rendition of tonal detail when enlarged.

Some compromise in negative quality is almost inevitable unless you can expose an entire roll of film on a single subject. This is because lighting and brightness range may vary from scene to scene, with each scene's image requiring different development conditions if you want to produce the best negative for each picture.

Unless you can group your exposures on different rolls or segments of a roll that you can separate, you will be forced to choose development conditions that will sacrifice some potential image quality on some of the frames. Even so, there are practical ways to deal with these problems.

It seems to be a peculiar quirk of human nature that while many photographers who work with 4x5 negatives are usually content with 8x10 prints, those who use 35mm systems seem compelled to make 16x20 images just to prove that it can be done. Remember, a 3-1/2x5 inch image, mounted well, can be beautiful.

It's tough to beat the combination of versatility, size, weight and simplicity of a 35mm SLR system. It's also possible to apply the principles of the Zone System to 35mm photography, as was done here. Photo by Theodore DiSante.

More enlargement sacrifices sharpness. Such sins as slight camera movement, inaccurate focusing, grain, dust spots and pinholes in the negative are revealed with astonishing clarity when negatives are magnified greatly. Though all of these problems can be minimized, this demands a lot of care and craftsmanship.

There's another danger awaiting the 35mm photographer—the problem of *attitude*. Because 35mm b&w film is relatively inexpensive per image, and exposures can be made very quickly, it's all too easy to fall victim to the "bracketing syndrome." This involves photographing a scene at what you think is the correct exposure and then taking a few more pictures with more and less exposure to be certain that one frame is good enough for printing. Alternatively, you may choose to photograph the same scene from a variety of angles with every lens that you to own on the theory that one picture is sure to be good.

Even if these approaches sometimes work, they replace more careful thinking with a shotgun approach that *may not* work. Creative b&w photography is a deliberate process requiring sensitivity, thought and control of all steps in making a photograph. By getting to know your equipment and doing the tests described in later chapters, you should be able to eliminate all guesswork. Ignorance is an unreliable ally.

The Zone System And 35mm Photography—There are two key steps to the Zone System. *First* is determining correct negative exposure, including the variables of shutter speed, aperture and filtration. *Second* is establishing conditions for negative development.

As shown earlier, the scene's brightness range is an important factor in both. Most TTL meters in 35mm SLRs measure an average brightness of the scene imaged in the viewfinder. Some meters average the whole scene with equal weighting. Some are center-weighted, giving emphasis to brightness in the central part of the viewfinder.

When we use the Zone System, we are not interested in an average brightness but rather, the *subject brightness range*. You determine SBR by measuring luminance values of important light and dark areas in the scene. The camera's exposure-control settings are determined from those values, *not* the average brightness. This will be discussed in more detail in Chapter 4.

Even though exposure settings based on SBR consideration *may* coincide with an exposure you determined by measuring the average brightness of the scene, *the values can also differ radically*. If you plan to rely on your camera's metering system to recommend exposure settings, you must learn when and how to override the

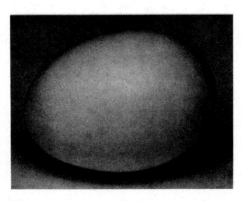

When exposed according to an averaging TTL camera meter, a predominantly white subject, such as this egg, reproduces as gray (above). With this type of subject, you'll get better exposure if you override the meter and give more exposure than indicated (below). Both prints were made in the same way. The tonal differences you see are due to different negative exposures.

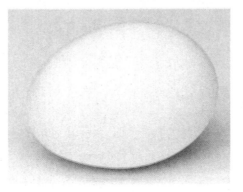

exposure settings indicated by the camera.

A second problem stems from the large number of exposures you can make on a single roll of film. As mentioned previously, in a typical day's shooting, subject matter and lighting conditions vary enormously—such that scene A should be underdeveloped (and exposed accordingly) to decrease contrast, scene B should be overdeveloped (and given accordingly less exposure) to increase contrast, and scene C is normal. Under these circumstances, two out of three of these subjects on the same roll of film will produce considerably less-than-ideal negatives that you can only *hope* to salvage during printing.

Or, your camera may be loaded with a slow, fine-grain film when a situation arises demanding a fast shutter speed attainable only with a faster film. One obvious solution to these difficulties is to have several camera bodies loaded with different film. Though this is useful, it's not always practical.

A less expensive approach is to use three different rolls of film. Each gets different development—less-than-normal development, normal development, and greater-than-normal development. This means that you rewind the film into the cassette in mid-roll when different exposure/development conditions are necessary due to a different brightness range.

Make note of the number of exposed frames on each roll and be sure to label each well. Rewind the film slowly. When you feel the film leader separate from the take-up spool, stop winding. The tongue of the film will protrude from the felt trap. Write down the number of exposed frames on the tongue. Load the other roll. If it is partially exposed, put the lens cap over the lens and advance the film to two frames beyond the last exposure.

If this procedure is too much of a nuisance, you may find it easier

to bulk-load cassettes with about 10 exposures and sacrifice the unexposed film when it's necessary to change rolls.

MEDIUM-FORMAT CAMERAS

Various medium-format cameras using 120 or 220 roll film are available, giving images sizes such as 4.5x6 cm, 6x6 cm (2-1/4 inches square), 6x7 cm and 6x9 cm. These cameras have many of the desirable features of 35mm systems, but produce a significantly larger negative at the expense of weight and ease of handling.

Three types are currently available. These are the single-lens reflex (SLR), twin-lens reflex (TLR), and folding-type cameras.

SLR Systems—SLR medium-format cameras are made by Mamiya, Bronica, Pentax, Hasselblad and Rollei for image formats from 4.5x6 to 6x7 cm. Each camera and system features a wide variety of high-quality lenses and accessories. All offer the advantage of lens interchangeability and either waist-level or eye-level viewing. The systems vary with respect to available meters and electronically controlled exposure operation.

Medium-format cameras are excellent for portraiture and studio photography, yet are also sufficiently versatile for field work demanding mobility. Some small medium-format SLRs, such as the Bronica ETR and Mamiya M645 cameras, rival their 35mm counterparts in terms of handling ease.

The price of such systems can be formidable, but equipment of this quality is an excellent investment if you want to produce professional-quality prints. For a complete description and evaluation of the most popular medium-format cameras, consult *How to Select & Use Medium-Format Cameras,* published by HPBooks.

In addition to the larger negative, two other features make many medium-format SLRs useful for Zone-System work.

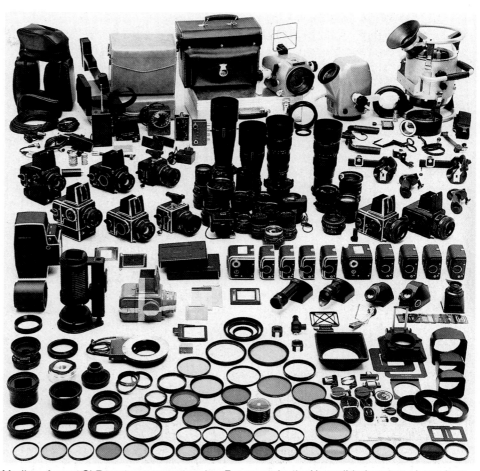

Medium-format SLR systems are extensive. For example, the Hasselblad system shown here includes four cameras, more than 20 lenses, interchangeable backs, viewfinders and other accessories.

These are *interchangeable backs* and *leaf-shutter* lenses.

Interchangeable Backs—This feature lets you use different rolls of film for a variety of exposure and development needs. For example, one back may contain b&w film for scenes that call for expansion of negative contrast (greater-than-normal development), another for compression (less-than-normal development), and a third for normal exposure and

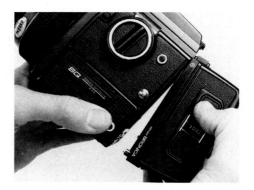

processing. Using one camera body and three backs is much easier—and less expensive—than using three separate cameras.

In addition, an interchangeable Polaroid back aids previsualization by giving you almost instant feedback when you make certain photographic choices. For example, the effect of various filters on the tone of the sky and the rendition of clouds can be seen immediately because most b&w Polaroid pack films are panchromatic. Using Polaroid film in this way to produce both prints and usable negatives is described in Chapter 12.

Two or three interchangeable backs for your medium-format SLR make Zone-System work practical and easy. You'll waste less film than with the 35mm method described and not need more than one camera body. Removing a back from a Bronica medium-format camera is shown here.

Leaf-Shutter Lenses—These allow electronic flash synchronization at *all* shutter speeds. Typically, the fastest shutter speed is 1/500 second. This is a decided advantage, especially when you use fill-in flash to illuminate heavily shadowed areas. Some older model 35mm cameras have this capability, but no current models do.

Twin-lens Reflex (TLR) Cameras—A TLR camera is a camera with separate viewing and picture-taking lenses. You use the top, or *viewing*, lens to focus and compose the image on a ground-glass screen. The lower, or *taking*, lens focuses the image on film. The lenses are coupled so they move together as you focus the viewfinder image.

TLRs are simple and rugged. They are quiet in operation because the mirror is fixed. The only shutter is a leaf shutter in the taking lens. A disadvantage is that the image that appears on the ground glass is reversed from right to left when you use a folding-hood viewfinder. For some models, prism viewfinders are available to give a right-reading image in the viewfinder.

Only a couple of TLR systems are still being produced. These include cameras made by Yashica and Mamiya. Both give 6x6 cm images. Mamiya TLRs have interchangeable lenses.

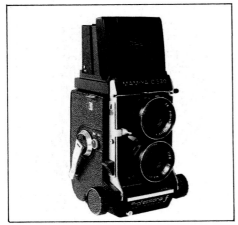

The Mamiya C330f TLR accepts interchangeable lenses with focal lengths from 55mm to 250mm. It's a rugged camera that is part of a system of interchangeable accessories.

Excellent bargains can be found in the used camera market. For example, both the Rolleicord and Rolleiflex are high-quality cameras with excellent lenses. Though they do not offer lens interchangeability like current Mamiya TLRs, models with fixed telephoto and wide-angle lenses were once available.

TLRs are modestly priced and are of extraordinarily good value. They can use both 120 and 220 roll film for 12 and 24 exposures in the 6x6 cm format. A TLR is capable of giving good image quality. The main disadvantage is that you cannot remove part of a 120 or 220 roll film from a TLR.

Folding Rangefinders—The folding rangefinder camera was virtu-

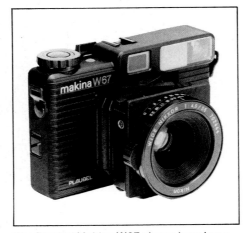

The Plaubel Makina W67 shown here has a fixed 55mm wide-angle leaf-shutter lens. Except for this major difference, it's similar to the standard Makina 67, which has an 80mm leaf-shutter lens.

ally extinct at one time, but now may be making a comeback with the introduction of the Plaubel Makina 67. This type of camera features a lens that extends from the camera body on a bellows. The Plaubel Makina 67 offers rangefinder viewing, an 80mm Nikkor lens, a built-in meter, and a 6x7 cm image format.

Some excellent used cameras such as the Super Ikonta models and the Voigtlander Bessa (look for a model with the Heliar lens) may be available. These cameras are easy to operate, quiet, and can produce high-quality negatives

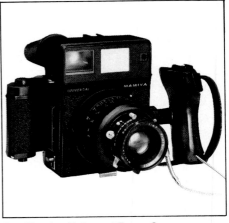

The Mamiya Universal Press Camera accepts interchangeable backs using roll and sheet films. The system includes a large variety of interchangeable lenses, grips and other accessories.

from 6x6 cm to 6x9 cm in size. The cameras are compact when folded and easily slip into a jacket pocket or purse.

Press Cameras—Two medium-format rangefinder cameras featuring interchangeable lenses are the Mamiya Universal and Rapid Omega systems. These are modern medium-format versions of the old-fashioned press camera. They are designed for situations in which fast handling and a relatively large negative are necessary, such as wedding photography, sporting events, aerial photography and publicity photographs.

Both cameras have interchangeable roll-film holders. The Mamiya Universal also accommodates sheet film and film packs, making it easy to use with the Zone System. With this type of film holder, each negative can be developed separately.

Medium-Format Lenses—The standard focal lengths of lenses for medium-format cameras vary from 75mm to 127mm. Consequently, depth of field, which is a function of both image magnification and aperture, will be noticeably less than with a 35mm camera using a 50mm lens at the same aperture. In addition, the maximum aperture of medium-format lenses is usually 1 to 2 *f*-stops slower than comparable lenses for 35mm SLRs.

Basically, this means that extra care is necessary when you use medium-format cameras. Otherwise, their inherent advantages are quickly compromised. You should use a tripod whenever possible to minimize camera movement. In my opinion, the additional care required with medium-format cameras is amply rewarded in terms of excellent image quality.

LARGE-FORMAT CAMERAS AND LENSES

Large-format cameras typically use sheet films measuring 4x5, 5x7 or 8x10 inches. Special cameras designed for 11x14 and 20x24 inch negatives are also available. Large-format cameras, commonly called *view cameras* or *field cameras,* allow the ultimate versatility for image control and Zone-System work.

For example, image control is relatively easy because of *movements* on the camera. These allow you to swing, tilt, and shift the lens or film plane to control depth of field, image shape, or converging verticals. Because you load each piece of sheet film individually in a film holder, you can develop each negative according to its individual needs.

Due to the large image size, resolution and tonal gradation are excellent. Negative retouching is also easy. View cameras *are not* designed for fast handling, so photographing with one is reduced to a deliberate and thoughtful process.

In addition, darkroom work is greatly simplified. Because the negatives are so large, you can make contact prints that are richer in detail and tonal gradation than you can achieve by enlarging. Even so, enlarged prints are perceptibly grainless, and sharp definition and tone far exceed what you can obtain from small negatives. Spotting prints is easier because the degree of enlargement of everything, including unwanted dust, is less.

View Camera Types—View cam-

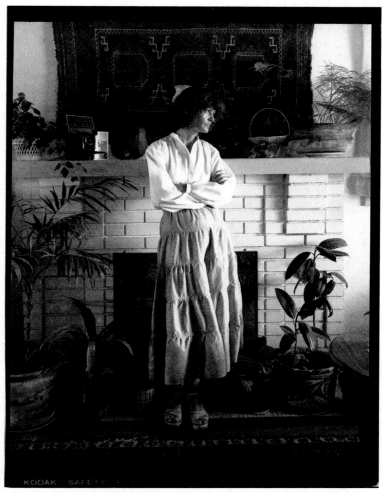

If you control negative exposure and development, it's easy to make fine prints from large-format negatives by contact printing. Image quality is superb.

eras consist of three basic parts—an expandable box made up of a standard and bellows, a film holder, and a lens mounted on a board.

Two basic types of view cameras are available—the *flatbed* type and the *monorail* camera. Flatbed cameras are also called *field cameras.* They are easily portable, folding up into a trim package that can be slipped into a carrying case or backpack. Some manufacturers of this type of camera are Calumet, Deardorff, Wista, Ikeda, Toyo, Nagoaka and Tachihara.

Monorail cameras consist of two frames—one for the lens, the other for the film holder and ground-glass screen. These are connected by an expandable bel-

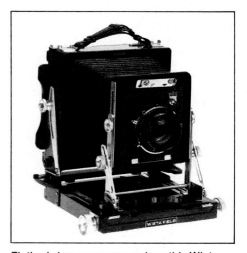

Flatbed view cameras, such as this Wista Field model, have an extensive range of swings and tilts. It folds into a compact unit that's easy to transport. Interchangeable lenses are mounted on individual lens boards. This type of camera is available in 4x5, 5x7 and 8x10 formats.

lows. Each frame slides along a monorail that can be mounted to a heavy-duty tripod. Because both the lens frame and the viewing frame have complete freedom of movement, monorail cameras offer a greater range of adjustments than field cameras.

Excellent view cameras, all of which are capable of superb performance, can be bought new for as little as $200 and as much as $3500. The price difference is a consequence of engineering and manufacturing differences, elegance and solidity.

Large-Format Lenses—With comparable lenses, view cameras at both extremes of the price range can provide *identical* results. Lens choice is critical, and can also be a bit bewildering.

You focus an image in many small-format cameras by moving lens elements *within* the lens barrel. The distance between the lens mount and the film plane does not vary. The manufacturer designs lenses so the entire surface of the film will be covered by the image you see through the viewfinder, regardless of lens focal length.

If you could put a 50mm lens from a 35mm camera on a medium-format SLR camera,

what you would see is a circle containing an image *identical* to that seen through the 35mm viewfinder, but the image will *not* fill the entire viewing screen or cover the film completely. This is because the lens has insufficient *covering power.* With large-format lenses, you must consider both the focal length of the lens and the ability of the lens to project an image that covers the entire film area. If the lens does not have sufficient covering power, image corners appear underexposed, or vignetted.

When a lens is focused at infinity and is the distance of the focal length from the film plane, it will produce an *image circle* of good definition on film. The diameter of the circle is a known characteristic of each particular lens design and is reported by the manufacturer. When purchasing a lens, you must be certain that the diameter of the image circle is at least as long as the diagonal of the film. If the view camera has movements, each of which effectively moves the image circle, the diameter should be greater than the film diagonal. The greater the covering power of the lens, the more useful (and expensive!) it will be.

Therefore, regular testing, cleaning, lubricating and adjusting of old shutters is a must. A local camera-repair center that works with professional photographers can do this for you.

Tripod—An indispensable accessory for large-format work is a sturdy tripod. Because the usual focal lengths of lenses for large-format cameras are much longer than those you commonly use with a 35mm camera and the cameras are much heavier, you must take care to avoid camera movement. To maximize depth of field, apertures of f-32 to f-64 are commonly used. As a consequence, even in bright light and with fast film, you often use slow shutter speeds. The camera *must* be steady.

When you compose the image in a view camera, you will see an upside-down image reversed from left to right. This is disconcerting at first, but you soon become used to it. A dark cloth over the camera and your head, to exclude ambient light, is a necessity. Image brightness on the ground-glass focusing surface is relatively faint. A reliable exposure meter, preferably with spot-reading capabilities, is also required.

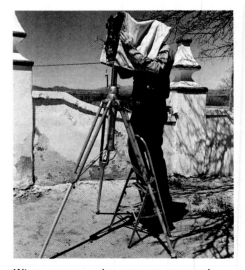

Vignetting is a partial cutting-off of the image. Typically, it's caused by using a lens that cannot cover the film with an image completely, by excessive use of camera movements, or by using an inappropriate lens hood for a particular lens.

MINIMUM CIRCLES OF ILLUMINATION	
Film Size (inches)	Circle Diameter (inches)
2-1/4x2-1/4	3-1/4
2-1/4x3-1/4	4
3-1/2x4-1/2	5-3/4
4x5	6-1/4
5x7	8-3/4
8x10	13
11x14	18

Lens prices vary, so the best advice is to purchase the best lens that you can afford. The lens, not the camera, makes the image. High-quality lenses are available from Fujinon, Calumet, Nikon, Rodenstock, Schneider and others. You can also find good-quality used lenses.

Marked shutter speeds of older lenses are generally unreliable.

When you use a view camera, you must compose the image under a dark cloth. It need not be black, but must be opaque. In hot conditions, working under a white cloth is a lot cooler and more comfortable than under a black cloth.

3

Sense From Sensitometry

In this chapter, I'll introduce some general concepts and definitions relating to film, light and measurement techniques. This provides you with a general overview of the photographic process and the necessary vocabulary to discuss the concepts. I treat many of these topics in more elaborate detail in subsequent chapters.

When you expose and develop b&w film, you obtain a negative—its brightness values are reversed relative to the scene. Printing the negative reverses tonality again, giving a print image similar to the original scene in terms of the luminance of elements within the scene. However, the brightness range of the print, obtained by measuring the reflectance of light and dark areas, is usually quite different from that of the scene.

To make a good negative, you must consider three variables—film speed, film exposure and film development. For *predictable* and *reproducible* results, you should determine parameters for each of these "unknowns." You do this by applying some simple principles of *sensitometry*, the science of measuring the effect of light on photosensitive materials. The procedures are simple to do and easy to understand.

THE EFFECTS OF LIGHT AND CHEMICALS ON FILM

B&W film is made of a transparent plastic base coated with light-sensitive silver-halides and dyes. When silver-halides are exposed to light they undergo a complex change. In this light-altered state, they can be converted to metallic silver through the actions of chemical reducing agents present in film developer.

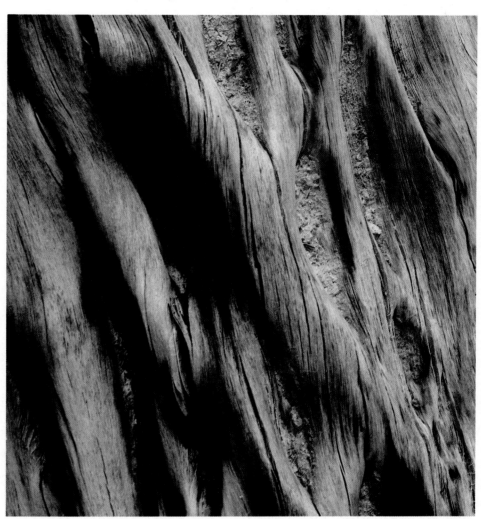

Understanding sensitometry is the technical part of b&w photography. Knowing it frees you to be as creative as you can be with the process. Consider it just another tool in the craft of making fine prints.

The impression of round and smooth surface details of this cactus skeleton was due to the ambient light. The overcast sky eliminated any sharply defined shadows and minute textures. I made a meter reading of the subject and placed the value on zone V. Negative development and printing were normal.

To prevent further action from light, you desensitize the developed negative by dissolving the unexposed silver-halides in fixer. Then you wash the negative.

Early photographers discovered that the blackness, or *density,* of the silver in processed film is related to two factors—exposure (E) to light and, for any specific developer at a given temperature, the development time.

Exposure, in turn, is a function of the Illuminance (I) of the light source *and* the duration of exposure (T) to that light source. This is expressed in the equation:

$$\text{Exposure} = \text{Illuminance} \times \text{Time}$$
$$\text{or, } E = I \times T$$

This equation is commonly known as the *reciprocity law,* which implies that any combination of illuminance and exposure time giving the same exposure yields the same photographic effect. It's valid except for circumstances in which exposure time is very short or very long. For the moment, let's ignore these exceptions.

Camera Controls And Exposure—Your camera has two sets of exposure controls—lens *aperture* and *shutter speed.* Aperture settings allow you to control the brightness of the light striking the film. Shutter-speed settings regulate the exposure duration.

You can increase exposure by "opening up" the lens—using a larger aperture—or using a slower shutter speed. To decrease exposure, do the opposite. You can control exposure by using either or both controls. To set these controls for good exposure, you need to know film speed and scene brightness.

TRANSMISSION, OPACITY AND DENSITY

These three terms can be used by photographers when they discuss b&w negatives. However, the first two are falling into disuse, making *density* most popular. I present them here so you can see the origins of density and appreciate its usefulness.

Transmission (T) is a measure of transparency, or clearness, of the film. It is the ratio of the intensity of light passing through the negative (I) relative to the intensity of the light source (I_o).

$$T = I/I_o$$

For example, if the intensity of a light beam is halved by the negative's blackness, the transmission is 1/2 or 0.5.

Rather than talking about a negative's transmission, it is usually more appropriate to talk about the inverse property, *opacity.* Opacity (O) is the reciprocal of transmission. Thus, a negative with a high opacity will have a low transmission.

$$O = 1/T = I_o/I$$

An easy way to remember this general principle is to remember that *opacity* is to *opaque* as *transmission* is to *transparent.*

Direct measures of opacity can lead to very large numbers because the value of the fraction 1/T increases rapidly as the transmission of a negative decreases. Eventually, the numbers are too big to use conveniently. As a result, we most commonly use another measure of opacity— *density* (D). It is the logarithm of opacity.

$$D = \log_{10} O = \log_{10}(1/T)$$

Negative areas that are dark have a high opacity and a high density. The idea is the same; only the numerical values are different. The darker the area is, the denser it is.

A typical low-density value is that of "clear" film, about 0.20. A typical high-density value on film is about 1.80. Another good reason to use density values is that because they are log values, you can add or subtract them. When I talk about negative blackness, I'll discuss density values exclusively.

Each 0.30 density increase represents a halving of light transmission. For example, a 0.50 section of a negative lets half as much light through as a 0.20 section.

Neutral-density (ND) filters are labeled in density units too. For example, a 0.30 ND filter absorbs half of the light striking it. This represents one step less exposure if you use the filter in front of a lens. A 0.60 ND filter absorbs two exposure steps of light by cutting down the light to one-fourth the incident brightness. Each increase of 0.10 density units represents a third of an exposure step.

EQUIVALENT VALUES OF TRANSMISSION, OPACITY AND DENSITY		
Transmission (T)	Opacity (O = 1/T)	Density (D = \log_{10}O)
1.00	1.00	0.00
0.80	1.26	0.10
0.63	1.59	0.20
0.50	2.00	0.30
0.40	2.50	0.40
0.32	3.16	0.50
0.25	4.00	0.60
0.20	5.00	0.70
0.16	6.31	0.80
0.13	7.95	0.90
0.10	10.00	1.00
0.08	12.60	1.10
0.06	15.85	1.20
0.05	19.95	1.30
0.04	25.12	1.40
0.03	31.62	1.50
0.01	100	2.00
0.001	1,000	3.00

EXPOSURE AND FILM DENSITY

Imagine a row of closely spaced light bulbs, each one *twice* as bright as the one to its left. I'll number these 1, 2, 3, 4 and so on. Their relative brightnesses, using bulb 1 as reference, is 1, 2, 4, 8, 16, 32, and so on. Note that each brightness is twice that of the previous value—16 is twice 8, 32 is twice 16, and so on.

The reciprocity law indicates that in a negative produced by photographing this sequence of light bulbs, the density of the negative image of each light source is directly proportional to the intensity of the light source. We can illustrate this on a graph to make the relationship easier to see and understand.

If you were to double the exposure by increasing the exposure time or opening the lens one exposure step, this would have the effect of shifting the line *up* by one density unit for each bulb. If you were to reduce the exposure by one-fourth, the line shifts *down* by two density units.

Therefore, with a given developer used for a specific time and temperature, film density is directly proportional to exposure. More exposure gives more density. You'll see how to prove this in tests described in Chapter 6.

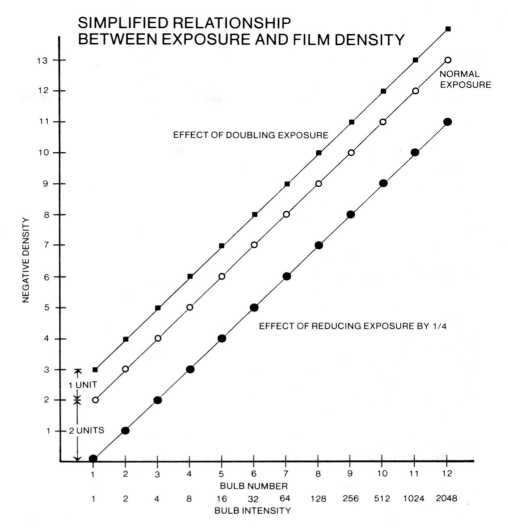

SIMPLIFIED RELATIONSHIP BETWEEN EXPOSURE AND FILM DENSITY

EXPOSURE AND FILM SPEED

When you photograph a scene, you must decide what is "good exposure." As mentioned earlier, good exposure gives a negative that records scene details that are easy to print.

In the example of the array of light bulbs, too little exposure may not record the faintest light bulb on the negative. This corresponds to *underexposure* of the scene—causing two or more bulbs to look equally dark.

Too much exposure records the faintest light source as an unnecessarily high density value. This corresponds to *overexposure*—

causing two or more bulbs to look equally bright. High negative densities increase printing time and grain, and sacrifice image sharpness. An overexposed negative is difficult to print well.

Basically, bad exposure sacrifices tonal separation. There is *one best exposure* for each scene! It is based on film speed and subject brightness. ISO film-speed values (ASA/DIN°) are determined by film manufacturers based on standardized testing. These represent *approximate* film speeds. The tests do not simulate normal photographic situations, so at best they are a guide to a "personal"

film speed, here called *exposure index (EI)*.

In this book, exposure index is based on a zone I exposure that yields a negative density of 0.1 above the density of *base-plus-fog (b+f)*. This is the density of a section of unexposed, developed film. Typical values for b+f are in the range of 0.1 to 0.3 density units. Whenever I refer to negative densities, the values will always be *corrected* for b+f by subtracting this constant value from the measured film density. For example, if the measured film density is 1.24 and b+f is 0.14, the corrected film density is 1.24−0.14=1.10.

For making fine b&w prints, it's essential to determine the exposure index for each film you use. Fortunately, this is easy to do. The procedure is described in detail in Chapter 5.

DEVELOPMENT AND FILM DENSITY

Suppose you photograph the array of light bulbs, using camera settings that give good exposure on three different sheets of film. Then you develop one for half the manufacturer's recommended development time, another for the recommended time, and the third for twice the recommended time. The *density range*—the difference between maximum and minimum density values—for each negative would vary considerably. A plot of density versus exposure would resemble the accompanying graph.

The graph shows that for a given exposure, negative density range increases as development time increases.

Negative Contrast—The contrast of a negative is defined as the ratio of the density range of a negative to the corresponding subject brightness range. By varying the development time for film, you can control the negative contrast.

To decrease the negative contrast, decrease the normal development time. To increase the contrast of a negative, do the opposite. Adjusting negative contrast by development is an effective and important control. Practical tests and applications of this subject are discussed in detail in Chapter 6.

MEASURING FILM DENSITIES

The key to determining accurate EIs and development times is measuring film densities. The easiest way to do this is with a *densitometer*. Basically, a densitometer is an exposure meter coupled to a standard light source.

A *transmission densitometer* is scaled to read negative density, so it measures light transmitted through film. A *reflectance densitometer* measures the reflectance

HOW DEVELOPMENT AFFECTS THE RELATIONSHIP BETWEEN EXPOSURE AND FILM DENSITY

from an opaque surface, such as a print.

A transmission densitometer is a valuable tool for the b&w photographer, so you should consider the possibility of purchasing one. You may be able to buy or order an inexpensive model suited to the serious amateur. Try your camera dealer.

If this is beyond your means, check with some local professional photographers, print shops, photo labs or schools with photography programs to see if they will let you

use their densitometers. If you have access to a densitometer, you can measure the densities of a 20-exposure roll of film in a few minutes.

ESTIMATING FILM DENSITIES WITH AN ENLARGER AND EXPOSURE METER

A simple yet surprisingly accurate way to measure negative densities is to use your enlarger and a handheld exposure meter. You can measure the light intensi-

With a transmission densitometer, you can measure negative density fast and accurately. This reasonably priced model is accurate in a density range from 0.0 to 3.0. It's powered by standard AC current and uses a CdS photoelectric cell. For the address of the nearest dealer that carries this product, write R.H. Products, 3212 Skycroft Dr., Minneapolis, MN 55418 (612-789-5622).

ty at the base of your enlarger with and without film inserted in the negative carrier. The *decrease* in light intensity caused by light absorption by the film is *directly related* to negative density.

You can estimate negative density by remembering that each unit decrease in the reading given by your exposure meter corresponds to halving the light intensity—transmission is half of the previous value. This is *equivalent* to inserting a 0.30 (ND) filter between the enlarging lens and your meter.

Therefore, by multiplying the *difference* in meter readings obtained by placing film in the negative carrier by 0.30, you get an approximate value of film density. The value is sufficiently accurate for you to do *all* of the tests described in this book.

To obtain accurate and reproducible results, you must standardize working procedures. The following procedure works well for me, but you may choose to modify it to accommodate your equipment. If you already have access to a transmission densitometer, you can skip this section and begin Chapter 4.

Setting Up—Set your enlarger to work in a diffusion mode by removing the condensers from the optical system. If your enlarger doesn't use condenser lenses above the enlarging head, you're one step ahead. Place your exposure meter on the enlarger baseboard with the meter's detector cell vertically below the enlarging lens, pointing up directly at the lens. A handheld large-area meter is easiest to use this way.

Mark the position of the meter on the baseboard because you want to make all of the readings from the same position, both now and later. To keep the meter in place, you may want to construct a simple clamp.

Lower the enlarger head so that the lens is about five inches above the exposure meter. Mark the enlarger column so you'll be able to duplicate this setting later. Place a white card at the height of the detector cell and focus the lens on that plane. Put a negative in the negative carrier for this step if you want, but critical focusing is not necessary.

Obtaining Calibration Data— With the enlarging lens set to its

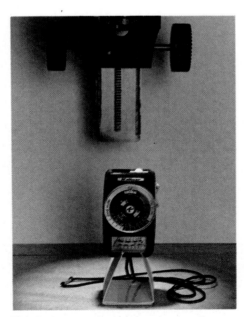

This is the setup I used to make density readings with an enlarger and an inexpensive exposure meter. The detector cell of the meter should be centered directly beneath the center of the enlarging lens. After placing the meter, tape the holder to the enlarger baseboard so it won't move during your measurements.

largest opening, turn off room lights and read the intensity of the light source as recorded on your meter.

Write down this value across from the lens *f*-stop. Then stop down the enlarger lens a full stop and take another reading. Continue this until you close the lens to its smallest opening.

You use the exposure-meter readout for density measurements, as described in the text. I illuminate the dial with a penlight to make a reading.

What you are doing is calibrating your exposure meter for *densitometry,* or density measuring. Closing the lens one full *f*-stop each time should result in a unit decrease in the meter reading. Even if it doesn't, that's OK.

The accompanying table lists a set of data that I obtained using a 150mm enlarging lens, a 4x5 enlarger in the diffusion mode, and an exposure meter that cost *less than $20.*

MY METER-CALIBRATION DATA USING AN ENLARGER		
Lens *f*-stop	Meter Reading	Relative Density
5.6	9.0	0.00
8	7.9	0.30
11	6.9	0.60
16	5.9	0.90
22	5.1	1.20
32	4.1	1.50
45	3.0	1.80

The data is plotted here, relating meter reading to relative density. The straight line indicates the accuracy of this calibration.

Using Calibration Data—To determine negative densities, insert a negative into the carrier without disturbing any enlarger settings. Set the lens to the largest opening and read the light value on your exposure meter. Multiply the difference between that value and the reading you get without a negative by 0.3. The result is the density of the film.

For example, with the above setup, enlarger lens set at *f*-5.6, a piece of film reduced the original meter reading (9.0) to 6.5. First find the difference:

$$9.0 - 6.5 = 2.5$$

Then multiply it by 0.3:

$$2.5 \times 0.3 = 0.75$$

Therefore, 0.75 is the density value of the film *uncorrected* for b+f. Notice that you can use *any* enlarger lens *f*-stop that you like—the principle and procedure you follow remain the same because all you need to determine is the *difference* in meter readings that occurs when a negative is placed in the carrier.

Or, you can use your calibration curve to find an uncorrected density value directly. Find the meter reading on the vertical axis and draw a horizontal line to the curve. Then draw a vertical line to the density axis and read off the uncorrected film density. To find b+f density for correcting these values, measure the density of an unexposed but developed piece of the same film.

A Sample Test—I photographed a gray card using a 35mm SLR, fully filling each frame with the image of the gray card. I varied exposures from four steps under the indicated meter reading to six steps over that value, using the ISO film speed suggested by the manufacturer as my exposure index (EI). I developed the film normally, according to the manufacturer's recommendation in a developer

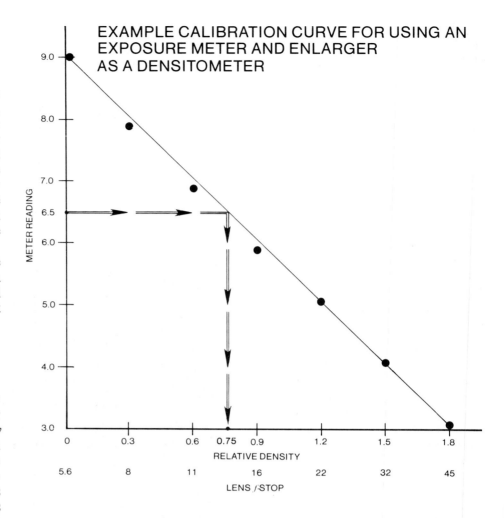

EXAMPLE CALIBRATION CURVE FOR USING AN EXPOSURE METER AND ENLARGER AS A DENSITOMETER

made by the film manufacturer.

Using an accurate densitometer, I then measured the density of each frame of this test roll and recorded the values. Then I inserted this roll of film in the negative carrier of my enlarger, set up as described for calibration. I recorded the exposure-meter reading for each frame along with densities measured with the densitometer.

Correlation between densities measured with a $20 meter and the $1000 densitometer were excellent, particularly in the critical region of negative densities from 0.0 to 1.5. The error in the worst case was only about 10%, well within the range required for practical applications.

After you have set up your enlarger, you can evaluate densities of a film strip in a few minutes. This procedure is much more accurate than visual techniques. It is also much more accurate and efficient than procedures requiring you to print film strips and compare print densities against known standards.

My method is simple, inexpensive, quick and a reliable alternative to using a densitometer. The necessary effort is not much when you consider that the results enable you to analyze the results of your exposure and development tests with confidence and reliability. This is an important step toward making fine b&w prints.

4

Meters & Metering

Careful metering and scene interpretation are the cornerstones of the Zone System. You base exposure and processing conditions on these two important factors.

Photographic light meters measure luminance and give a readout that you convert to exposure-control settings for the camera. The readout of some meters is a number. On this numerical scale, a difference of one unit represents one exposure step. Typically, you transfer this number to a calculator dial or scale that gives you different combinations of *f*-stop and aperture, all of which give the same exposure. With most camera meters, you turn either the aperture ring or shutter-speed control to make the meter's visual display indicate correct exposure.

The type of meter you use greatly affects how much you can control exposure. Whether you use large-format, medium-format or 35mm cameras, the most practical meter for zone-system work is a *handheld spot meter.* Even so, this chapter explains various kinds of meters and their applicability to Zone-System work.

HOW METERS WORK

The light-sensitive part of a light meter "sees" the luminance of a certain area. Light in this area is averaged by the light-sensitive *photocell* and electronically translated into a usable form of readout. From this readout you get exposure-control settings. The

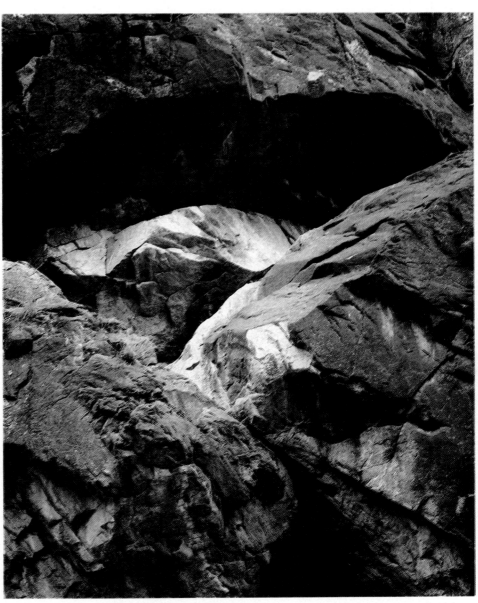

Careful metering is essential to get the picture you want. You want the resultant tonal values to contribute to the composition's impact.

The brightness range of this scene was only three steps, which was measured with a spot meter. I based exposure on a zone V value for the midtone and expanded the density range by doubling normal development time, giving N+2 development in this case. Some dodging and burning during printing emphasized light and dark tones in the final print.

major differences among light meters are the size of the metered area and whether they measure *incident* or *reflected* light.

INCIDENT-LIGHT METER

This type of accessory handheld meter measures the light illuminating the subject. You can recognize an incident meter by the white hemispherical dome covering the meter's photocell. This dome averages the light striking it in such a way that the exposure-control settings it recommends are the *same* as taking a reflected reading from an area of 18% reflectance, zone V.

Typically, you meter the light at subject position by holding the meter near the subject and pointing the dome at the light source or the camera. This makes the exposure reading *independent* of subject reflectivity. For example, the incident reading for a predominantly white subject will be the same as the reading for a predominantly black subject—if they are in the same light.

Incident-light meters are ideal for measuring light in a scene when there is more than one light source. This makes them useful for studio setups in which the effect of a picture, such as a portrait, depends on the relative amounts of light in the bright areas and shadow areas. The difference in steps is a measure of *lighting ratio*.

REFLECTED-LIGHT METER

This type of meter sees light reflected from the subject. The meter's photocell averages the light it sees and gives a readout. Light meters used in medium-format and 35mm cameras are reflected-light meters.

The zone value of an element in a scene depends on the amount of light striking it *and* the reflectivity of the element. For this reason, reflected-light measurement is best for Zone-System work. It includes the interaction between object and light, which is what you are photographing.

Many different kinds of reflected-light meters are available, but not all are practical for careful Zone-System metering. Generally, reflected-light meters

This drawing represents the center-weighted metering pattern for the Canon F-1 35mm SLR. It has maximum sensitivity in the center, with progressively less sensitivity in zones farther from center. With this camera, you can select the metering pattern you want by selecting different focusing screens!

that see small areas are best. You can determine the luminance, or zone value, of a small, evenly-toned area. Large-area meters will usually see more than one zone value.

LARGE-AREA REFLECTED-LIGHT METERS

This category of reflected-light meters includes both camera meters and handheld accessory meters. I do not recommend these for Zone-System metering. The following discussion tells why.

Camera Meters—A typical camera meter sees the same angle of view as the lens. Some meters average all of the light in this area equally. The light in the corner of the field of view is measured with the same sensitivity as light in the center. This is *full-frame averaging.*

Other camera meters are *center-weighted*—most of the meter sensitivity is at the central part of the image, with sensitivity decreasing farther from the center. This makes sense because most photographers put the most important subject elements in the central part of the frame. For example, bright areas of sky above the central part of the image will not

The Minolta Auto Meter III is a digital incident-light meter that can store two readings for conveneient comparison. In addition, it can be used with a variety of accessories for reflected-light metering. Shown here is an accessory spot-metering attachment. It narrows the meter's field of view to about 10°.

The Calcu-Light-XP works as an incident- or reflected-light meter. When you add the SX-1 spot-metering accessory, you limit the field of view for reflected-light metering to 10°.

affect the meter reading as much as the elements below the sky.

Handheld Meters—This kind of reflected meter acts as a full-frame averaging type and typically sees a 30° angle of view. This is about the same as seen by an 85mm lens for the 35mm format. If you use other lenses, what the meter sees and measures will not be the same as what you see through the lens. At times, this can lead to exposure problems.

For example, when you use a telephoto lens, you isolate a small fraction of the scene. If the section that you isolate with your lens is lighter or darker than the overall scene, an exposure error will occur. A large-area reflected-light meter averages the luminance of all parts of the scene "seen" by the meter. You and your camera lens may choose a part of the scene that differs from the average.

With a wide-angle lens, the problem is similar but opposite in character. Your camera lens will cover a wider area than the meter. You must be certain that no important bright or dark regions are omitted from the area to be photographed while you're metering.

A frequent problem that users of large-area reflected-light meters encounter is consistent under-exposure of outdoor scenes. This happens because the sky is generally several zones brighter than the foreground. If you hold the meter level or pointed slightly upward, your meter will give you a reading that is too high. The foreground will be underexposed.

To avoid this problem, point the meter down at about a 45° angle. Take a light reading of just the foreground. Place the foreground on the zone you determine is correct and set the camera controls from this reading.

Some large-area meters accept accessories that make them operate as incident light meters. Other accessories narrow the angle of view for spot-meter operation.

Problems With These Meters—A reflected-light meter is calibrated to assume that the reflected light

The brightness range of this scene was not extreme because the shadowed area was very bright. Therefore, I knew that film exposed and developed normally would record all important detail. I used a reflected-light meter to measure just the door. I did this by moving up close to it. I used the recommended exposure-control settings—which is the same as saying I placed it on Zone V. For this scene I could have also metered a gray card in the shade or used an incident meter in the shade.

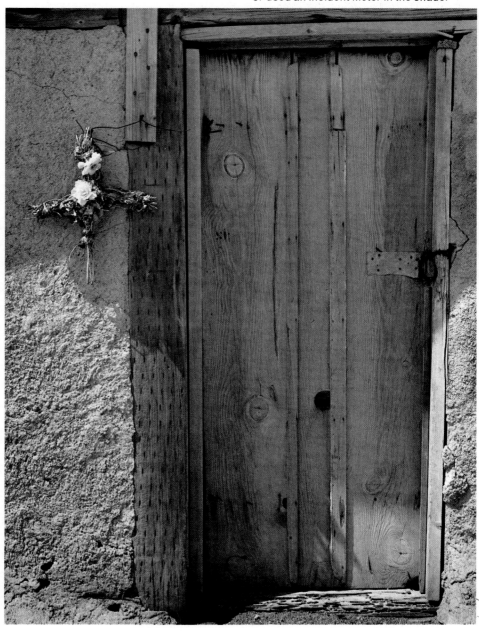

averaged is a zone V midtone. It gives exposure recommendations that reproduce that tone as a middle gray on film. For a typical indoor or outdoor scene with a brightness range of about seven steps between detailed shadow (zone II) and textured highlight (zone VIII), this kind of average reading will give good results. But only if there are approximately equal amounts of light and dark areas in the scene. This is called an *average scene.*

However, many scenes are not average. Using a large-area reflected meter with these can lead to bad exposures. For example, if you made an average reading of a predominantly white scene, such as a person dressed in white in front of a white wall, the meter will recommend an exposure that reproduces the scene as a zone V midtone. The scene is effectively underexposed.

Conversely, metering a predom-inantly dark scene, such as a black cat in a coal bin, yields a negative that produces the scene as a zone V midtone. The negative is overexposed.

You can still enlarge the negatives to make prints that nearly match the original scene brightnesses. However, the exposure error in each case leads to a significant sacrifice in print quality. A correctly exposed negative always yields best print quality.

One way to overcome this limitation of a large-area reflected-light meter is to *interpret* the scene's average luminance. If you want the average luminance of the area the meter sees to reproduce brighter than a zone V on the print, give the film *more* exposure than the meter recommends. This compensation is usually between one and three steps.

If you want the average luminance of the area the meter sees to reproduce darker than a zone V in the print, give the film less exposure than recommended—usually between one and two steps. However, in either case, you can't be sure of exactly *how much* exposure compensation is best. Bracketing in half-step increments can help a bit here, but it does not give you the control you should have to make a fine b&w print of a non-average scene.

Substitute Metering—One way to deal with non-average scenes and large area meters is to meter an object of known reflectivity. Use that value to calculate your exposure setting.

A Kodak gray card reflects 18% of the incident light, which is the same as zone V on the gray scale. To use it, place the card in the same light as the scene you are photographing. Angle the card to avoid glare or shadows. Meter the card with your exposure meter.

The meter then recommends correct exposure settings to repro-

When in the field, metering an 18% gray card with a large-area meter (left) will place midtone subjects on midtone densities in the negative. It works well when photographing average scenes. If you don't have a gray card, you can always meter the palm of your hand (right). Calibrate your skin tone by comparing the readings from a gray card to that from your hand. Typically, the palm of your hand reflects 36% of incident light, making it a good zone VI placement.

METERING, PLACEMENT AND DEVELOPMENT

This chapel illustrates the kind of problems you can encounter if you use your exposure meter without thinking. The composition is dominated by a brilliant white-washed facade. An "average" meter reading will assume that the overall brightness range averages to a normal midtone gray and will recommend settings that reproduce it that way. In this case, the meter suggested an exposure about 2-1/2 steps less than appropriate! Normal development and printing yielded the print at right. It is muddy and lacks detail in the shaded interior of the chapel.

Placing a meter reading gives a better photo of this non-average scene. I metered the white surface and placed it on zone VIII—exposing for three steps more than the meter recommended. With normal development, the negative yielded the print below left. It has more natural b&w tones. However, the brightness of this scene is about eight zones if you measure the lit facade and the shaded interior. Film exposed and developed normally can't record details in both areas, so the interior reproduces black.

To reproduce details in the shaded area, I placed the meter reading of the facade on zone X and reduced development time for N−2 development. This reduced the negative's density range, so interior details are visible. The resultant print is below right. Each of these prints received the same exposure and processing. The differences you see are due to different negative treatments.

Either of the last two photos is acceptable, depending on what is important. But, if I wanted to make a print of this subject showing good detail both inside and outside, I would have lit the interior to brighten it, thereby reducing the scene brightness range.

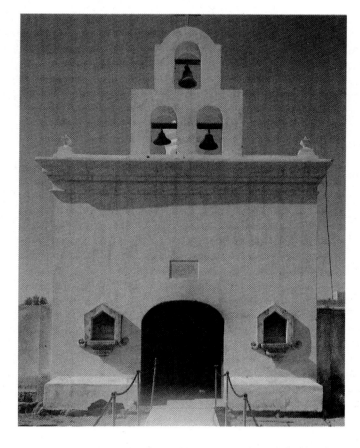

duce *midtone values* properly. However, if the scene you are photographing has an excessively long or short brightness range, you may find that the negative will not enable you to produce the expressive print you envisioned.

If a gray card is not available, you can use other "zone V" subjects such as green grass. Or, use the palm of your hand as a metering guide. Light Caucasian skin has a reflectance of about 36% and would normally be placed on zone VI. Darker skin may be more closely approximated by zone IV or V. Calibrate the palm of your hand by metering a gray card and then your hand in the same light. Remember the difference—about one step for light skin—and you'll always have a portable "gray card" with you.

Substitute metering gives essentially the same result as using an incident-light meter. It too recommends exposure-control settings that reproduce midtones as midtones on film.

The most control you have with a large-area reflected meter or incident meter is placement of zone values relative to the midtone, zone V. This can give satisfactory results *provided* no important subject areas fall outside the brightness range the film can record with normal development—about seven steps.

Unless you move in very close and meter just one part of the scene, you cannot isolate the reflectivity of different elements of the scene. You can't determine the brightness range of the scene. This prevents you from using development-time control to decrease or increase negative contrast, as first described in Chapter 1.

Generally, the best way to compensate for this limitation is in the darkroom. You can *intensify* or *reduce* the negative or print. You can use a higher- or lower-than-normal grade of printing paper and do selective dodging and burning of the image. These

controls are described in Chapters 7 and 11. All are important and useful. However, they make printing more laborious than it is with a carefully exposed and developed negative.

Working this way uses only *half* of the potential control the Zone System offers. These meters will usually get you in the right ballpark, but they won't get you into the ballgame where the action is.

By design, they work best with "averages." But fine photographs *are not* average! If you plan to use one of these meters for Zone-System work—something I don't recommend—you must be aware of their limitations. Basically, these are lack of precise exposure control, lack of careful zone placement, and an unpredictability of end results. There is a better way.

SPOT METERS

A spot meter is a reflected-light meter that sees a very small part of the scene. Some large-area reflected light meters can be used with a spot-metering accessory that limits the angle of view to about 10°. The accessory has an optical system that allows you to see the metered part of the scene.

A spot-type meter is available with some cameras. For example, the Canon F-1 35mm SLR offers two different spot-metering patterns. One sees a central rectangle in the field of view that corresponds to 12% of the picture frame. The other sees 3% of the scene, as represented by a circle inscribed on the focusing screen. An accessory metering viewfinder for Mamiya RB67 Pro-S and RZ67

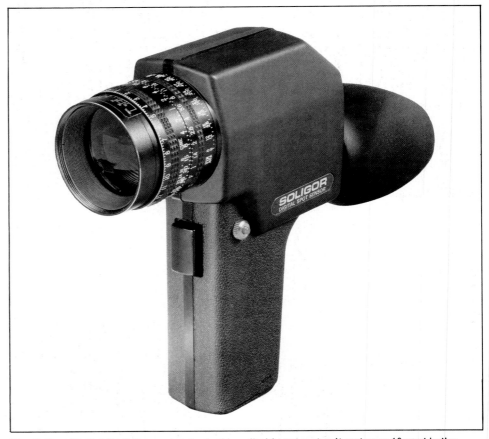

The Soligor Digital Spot Sensor is a typical handheld spot meter. It meters a 1° spot in the center of the scene you see through the lens. It uses a silicon photocell and gives a digital LED readout. You transfer the reading to the calculator scale on the lens to get exposure-control settings. Spot meters are also made by Bewi, Minolta, Pentax and others.

The spot-metering focusing screen for the 35mm Canon F-1 limits the metering pattern to a 3% area of the focusing screen, as determined by the center circle.

If you want to meter a larger area—in this case 12% of the scene in view—with the Canon F-1, use the Selective-Area focusing screen. It limits the pattern to the central rectangle.

With the metering pentaprism finder for the Mamiya RZ67 Professional SLR, you can select a full-frame averaging or spot-metering pattern. The center spot on the focusing screen represents the 6° spot-metering area. Because the RZ67 gives a 6x7 cm image, this illustration is not enlarged to the same scale as the above screens.

Professional medium-format cameras reads a small central spot. A similar metering viewfinder is also available for the Mamiya TLR system.

An accessory handheld spot meter has a lens and an eyepiece you look through to see a field of view of about 30°. The meter reads a small part of the scene, typically 1° to 5°, as shown by a small circle on the viewing screen.

The light falling on this small area is averaged, then the meter displays a number readout, also visible in the viewfinder. You transfer this number to a scale on the meter to get exposure-control settings.

I strongly recommend that you use a handheld accessory spot meter for best results with the

This is the focusing screen for the Pentax spot meter. The center circle represents the 1° metering area.

Zone System. With one, you can meter a small, consistently toned part of the scene, such as a door-knob instead of the whole door, frame and doormat. And, you can usually do this without moving from camera position.

Photographs of common objects—such as this bedspread—can be lovely. Look carefully around you. Everyday texture and shadows are interesting subjects to photograph. For this photo, I used a handheld spot meter to measure the brightness of the lightest part of the spread and placed it zone VII. I developed the negative normally and didn't need any special controls to print it.

SPOT METERING FOR THE ZONE SYSTEM

The range of luminance values in a scene, the brightness range, is the *critical measurement* you make with a spot meter. The key to successful exposure control is to determine what exposure setting will record all of the important subject detail on the film when it is developed in a certain way. The second part of the process, discussed later, is determining what development conditions will produce a negative that records all of this information and can be easily printed.

Remember that general-purpose b&w film developed "normally" can record (for b&w printing purposes) a seven-step SBR. In the terminology of the Zone System, this corresponds to a range of seven zones.

The readout scale of most spot meters is usually from 0 to 20, although this varies with respect to the sensitivity of various models. Some meters actually give a readout in exposure-value (EV) numbers.

For example, suppose you measure an area of textured shadow (zone II) and get a readout of 10. Then you meter an area of textured highlight (zone VIII) and get a readout of 16. The range of these readouts—10 to 16 inclusive, or 7—is the brightness range. In this case, a brightness range of 7 means the scene is average.

The next step is to determine exposure-control settings. When you place zone values properly during exposure and then develop the film normally, the film records all of the scene brightnesses you consider important, from zone II to zone VIII.

After determining the brightness range, you can find an exposure setting for the camera in many ways. Notice that in each case, exposure is based on the midtone, zone V. This is because all meters are calibrated to recommend settings that reproduce the light as a zone V midtone. Each method described here gives the same result:

1) Meter an 18% gray card (zone V).

2) Meter your 36% palm (zone VI) and set the camera for *one more* step of exposure.

3) Give two *less* steps of exposure than the meter recommends for zone III.

For this scene, the brightness range between textured shadow (Zone II) and detailed highlight (Zone VIII) is seven steps. The scene is average.

4) Give three steps *more* exposure than the meter recommends for zone VIII.

In each case, you are *placing* a zone to reproduce it a certain way. When you do this, all other values automatically *fall* in zones above or below that value, corresponding to the difference in luminance value. As I'll show you later in Chapter 6, it's possible to expand or contract these differences by controlling negative development.

Non-Average SBRs—Placing zones is a little more difficult to understand when you are dealing with a scene with a brightness range either shorter or longer than seven steps.

For example, suppose you measure a brightness range of another scene. A shaded area has a reading of 11, and a white surface has a reading of 17. A gray-card reading gives a readout of 15. The SBR is 11 to 17 inclusive, giving seven steps. This range falls within the capabilities of the film developed normally. The next thing to do is determine exposure.

Should you transfer 15 to the meter's calculator dial and use the recommended exposure settings? Should you average the dark and bright readout $((17+11)/2 = 14)$ and transfer 14 to the calculator dial? Should you use another setting? The answer depends on how you want to interpret the scene in the print.

Recall that zone I is the first step above base plus fog, and in a b&w print it becomes a textureless black. In this case, if your zone V exposure is based on a calculator dial readout of 15, the white surface (17) will be clearly defined (zone VII), and the shadow area (11) will be a black zone I. If this is the effect that you want in the print, use the exposure setting recommended with a meter reading of 15.

On the other hand, if the shaded area contains textures that you believe are important and need to be visible in the print, a zone II rendering of the shadow areas is better than zone I. Do this by increasing exposure one step relative to the gray-card reading. Now the gray-card falls in zone VI and the white surface in zone VIII. As a result, detail that you gain in

In this *high-key* photo of salt mounds at Mono Lake in California, all important tonal values fall above zone V. Metering the whole scene with a large-area reflected-light meter without considering proper tonal values for the subject would lead you to underexpose the film by two or three steps. By using a spot meter, I could measure the brightness range and place a textured-highlight area in the appropriate zone. The print was made from a 4x5 negative made with Polaroid Type 55 positive/negative film, described in Chapter 12.

the darker areas *may* be offset by some loss of detail in the highlights.

Another alternative is to increase the exposure by two steps relative to the gray-card reading. The shaded area will now show the clearly defined features associated with zone III, the gray card will fall on zone VII, and the white area will be a brilliant, textureless surface, zone IX.

The scene brightness range remains a constant in each of these examples. Their placement can be altered according to your exposure preference. This shows what exposure control alone can do for the way the scene looks in the final print.

An Example Of Zone Placement—The illustrations show a sequence of photographs of a target containing a Kodak Neutral Gray Test Card and a 19-step gray scale. The gray scale corresponds to an average brightness range.

An exposure setting based on metering the 18% gray-card yielded a negative. It was printed to reproduce the gray card density as closely as possible. The gray scale in this print was reproduced in its entirety, example A. Examples B and C demonstrate the effect of overexposing and underexposing the negative by two steps respectively. I printed each negative with the same settings used with A.

Notice that the gray card in B now falls on zone VII; in C it falls on zone III. In B, the dark portions of the gray scale are clearly distinguishable. The lighter grays have merged to white due to the extra exposure. In C, the dark portions of the gray scale have merged—corresponding to loss of shadow detail. But the lighter steps are clearly distinguishable, though depressed in brightness value. Both results are due to underexposing the negative relative to the gray-card reading.

I made example D by increasing the printing time of negative B so that the gray-card image matched zone V. The gray scale again appears in its entirety, but a critical examination of the print indicates that some perceptible changes occurred. Overexposure increased the grain slightly and decreased image sharpness. These details are somewhat lost in the reproduction process used to print this book. They are visible in the actual print. Bigger enlargement of the negative would accentuate this even more.

Example E is a print from negative C that was made by decreasing the enlarging time so the test card

again matched zone V. Note that in this case, while the highlight values fall in their expected zones, the darker values of gray have not been recorded on the negative. This corresponds to a loss of shadow detail. Darker tones have merged to black.

There is an important lesson to be learned from these prints—if you are uncertain about exposure, it is better to err on the side of *slight* overexposure rather than underexposure. If an important detail is not recorded on the negative, it cannot appear in the print. There *are* penalties associated with overexposure—an increase in grain and a potential loss of highlight detail and image sharpness.

With a little thought and practice with your exposure meter, correct exposures become a matter of simple routine. A few moments of careful metering can save hours in the darkroom later.

EXPOSURE RECORD

A useful aid to help you understand and apply the Zone System is a careful record of key data for

each scene that you photograph. A detailed record lets you compare results that differ from your expectations. You should be able to pinpoint the problem by referring to the exposure record.

A complete exposure record should have a brief description of the subject, the exposure or frame number, the lens used, the filter and filter factor, the aperture and shutter speed and, finally, meter readouts and zone placements of important elements of the picture. An exposure record that I find useful is shown here. Photocopy it or make your own. Special lighting conditions, film and development data can be recorded in the heading under *Comments*.

As is often the case, procedures are easier to do than to explain. Spend an hour in your neighborhood evaluating scenes. Take average light readings and spot readings. Make exposure decisions in a variety of lighting situations. Deliberately over- and underexposing negatives from the norm will quickly drive home these principles. I urge you to reread this chapter until you understand it thoroughly.

EXPOSURE RECORD

Film: _____ EI: _____

Subject: _____

Location: _____

Date: _____

Time: _____

Weather: _____

Gray-Card Meter Reading: _____

Basic Exposure: *f*-stop _____

 speed _____

Filter(s): _____

Filter Factor: _____

Adjusted Exposure: *f*-stop _____

 speed _____

Comments: _____

Zone	Subject Area	Meter Value
I		
II		
III		
IV		
V		
VI		
VII		
VIII		
IX		
X		
XI		
XII		

How to use THE ZONE SYSTEM FOR FINE B&W PHOTOGRAPHY, HPBooks

5

Film Characteristics & Measuring Film Speed

To increase the impression of the thorny, impenetrable nature of this Prickly Pear cactus, I made a double exposure. I metered the whole scene with a large-area reflected-light meter and used the indicated reading for a zone V exposure setting. After making the first exposure, I rotated the back on my view camera 180° and re-exposed the negative, using the same settings.

Essentially, this overexposed the film by one step. But because I was exposing sheet film, the extra exposure did not lead to deleterious image quality. The negative was developed normally and printed on a normal grade paper. With double exposures, Polaroid film is useful because you can make trial exposures to test various compositions until you find exactly what you are looking for in the print.

The negative is the basic record you use to make a b&w print. The information on the negative provides all that you can produce in the b&w print. For example, if the negative does not resolve fine detail adequately, no amount of darkroom manipulation can give the resolution you want. If your negative is grainy, the print will show that grain.

The characteristics of any negative are determined by the basic properties of the film you use. Some fundamental film properties are *speed, grain size, resolution, inherent contrast,* and *color sensitivity.* These differ for every brand and type of film.

How you expose and develop the film are also important. Tests in this chapter will show you how to determine film speed for any combination of film, developer, camera and exposure meter.

Each of the film properties mentioned represents a *limiting characteristic* of the film. You should learn these characteristics for each type of film that you use. A limiting characteristic represents a theoretical boundary beyond which you cannot go. For example, the resolution of fine detail is limited by the size of the developed silver grains in the film. Just as a very coarse screen cannot separate fine grains of sand according to their relative size, a coarse-grained film cannot resolve very closely spaced, fine lines.

By understanding the effect of each limiting characteristic, you can choose a film that will produce a negative capable of recording a scene as you previsualize it.

FILM SPEED

B&W photographic films use an

emulsion of light-sensitive silver halides and sensitizing dyes coated on a dimensionally stable plastic base. Films differ because emulsions are formulated and manufactured with different components and by different methods. This is why there is a variety of film speeds and film characteristics.

When silver halides are struck by light of sufficient brightness, a complex physical change occurs. *Film speed* is a measure of the minimum amount of light necessary to create this change. Therefore, film speed is based on reproducing dark zones on film. As I described earlier, film speed is a measure of the exposure necessary to produce a film density of 0.10 units above b+f, using the film manufacturer's recommended development conditions.

Currently, manufacturers report film speeds as ISO values. These numbers are a combination of ASA and DIN values. For example, an ASA 400 (DIN 27) film is now rated as ISO 400/27°.

With both the ASA and DIN systems, the smaller the number, the slower the film, and the more light is necessary to expose the film. Fast films require less light for correct exposure.

ASA values are based on a geometric scale so that every time the ASA rating doubles, film speed doubles. The DIN system is an arithmetic scale—an increase of three units indicates a doubling of film speed. The two systems agree at a rating of 12.

Many cameras and meters have both ASA and DIN scales. I'll refer only to ASA values because they correlate more logically with aperture and shutter-speed settings on cameras. For example, a change of one *f*-stop doubles or halves the amount of light passing through a lens. And, each change of standard shutter-speeds doubles or halves exposure time.

ASA film speeds are determined in laboratory conditions with highly specialized sensitometric procedures and equipment. These

FILM-SPEED RATINGS	
Category	ISO Film Speeds
Slow	12/12° 25/15° 50/18°
Medium	100/21° 125/22° 160/23° 200/24°
Fast	320/26° 400/27° 800/30° 1600/33°

tests resemble actual photographic conditions only remotely, making the film speeds only approximate values in real-life situations.

This happens because our photographic equipment is less than ideal. Shutter speeds are not always precise and aperture settings may be imperfect. Internal lens reflections will reduce light transmission through lenses, light meters may be imprecise, and so on. Each variable affects negative exposure.

As a result, you should determine a working film speed for each camera, film and developer combination that you use. This personal, user-determined speed is the *Exposure Index* (EI). It's based on the ASA numbering system. A simple test for determining EI is described later in this chapter.

GRAIN SIZE

The "graininess" of a film is directly related to film speed. It is also influenced by development. Generally, the slower the film speed, the finer the grain. Faster films appear grainier.

A fine-grain film has smaller and more silver-halide particles per unit area than a coarse-grain film. Chemical reduction occurs if a silver halide grain is struck by a pulse of light of sufficient intensity to "activate" the grain. Because fine-grain films have more particles for the same unit area, more light is needed to activate them. Because more light is needed, film speed is slower.

Magnification—Grain is an important concern when a high degree of enlargement is required. This is usually most critical with 35mm negatives. For example, an 8x10 print from a 4x5 negative requires only a 2X enlargement. But you have to enlarge a 35mm negative about 7X to make an 8x10 print. This makes grain more apparent in the print.

Apparent graininess in a print is a subjective matter. Some people can tolerate more than others. Grain is most apparent in the midtone regions, where there are broad, uniform expanses of gray, such as a clear north sky. It tends to get hidden in the highlight areas and is absent in the shadow regions. Grain is also camouflaged by structural detail and texture.

Too much grain obscures fine

The faster the film, the larger the silver-halide grains (above). In addition, there is a wider distribution of sizes. Slow-speed film has smaller silver-halide grains (below) and a smaller range of grain sizes too. Magnification about 3000X. Photos courtesy of Eastman Kodak Co.

details in a print and reduces resolution. Tonal variation, especially in midtone regions, will not be as smooth as in a print made with a less grainy negative. When you take a photograph, grain and film speed are trade-offs you must consider. If you need a fast film, you must be prepared to accept a "grainy" print. If you want a print that shows less grain, you have to use a slower film, enlarge the negative less, or both.

Exposure—A major factor influencing apparent graininess is exposure. The more exposure a film receives, the greater the concentration of clumps of silver halides per unit area that are exposed. As a result, an enlarged mid-gray zone that has been overexposed—for example, a zone V exposed to become zone VII—and *printed down*—printed to zone V by increasing the exposure time during enlargement—shows more grain than a negative exposed and printed for zone V. This is why best image quality results from the *minimum* exposure necessary to record detail on film.

Modern b&w films can be overexposed and still yield a good image, but you'll get the best-looking print if the negative is not overexposed. This is why knowing a film's EI and exposing carefully are important.

Development—Grain is also influenced by development conditions and the type of developer you use. For example, you can use a fine-grain developer to minimize apparent graininess, but typically this is at the expense of some film speed. Developer types and development are discussed in more detail in Chapter 7.

RESOLUTION

As the word implies, *resolution* is a measure of a film's ability to record and separate fine detail in subject matter. This property is related to the grain size of a film, and the characteristic parallels film speed. Generally, slower films

The apparent graininess in the print greatly depends on the film and developer you use. The degree of magnificaion is important too. The above print was made from a 35mm Agfapan 100 negative developed in Kodak Microdol-X. The print below was made from an Ilford HP5 negative (ASA 400) developed in Rodinal, which is not a fine-grain developer.

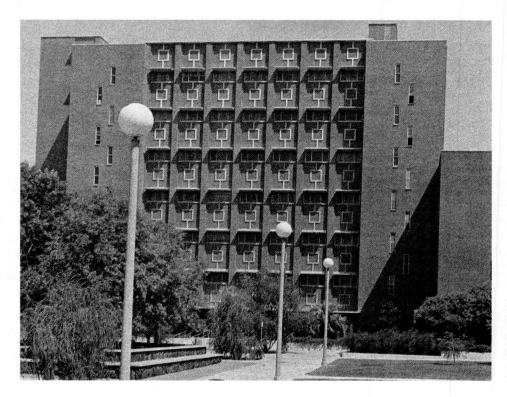

have greater resolution, or *resolving power.*

Resolution is also diminished by overexposure. Most modern films have much thinner emulsions than their predecessors and, as a consequence, their resolving power has improved markedly.

Thick emulsions cause light to scatter as it penetrates. This light spreading reduces the resolution capability of the film.

Measuring Resolution—It is measured under laboratory conditions. A standard test target consisting of a geometric array of lines of known spacing is photographed. When the image is magnified, an observer selects the least discernible line pattern. The spacing of this pattern is a measure of resolution, which is reported in line pairs per millimeter (lines/mm).

Eastman Kodak reports these ratings for the categories they use to describe the resolving power of their film. See the accompanying table.

Acutance—This is a property related to the apparent resolution of a film. It is a measure of the contrast of the negative in areas with sharply defined boundaries between dark and light. Unlike grain and resolution, which are relatively independent of the type of film developer you use, acutance is very sensitive to the chemical properties of the developer and the type of agitation you use during development.

In a b&w print, high actuance in the negative appears as image sharpness. Lines are crisply defined. A negative with low acutance gives a print that is slightly "mushy" in terms of definition, even though the camera was correctly focused and held steady during exposure. Acutance also exaggerates grain, so high-acutance developers should be used only with slow-speed, fine-grain films.

HOW FILM RESOLUTION IS LABELED	
Name	Resolution (lines/mm)
Low	less than 70
Medium	70-90
High	96-135
Very High	136-225
Extremely High	226-600
Ultra High	Greater than 600

This is a highly magnified section of a print made from a negative with low acutance. Notice how tones merge smoothly, similar to the tonal gradation shown above.

This section is from a print made from a negative with high-acutance. In addition to the obvious contrast difference in the two prints, you can also see a sharpness difference in border areas of dark and light tones. Look at the railing on the left side to see the affect of acutance—a "crisper-looking" print. The above tonal gradation illustrates what happens at border areas of high and low density.

NEGATIVE CONTRAST

As defined earlier, the contrast of a negative is the ratio of the density range (DR) of the negative to the corresponding subject brightness range (SBR) of the subject, DR/SBR.

Contrast is a function of the film type used, the type and temperature of the developer, development time and the agitation method. Generally, constant agitation, high temperatures and long development times increase negative contrast because these factors increase negative density range. As you'll see in Chapter 7, high-energy developers produce more negative contrast than low-energy developers.

In addition to negative contrast affected by these factors, each film has an *inherent contrast*. For example, a scene photographed on Kodak Panatomic-X and Tri-X films and developed for the same time will have more contrast on the slower film, Panatomic-X.

In general, slower films will have greater inherent contrast than faster films. (An example of this is on page 40.) One reason for

this is that fine-grain films have a narrow and uniform range of silver-halide particle sizes. Fast films have a broader range of silver-halide particle sizes in the emulsion. As a consequence, the probability of exposure of a single grain is different with slow and fast film.

On fine-grain film, a grain is either exposed or not—therefore, developed or not. With fast film, the variety of grain sizes increases the probability that some grains in an illuminated area of the film will be struck by light and at least partially developed. This reduces the contrast of the negative relative to the slow film.

A second reason for the higher inherent contrast of slow films is that emulsions are thinner. Relatively more surface area of exposed silver halide grain is presented to the developer. As a consequence, development proceeds more rapidly and completely for a given period of time, yielding greater contrast.

Using Inherent Film Contrast— The inherent contrast of a b&w film is a useful control to consider when you photograph a non-average scene. For example, if you are photographing a subject with a short SBR, you may want to increase the density range of the negative beyond the normal range. It's best to use a slow-speed film and increase normal development time. Slow films respond to this kind of development control more readily than fast films.

Conversely, it is easier to reduce the contrast of a negative by using a high-speed film and reducing development time. It *is* possible to increase or decrease the contrast of *any* b&w negative, but development times can become inconveniently long or short, possibly contributing to other image problems. This topic is discussed in greater detail in Chapter 6.

CHARACTERISTIC CURVE

A good way to summarize a film's response to exposure and development is to plot a graph of subject brightness range (SBR) vs. density range (DR). This graph is called the *characteristic curve*. A typical generalized curve is shown here. The horizontal axis represents subject brightness, or zones. The vertical axis represents negative density. By now you know how to measure both.

The characteristic curve consists of three parts—the *toe,* the *straight-line portion* and the *shoulder.* All b&w films have the same general S-shaped feature, but the relative size of the segments vary.

The Toe—This portion of the curve represents the shadow area of the subject, zones 0 to II or III, though with some long-toe films this can extend to zone IV.

Contrast is the steepness, or slope, of the curve at any point. The steeper the curve, the higher the contrast in that region. Negative contrast in the toe is lower than the straight-line section. This implies that more exposure at low-light levels results in less film density increase than in the straight-line section.

Similarly, in the shoulder region of the curve, an increase in

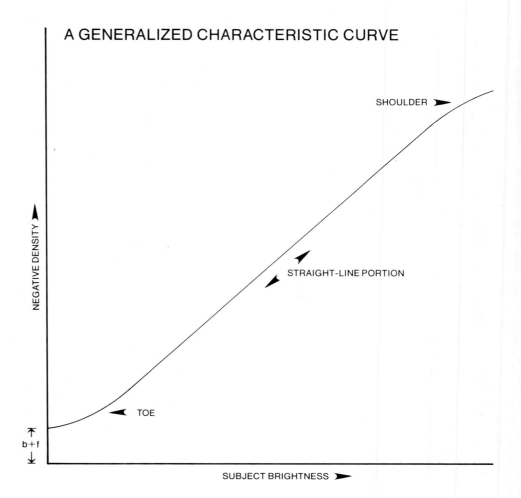

A GENERALIZED CHARACTERISTIC CURVE

NEGATIVE DENSITY ▲

SHOULDER ➤

STRAIGHT-LINE PORTION

TOE

b+f

SUBJECT BRIGHTNESS ➤

light intensity does not generate a proportional increase in film density. As a practical matter with modern b&w films, the shoulder portion of the curve is never reached under normal conditions.

The Straight-Line Portion—This segment of the curve generally contains zones III or IV through zone IX or more. It is in this region that a *linear* correspondence exists between zones and image density.

The steepness of the curve is a function of the inherent contrast of the film and the development conditions you use. The steepness, or *slope,* of the straight-line portion of the curve is defined by the equation:

$$slope = DR/SBR$$

For most photographic work, a negative with a slope of about 0.5 prints well on a middle-grade paper. The measurement of slope is of no practical use to the working photographer, because it excludes important zones in the toe and shoulder. Even so, it is often mentioned in photographic literature, so you should understand what it means. Basically, the higher the value of slope, the greater the negative contrast.

More recently, a new measure of contrast, *contrast index* (CI), has been introduced. This is similar to the slope value except that it includes the useful portion of the toe of the characteristic curve.

Controlling negative contrast through development is the single most powerful tool available to you in b&w photography because it provides you with an opportunity to impose your own creativity on a scene. In Chapter 6, I discuss this subject in detail.

DETERMINING EXPOSURE INDEX (EI)

For this test, you'll need the stuff listed in the accompanying table. If you are using a 35mm or medium-format roll film camera,

the following procedure works well.

ROLL-FILM METHOD

Load your camera with a roll of film and set either your camera meter or your handheld exposure meter to the ISO speed reported by the film manufacturer. Use the meter that you'll subsequently use in real-life shooting. Place the gray card in even, diffused light such as you would find in open shade. Mount your camera on a tripod and position the camera so the gray-card image fills the entire viewing screen.

Exposing For Zones—Set the lens to its smallest aperture (largest *f*-number) and use your meter to determine the appropriate shutter speed for a zone V exposure at that *f*-stop. If you're using an automatic-exposure camera, use the meter manually.

To avoid reciprocity failure, photograph in light bright enough to keep shutter speeds between 1/2 and 1/1000 second. When you have determined the shutter speed, expose the first frame using that setting. This frame will serve as a marker on your film.

Now move the shutter-speed dial *six* steps in the direction of *faster* shutter speeds. For example, if your meter indicates that an exposure of *f*-16 and 1/8 second is appropriate for a zone V exposure, adjust the shutter speed to 1/500 second. This is equivalent to six steps underexposure, giving a "zone −I." Unless the film is considerably faster than the manufacturer's recommended ASA value, this frame should be completely blank after development, except for b+f density.

Expose the second frame at this setting. For the third frame, open the aperture by one step, keeping shutter speed constant. Continue doing this in full *f*-stop increments until your lens is open to its maximum aperture. At this point, take the remaining exposures by increasing exposure times, one step at a time.

Eventually, you reach the point where your lens is at maximum aperture and a shutter speed of 1/2 second. Reset the camera for the original zone V exposure and expose the remainder of the roll of film at this setting.

Filling the roll with exposures this way standardizes developer exhaustion for consistent results. Enter all of your data on a form like the one on page 45. A blank form in the appendix is made for you to photocopy. Be careful to enter all of the data accurately.

Carefully meter the gray card in even lighting when doing film-speed and development-time tests. Be sure to take notes. Use the handy blank forms supplied in this book.

Don't rely on your memory. If you complete a test and are uncertain about your data points, the results are useless. A clear and logical record enables you to recheck any aspect of your experiment at any time, becoming most valuable when troubleshooting is necessary.

Processing—Develop the film according to the recommendations provided with the film instruction sheet. Finish processing the film normally.

Data Collection—When the film is dry, measure the density of each frame and record this value on the form. Subtract the value for b+f from each density value and then plot the data on a sheet of graph paper (see appendix), using exposure zone as the horizontal axis and film density as the vertical axis. A sample set of data that I obtained exposing 35mm, 20-exposure Kodak Plus-X film, developed in Acufine, is recorded here; and the data plotted in the accompanying graph.

Along the horizontal axis, write in your assumed film speed at the point corresponding to exposure zone I. Write in twice that value at zone 0, half that value at zone II, one-fourth that value at zone III and so on.

With a French curve or similar drawing tool, draw a smooth curve through all of your data points. This is the *characteristic curve* for the conditions you used. A lot of useful information is summarized in the graph—analyzing it further is detailed in Chapter 6.

Finding Film Speed—Draw a horizontal line from the 0.10 value of the vertical density scale until it intersects the graph. Then draw a vertical line down from the graph to intersect the horizontal axis.

Where this line intersects the horizontal axis, read the value for the exposure index. You may need to estimate the value and round it off to the nearest *lower* setting on your meter. Do it this way because it is better to err on the side of *slight* overexposure

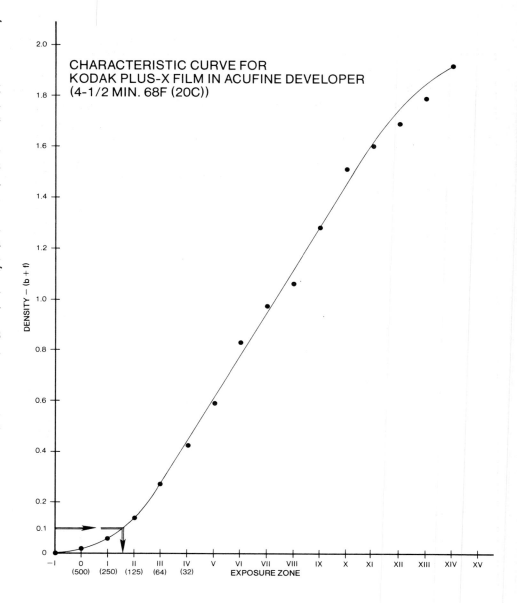

than underexposure.

In the example shown, the exposure index is about halfway between 250 and 125, so I rounded this to 160, which corresponds to a setting on my camera and meter.

You may wonder why I chose to use an EI value of 250 for Kodak Plus-X film when the value recommended by Kodak is 125. I did this to test Acufine developer, because the manufacturer claims that the developer gives a speed increase for *all* films. This test

showed me that a slight increase—about a half step—actually does occur with this developer and my equipment. Doing the same experiment using Kodak Microdol-X film developer indicated that an EI of 80 is correct.

You should determine an exposure index for each film/developer and camera combination you use. This way you can be certain that with correct metering of a scene you'll record all important shadow details on the negative.

EXPOSURE-RECORD FORM

Film: 35mm Kodak Plus-X
ISO: 125; test for EI 250
Camera and Lens: Nikon F2, 50mm
Developer: Acufine

Development Time: 4-1/2 min.
Developer Temperature: 68F (20C)
Film b+f: 0.31
Exposure Index (Measured): 160

Frame	Aperture	Shutter Speed	Exposure Zone	Density	Density −(b+f)
1)	32	1/8	V	0.90	0.59
2)	32	1/500	-I	0.31	0
3)	22	1/500	0	0.33	0.02
4)	16	1/500	I	0.37	0.06
5)	11	1/500	II	0.45	0.14
6)	8	1/500	III	0.59	0.28
7)	5.6	1/500	IV	0.74	0.43
8)	4	1/500	V	0.90	0.59
9)	4	1/250	VI	1.14	0.83
10)	4	1/125	VII	1.28	0.97
11)	4	1/60	VIII	1.37	1.06
12)	4	1/30	IX	1.59	1.28
13)	4	1/15	X	1.82	1.51
14)	4	1/8	XI	1.91	1.60
15)	4	1/4	XII	2.00	1.69
16)	4	1/2	XIII	2.10	1.79
17)	4	1	XIV	2.23	1.92
18)	4	1/500	V	0.90	0.59
19)	4	1/500	V	0.91	0.60
20)	4	1/500	V	0.89	0.58

SHEET-FILM METHOD

The principles of testing the speed of sheet films are identical to those described for roll film. Only some working methods differ.

Load three sheets of film into holders. Focus the camera at the infinity setting by focusing on a distant object. This will avoid the necessity of correcting exposure for the bellows-extension factor necessary when you photograph close-ups.

Without changing any of the camera settings, move the camera close enough to the gray card so the out-of-focus image completely fills the viewing screen. It is *not* important that the image be in focus for these tests.

Exposure And Processing—Meter the gray card for a zone V exposure recommendation. Then adjust exposure-control settings so you can expose the three sheets of film on zones 0, I and II respectively.

Develop the sheets of film according to the manufacturer's recommendation in the developer of your choice.

Data Collection—Determine the corrected density of each film. Plot the data as described—vertical density vs. horizontal zones/film speeds. Draw the curve and find the point on the horizontal axis that corresponds to the value of 0.10 above b+f on the vertical axis. This point corresponds to your film speed.

If your zone I exposure is more than a step above or below this point, you may need to make an additional exposure, or two, giving more or less exposure as the case may be.

If your zone I is to the right of the point by more than a zone, use a film-speed setting at least one step slower. If your zone I is to the left of the point by more than a zone, use a film-speed setting at least one step faster. Again, be sure to keep a careful record of all of your exposures.

If the density that corresponds to your zone I exposure differs from a density of 0.10 by more than ±0.05, draw a smooth curve through your data points and estimate where the curve will cross the 0.10 density line. Then replot the curve by shifting it to the left or right so the 0.10 density point lies on zone I.

Calculate the correct EI, remembering that each zone shift to the right corresponds to halving the film speed and each shift to the left corresponds to doubling the speed. Usually, the amount of the curve shift required will be less than one exposure zone, but don't be afraid to *interpolate* your data this way. If you need to round off your EI, do so on the side that favors overexposure—a lower EI.

CALIBRATION OF EXPOSURE METERS

If possible, you should calibrate your exposure meter by comparing it to a standard light source. Most camera repair shops will have such a device.

For a rough estimate of your meter's accuracy, set the calculator dial to a convenient ASA value such as 125. In bright sunlight, take an exposure reading off of the surface of a Kodak Gray Card. At *f*-16, the shutter-speed indication should be close to 1/ASA, or 1/125th of a second for this example. If there is a significant deviation—a half step or more—from the predicted value, you should suspect the accuracy of your meter.

This "Sunny-Day Exposure Rule" is valuable to remember. I make a habit of estimating what an exposure reading will be *before* I take a meter reading, and then compare my guess to the metered value. You should do this too. Batteries have a penchant for dying at awkward times and in out-of-the-way places. It's in these circumstances that your experience can save an important picture-taking session.

If you have several exposure meters and camera bodies with built-in metering systems, you should compare them against a standard light source or a Kodak Gray Card. It is not at all unusual for different meters to give readings that vary by a half step or more. For critical exposure control, a half-step deviation or more is significant. As long as you know the direction of error for each meter, it's easy to make the appropriate exposure adjustment.

For cameras with built-in metering systems, you can do this by adjusting the film-speed dial upward or downward. For example, if your camera meter consistently gives readings that are a half step too low, you will be overexposing each picture by 50%. Compensate for this by *increasing* the EI that you normally use by 50%. Do it with just that camera meter.

6

Determining Film-Development Times

The main objective in fine b&w photography is to produce an impressive print. A correctly exposed negative represents no more than a potential photograph. For you to exploit the film's potential, you must develop it correctly. The goal of film development is to make sure that areas you placed on certain zones develop to negative densities that you can easily translate to corresponding tones in the print.

Testing and controlling development times lets you do two things. You'll be able to place a given exposure zone at a negative density that corresponds to a particular print tone on your photographic paper. You can also control the *tonal separation* between adjacent exposure zones because this separation is *directly* related to negative contrast. Negative contrast, in turn, is determined by development time and the chemical composition of the developer you use.

BASIC PRINTING THEORY

When you print a negative, the tones produced on a given grade of photographic paper are controlled by negative densities. The *density range* of a negative is defined as the difference in densities between the darkest detailed shadow of the negative and the brightest textured highlight.

A negative with a density range of about 1.25 produces a print with the extremes of black and white on a typical grade 2 paper if you make a contact print.

When you are printing by enlarging, a smaller density range may be preferable. The optimal

In this chapter, you'll learn how to test for film-development times that allow you to expand or contract the negative density range. This is an essential control of the Zone System. It lets you control the resultant tonal range of the image.

In this scene of a desert stream, the brightness range was about eight steps—beyond the range that you can record in a negative exposed and developed normally. To record shadow details and the texture of foreground rocks, I spot-metered the shaded area and calculated exposure to place it on zone IV. I gave the negative N−2 development. The resultant negative has excellent detail in both shadow and highlights. The print from the 4x5 negative is on a grade 2 paper.

value of the usable density range is determined by the type of enlarger you use.

If you use an enlarger fitted with condensers, you aim for a density range about 1.15 ± 0.05 for an average scene with a brightness range of seven zones. This means a scene in which the brightest textured highlight is placed on zone VIII and the darkest detail on zone II. For all practical purposes, zone I is a pure black in the print. Zone II to zone VIII, inclusive, is a seven-zone range.

For enlargers equipped with a cold light or other diffuse light source, you'll develop negatives for densities toward the upper end of this density range. Enlarging is discussed in more detail in Chapters 10 and 11.

TARGET NEGATIVE DENSITIES FOR PRINT ZONES

Zone	Density (± 0.05)
0	0
I	0.10
II	0.25
III	0.40
IV	0.60
V	0.75
VI	0.95
VII	1.15
VIII	1.35
IX	1.55

NOTE: These densities are corrected for b+f. They are recommended when using a diffusion enlarger. If you're using a condenser enlarger, midtone densities can be a bit lower, as described in the text.

Photographic Papers—As you probably already know, photographic papers are available in a range of contrasts, or *grades*. They are designed to accommodate negatives with different density ranges between shadow detail and textured highlights. This allows you to match your negative to a paper that can reproduce all of the negative detail in the full range of black to white or, if you choose, to expand or contract that range.

Papers from different manufacturers will vary in this respect. The accompanying table lists some general ranges of negative

densities that will produce a full-scale print from darkest black to paper base white on different grades of paper.

The *exposure range* (ER) of a photographic paper is the range of densities that give a complete scale from white to black in the print.

The contrast of a b&w print is the ratio of the density range (DR) of the b&w print—measured with a reflectance densitometer—to the ER. You can control print contrast either by controlling negative contrast, or by your choice of photographic paper grade, or both. Contrast can also be modified by your selection of paper developer and the type of enlarger you use.

I believe that the most sensible approach to b&w printing is to produce negatives that give an image on a grade 2 paper *close* to what you previsualized. Then you can always use a higher or lower grade paper to fine-tune print contrast

COMMON EXPOSURE RANGES WITH DIFFERENT PAPER GRADES

Paper Grade	Exposure Ranges
0	1.40 to 1.70
1	1.15 to 1.40
2	0.95 to 1.14
3	0.80 to 0.94
4	0.65 to 0.79
5	0.50 to 0.64

or to correct an inadvertent error.

Negative Characteristics—Development conditions recommended by manufacturers will produce a negative with characteristics approximating those listed in the accompanying table. The density (D) values listed are corrected by subtracting the b+f density from measured densities. These densities are suitable for printing with a cold-light source in your enlarger. If you use a condenser enlarger, a zone V density of 0.60 is better.

When you photograph moving water with a slow shutter speed, it can be difficult to predict the results on film. Details of the water tend to merge, being replaced by a blanket-like mist. Even though you may expose and process the negative for a certain paper grade, having higher- and lower-contrast papers available may be useful in making the best print. I used a two-second exposure for this scene of the Merced River.

DEVELOPMENT-TIME TESTING

The next tests involve determining the "normal" development time for a negative and measuring the effect of increasing and decreasing this time on negative densities. A working objective for "normal" development is to develop the negative so that a zone V exposure produces a negative density of 0.75 ± 0.05 above b+f if you use a diffusion enlarger. If you prefer to work with a condenser enlarger, aim for a zone V negative density about 0.60 ± 0.05.

I have chosen to target a midtone because this is the region in which it is easiest to "read" photographic information. The impact of a b&w picture is most often controlled by moving subject elements on or off zone V by selective placement through metering and appropriate development of the negative.

Another advantage of using zone V as a target zone is that exposure/development variations will result in changes in your b&w print that are easier to previsualize, because you should make an effort to remember the tonal character of neighboring zones. In practice, you can select any target zone you desire, such as zone VIII. The principles remain the same.

ROLL-FILM PROCEDURE

Set up a gray card in an evenly lit place as you did for your film-speed test. Meter the card and use the EI that you previously determined for your film, developer,

WHAT YOU NEED FOR TESTING DEVELOPMENT TIME WITH ROLL FILM

- Kodak 18% gray card
- Camera and tripod
- Four or five rolls of film
- Development-time record form
- Processing solutions
- Densitometer
- Graph paper and French curve

meter, camera and lens.

Set exposure for a zone 0 exposure—five steps *faster* than your meter reading indicates. Place your camera close to the gray card so the entire frame is filled with the image of the gray card. It need not be in focus for these tests. If you're using an automatic camera, use the camera manually.

Exposing For Zones—Expose the roll of film by giving each frame more exposure sequentially—from zone 0 to I, II, III, IV, V, and so on until about 10 to 15 zones are recorded on film.

If you are using a 20-exposure roll of film, expose remaining frames on zone V. For medium-format cameras that give less than 15 exposures, you will have to make do with less data. Start at zone 0 and end up at zone IX if you're using a camera giving 10 6x7 cm images on 120 film, for example.

If, for some reason, you need to analyze data associated with higher exposure zones, simply make the additional exposures on a second roll of film and proceed as described.

Repeat this procedure until you've exposed a total of four or five rolls of film in *exactly the same way.* Enter your exposure data on a photocopy of the development-time form in the appendix.

Determining Normal Development Time—Next, go back to the data record you made to determine your EI. Identify the frame that corresponded to a zone V exposure. Determine the corrected density of that frame. If the corrected density is *greater* than that desired for your enlarger system—0.75 for a diffusion source, 0.60 for a condenser system—the development time recommended by the manufacturer is too long.

Conversely, if it is lower than these values, development time is too short. Guess at "normal" development time by assuming that a 10% change in your previously used time results in a zone V

density shift of 0.05. This time should then be very close to your "normal" development time.

Processing—Proceed to develop the films individually for the following times:

1) The manufacturer's recommended development time as adjusted by you for normal development. I'll call this *N* development.

2) Half normal development time (N−50%).

3) Three-fourths normal development time (N−25%).

4) One and one-half normal development time (N+50%).

5) Twice normal development (2N).

For example, with Kodak 35mm Panatomic-X film I found that my normal (N) development time using Kodak HC-110 developer (dilution B) was 4 minutes. Therefore, I used the following times: 2 minutes for N−50%; 3 minutes for N−25%; 6 minutes for N+50%; and 8 minutes for 2N.

Because of some points that I want to make in the discussion that follows, I also developed two additional rolls of film at times of 5 and 10 minutes.

Data Collection—For meaningful comparisons, it's *critical* that you develop all of your film in precisely the same conditions. Wash and dry the films thoroughly. Mark the development time on each roll with indelible ink and measure the density of each frame. Record all of your data alongside your exposure entries on a photocopy of page 156. Correct each data point by subtracting b+f density and record that value in the appropriate column of the form.

A sample data set that I obtained is recorded on page 50. It would be coincidental if your results matched these.

Plot the data for each roll of film in the same way as described for film-speed testing. Each roll of film becomes a separate characteristic curve. Plot each curve on the same sheet of graph paper. Label each curve with the development time of the roll.

RECORD FORM FOR DEVELOPMENT-TIME TESTS

Film: Kodak Panatomic-X 120
EI: 25
Developer: Kodak Microdol-X (undil.)

Developer Temperature: 68F (20C)
Agitation: Cont. 1 min; 10 sec./min
Development Times: 3-1/2, 5-1/4, 7, 8-3/4, 10-1/2 min.

Frame	Aperture	Shutter Speed	Zone	3-1/2		5-1/4		7		8-3/4		10-1/2	
				D	D-(b+f)	D	D-(b+f)	D	D-(b+f)	D	D-(b+f)	D	D-(b+f)
1)	22	1/500	0	0.24	0.02	0.25	0.03	0.25	0.03	0.29	0.05	0.30	0.07
2)	16	1/500	I	0.25	0.03	0.31	0.09	0.33	0.11	0.39	0.15	0.43	0.20
3)	11	1/500	II	0.32	0.10	0.40	0.18	0.43	0.21	0.52	0.28	0.57	0.34
4)	8	1/500	III	0.39	0.17	0.54	0.32	0.60	0.38	0.72	0.48	0.80	0.57
5)	5.6	1/500	IV	0.49	0.27	0.70	0.48	0.79	0.57	0.94	0.70	1.02	0.79
6)	4	1/500	V	0.59	0.37	0.84	0.62	0.97	0.75	1.11	0.87	1.25	1.02
7)	2.8	1/500	VI	0.66	0.44	0.94	0.72	1.08	0.86	1.27	1.03	1.44	1.21
8)	2.8	1/250	VII	0.71	0.49	1.02	0.80	1.21	0.99	1.41	1.17	1.57	1.34
9)	2.8	1/125	VIII	0.79	0.57	1.11	0.89	1.30	1.08	1.52	1.28	1.69	1.46
10)	2.8	1/60	IX	0.85	0.63	1.18	0.96	1.40	1.18	1.60	1.36	1.78	1.55
11)	1.8	1/30	X	0.88	0.66	1.21	0.99	1.44	1.22	1.63	1.39	1.82	1.59
12)	2.8	1/15	XI	0.91	0.69	1.26	1.04	1.51	1.29	1.68	1.44	1.88	1.65
13)	2.8	1/8	XII	0.92	0.70	1.30	1.08	1.56	1.34	1.74	1.50	1.92	1.69
14)	4	1/500	V										
15)	4	1/500	V										
16)													
17)													
18)													
19)													
20)													

SHEET-FILM PROCEDURE

Even though the principles for determining development times for roll and sheet film are the same, there are important differences in methods. Normally, you can obtain only one piece of data from each sheet of film. This rapidly increases the cost of doing tests. But with a little ingenuity, you can get all of the data for a characteristic curve from a single sheet of film.

Making A Special Film Holder—Purchase eight dark slides for your film holder. You can probably salvage them from a photo store that has a supply of used and abused film holders that are ready to be thrown away.

Make up a template containing eight 1/4-inch holes suitably spaced on a 4x5—or whatever size format that you intend to use—card so they are separated by about 3/4 inch in each direction from their nearest neighbors. See the accompanying illustration.

Place the card on a dark slide about 1/4 inch from the bottom and, with a marking pen, mark hole 1. On a second slide, mark hole 2, a third 3, and so on, to slide 8. Carefully drill a 1/4 inch hole in each of the dark slides with only one hole to a slide.

Dark slides are made of a tough, brittle plastic, so rest the slide on a solid disposable block of wood and drill slowly. Sandpaper any burrs off of the edges of the drilled holes. Number the dark slides 1/9, 2/10, 3/11, 4/12, 5, 6, 7 and 8. Slide 1 becomes slide 9 when you reverse it in the film holder.

Use this life-size template as a guide for drilling holes in dark slides, as described in the text.

This is the way the dark slides and resultant negative should look. Each sheet of processed film has enough information for a characteristic curve.

Exposing For Zones—Set up your camera and a gray card as usual so the card fills the entire viewing area. It need not be in focus. As before, the lens should be focused at infinity.

Put the film holder containing an unexposed sheet of film in the camera, withdraw the dark slide, and insert slide 1/9. Meter and set exposure-control settings for zone I by underexposing the meter recommendation by four steps. Expose the film.

Remove the slide and replace it with slide 2/10. Then set the camera for one more step of exposure to expose for zone II. Expose the film.

Continue this procedure. After exposure 8, take slide 1/9, insert it into the film holder *reversed* and expose for zone IX.

After making all 12 exposures, replace the original dark slide. You now have a single sheet of film containing 12 different exposures. Repeat the procedure with 3 more sheets of film.

Processing—Develop the different sheets of film for the manufacturer's recommended development time (N), and for N−25%, N+25%, and N+50% times. Finish processing each sheet of film normally. Mark the development time on each sheet with indelible ink.

Data Collection—Each sheet of processed film contains 12 spots of varying density. Measure and plot density of each spot vs. exposure zones. Each sheet of film yields its own curve. Label each curve with the development time corresponding to the film that gave each curve. The analysis of the data and characteristic curves, which follows, is the same as that described for roll film.

For many of the tests described in this book, you need a standard enlarger height. Mark this position on the enlarger column with a piece of tape or indelible ink.

DATA ANALYSIS

The quickest way to appreciate the effect of varying development time is to make a contact print of each roll of film that you developed. By comparing the printed gray tones, you'll have a visual record of how exposure zones are translated into print tonalities. To make the visual comparisons meaningful, the contact prints must be made under standardized conditions.

STANDARD PRINTING TIME

For this purpose, you must determine a value called the *standard printing time* (SPT). This is the minimum print exposure time that yields the darkest black achievable on that paper with a certain enlarger height, lens and *f*-stop. The SPT for each combination of film, printing paper, and developer will be different. Because SPT is a function of b+f, use the same film that you exposed for your characteristic curves for the following tests.

Exposure—Place an unexposed, but processed piece of film in the negative carrier of your enlarger. This can be a blank frame, the unexposed end of a roll of film or an unexposed piece of film that has been developed for the normal development time and fixed. This film segment repre-

sents the negative's minimum density, zone 0. The SPT yields zone 0 in the print.

Adjust your enlarger to the height that you would normally use to make a full-frame 8x10 print. Mark this height permanently on your enlarger column. Stop down the enlarging lens to two stops below the maximum aperture. For example, if maximum aperture is *f*-2.8, set the enlarger lens to *f*-5.6.

Cut a piece of grade 2 enlarging paper into four 2x10–inch strips. Make a series of exposures on one strip of paper, which is held down either by a piece of glass or by weights at each end. Make each exposure two seconds long. After the first exposure, move an opaque card along the strip about one-half inch. Continue in this way until you reach the end of the paper.

Processing—Develop the paper for two minutes with continuous agitation in your normal paper developer at 68F (20C) and fix normally. Dry the paper after a brief washing. A handheld blow drier speeds this up.

Fine-Tuning—What you'll see in the dry print is a series of gray steps ranging from white to black. These correspond to exposure times of 2, 4, 6, 8, 10, 12 . . . seconds respectively. At some point in this sequence, black tones merge and you'll note that beyond, for example, 16 seconds (18, 20, 22 . . . seconds) all of the steps are the same black tone.

Find the *first* step where maximum black occurs and record that time. That value is *close* to your SPT. It may not be exact because of something known as the *intermittency effect* and cumulative errors in your timer.

The intermittency effect occurs because a series of exposures on photosensitive materials—for example, 10 two-second exposures—is not the same as a single exposure of the same total duration, 20 seconds.

A second error can arise from

2 4 6 8 10 12 14 16 18 20

To determine Standard Printing Time (SPT), I made a series of exposures with the enlarger at my standard setting. This strip indicates that SPT for the paper I was testing is in the range of 18 to 20 seconds.

18 19 20 21

A second test, beginning with a basic exposure of 18 seconds, indicated that the correct SPT at the conditions I was using was 19 seconds. Slight differences in print densities are lost in the reproduction process, but are detectable in the original print.

inaccuracies in your timer. With mechanical timers, it is almost impossible to achieve better than ±10% accuracy for exposures as short as two seconds. Digital timers are more reliable, but even so it usually takes the enlarger lamp a fraction of a second to reach peak brightness. Therefore, you should repeat the above test using an initial exposure 1 second less than your approximate SPT.

In this example, I would make four *separate* tests with exposures of 15, 16, 17, and 18 seconds. The second part of the test should give the SPT for that film and paper combination in your enlarger. Record this time in a convenient place in your darkroom.

PRINTING
YOUR NEGATIVES
Remove the film from the negative carrier and reinsert the empty carrier in your enlarger. Cut your negatives into strips so you can contact print an entire roll of film on a single sheet of 8x10 inch paper.

Insert a sheet of enlarging paper—from the same batch for which you determined the SPT—in a contact-printing frame

and arrange the negatives from a single roll of film on the surface of the paper with the emulsion side of the negative facing the emulsion side of the paper. Close the frame and place it on the enlarger baseboard.

Exposure—Expose the paper through the negatives for the SPT. Do this for each roll of film you developed. Write the roll number, N value, enlarger-lens setting and

SPT in pencil on the back of each sheet of paper for later identification.

Processing—Prepare a fresh solution of paper developer. Clip the corner of one of the exposed sheets of paper and place that sheet on top of the exposed stack of contact sheets you made. Start

The contact print of a roll of film exposed for development-time tests contains a lot of useful information. A 120 roll of 4.5x6 cm images is shown here.

your timer and, as quickly as you can, insert one sheet at a time—clipped sheet first, emulsion side down—into the developer. Shuffle the sheets continuously by removing the bottom sheet and placing it on top of the stack. The clipped sheet will serve as a marker so all sheets receive the same agitation and development.

At the end of two minutes, continue shuffling the sheets until the clipped one is on the bottom again. Then begin transferring them into the stop bath at approximately the same rate and order as you placed them in the developer. Shuffle the sheets for one minute in the stop bath and transfer them to the fixer. Fix, wash, and dry the prints in the usual way.

Each contact print is a visual record of the effect of varying development times on negative densities. You will quickly see that as you increase film development time, the *number* of steps between the black frame and the first frame that prints as paper-base white *decreases*. For negatives that were developed for very short times, paper-base white is never reached.

VISUAL ANALYSIS

The following exercise is useful, although not essential. I recommend that you do it to get a visual appreciation of the effect of varying film-development time.

Arrange the contact sheets in order of increasing development times and cut out a segment of each frame on a sheet. Attach these patches in sequence from left to right—starting with the zone 0 exposure—on a sheet of mounting board. Double-stick tape works well for this purpose.

Underneath the patches, record the exposure zone that you used. Label each row with the development time and *N* value used.

This display is a handy reference that shows how each exposure zone translates into a print tone as a function of development time. Though it's impractical to memorize it, the more familiar you

become with it, the more comfortable you will be making Zone-System decisions in the field.

One Example Analysis—Page 55 illustrates a set of data that I obtained from Kodak 35mm Panatomic-X Film developed in Microdol-X. I made contact sheets of all the tabulated negatives on Ilford Ilfobrom Grade 2 Glossy paper, developed in Kodak Dektol for two minutes at 68F (20C). Although the subtleties of tonal gradations are somewhat obscured in the reproduction process, the illustration here does give useful information.

The first thing that is easy to see is that the density range of Ilford Grade 2 Glossy paper is approximately 1.2. This follows from an examination of the data for N+25% development. There's a perceptible tonal difference between patch 7—negative density 1.17—and 8—negative density 1.28. But none between patches 8 and 9. Therefore, the density range of the paper must be between 1.17 and 1.28. This is very useful information.

Second, notice that there is almost *no perceptible difference* in any of the patches corresponding to zones 0, I and II, regardless of the development times you used. From this observation you can legitimately conclude that negative densities in the shadow areas are relatively insensitive to changing development times.

Third, notice that for the higher exposure zones—VII and above—negative densities are very sensitive to changing development times. For example, with N−50% development, a zone VII exposure produces a zone III print tonality. But N+50% development of the same exposure zone yields a zone IX print tonality! In the midtone regions, the effect is between these extremes.

I've defined normal development (N) as the development time necessary to produce a zone V relative negative density of 0.75 for a zone V exposure. If I com-

pare the zone V patch for the normally developed negative with others, I find that it matches the zone IV patch for N+50% development. This means that by increasing development time by 50%, I *promoted* a zone IV brightness to a zone V negative density.

In the language of the Zone System, this is called *N+1 development*. The number following N indicates the number of zones that a particular exposure zone has been promoted—or demoted—due to development to achieve a zone V density. If a zone VIII exposure were developed to produce a zone V density in the negative, this is called *N−3 development*.

The normal zone V patch also matches the segment for the zone VI exposure and N−25% development. This means that by decreasing development time by 25%, I reduced a zone VI brightness to a zone V negative density. In the terminology of the Zone System, this is called *N−1 development*.

The gradations of gray shown on page 55 can be further modified by changing paper grade. On a grade 0 or 1 paper, the normally developed negative will produce a range of grays similar to those of the N−25% scale. Paper grades 3 to 5 produce an array corresponding to N+25% and N+50%, or more, development.

By targeting your normal negative to print easily on a grade 2 or 3 paper, you can reserve the flexibility offered by various paper grades to fine-tune your prints, or to help out when your negatives are less than perfectly exposed and developed.

Do not confuse the tones that are shown on page 55 with the gray scale. They are not the same. To obtain a close match to the gray scale from the normally developed negative, I would need to find a printing paper that will produce 10 distinct zones of gray, ranging from black to white, from 10 exposure zones. If you can see more than 10 exposure zones on a printing paper, this means only

VISUAL ANALYSIS OF THE EFFECT
OF VARYING DEVELOPMENT TIMES

Kodak Panatomic-X 120 developed in
Microdol-X, undiluted, 68F (20C).
Contact Prints on Ilfobrom #2 Glossy.

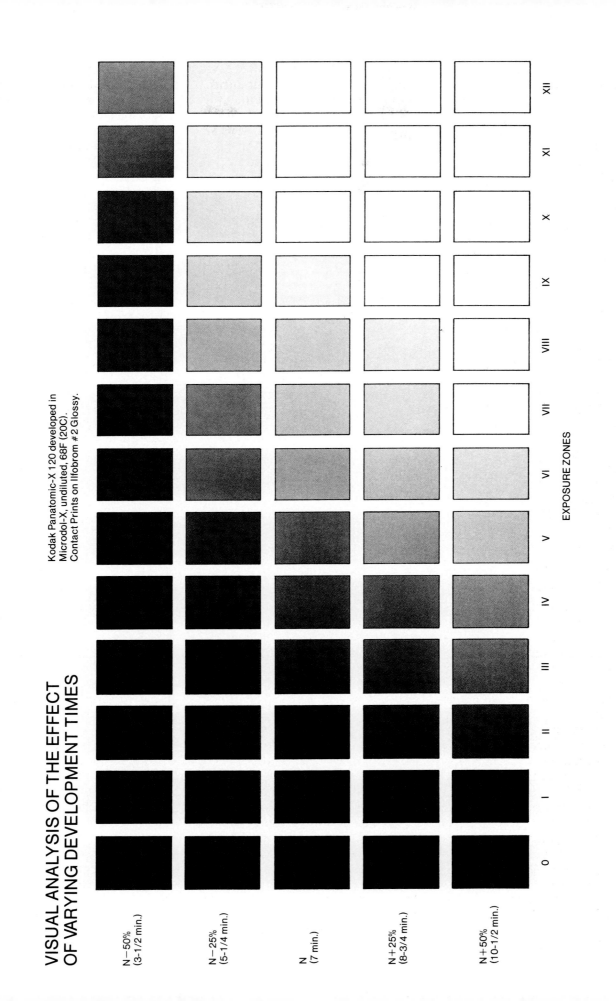

N−50%
(3-1/2 min.)

N−25%
(5-1/4 min.)

N
(7 min.)

N+25%
(8-3/4 min.)

N+50%
(10-1/2 min.)

EXPOSURE ZONES

0 I II III IV V VI VII VIII IX X XI XII

that the separation between adjacent zones has been compressed.

CURVE-FAMILY ANALYSIS

A more common way to analyze density data is to convert it to a graphic display. Make a few photocopies of the graph paper in the appendix or purchase a pack of graph paper with 20 squares per inch. On one sheet, label the horizontal axis at evenly spaced intervals with the exposure zones that you used. This is shown below.

Label the vertical axis with the appropriate film density values in the same way, as I have done in the same illustration. For each exposure zone (horizontal axis), mark the density value that you measured along the vertical axis. Draw the curve for the set of points corresponding to each roll of film, and label the curve with development time. Then plot the next set of points.

The set of characteristic curves that you create this way is the *family of curves* for your film, developer and conditions. They graphically summarize all the data that appear in the table—in addition to the contact prints you made.

Interpreting The Curves—At the beginning of this chapter, I stated that a negative with a density range of about 1.15 ±0.10 should print easily on a grade 2 paper. Let's assume that your normal paper has an exposure range of 1.25.

On the curve-family graph I have drawn a horizontal line at a density value of 1.35. Any negative densities higher than this print as paper-base white if the negative is printed with the SPT to make zone I maximum black. Printing zone I as maximum black is reasonable because it corresponds to the first perceptible density above b+f on your negative. Any negative densities below this line—1.35 or less— produce a shade of gray.

An examination of the characteristic curves shows that for the development conditions I defined as normal, seven zones of subject brightness (zones II to VIII inclusive) are accommodated in the density range of 0 to 1.35. As I decreased development time, the number of zones that fell under the density value of 1.35 increased.

For example, with a development time of 10 minutes, any exposure zone above VI prints as paper-base white. With a development time of only 2 minutes, 11 exposure zones could be recorded in the density range of 0 to 1.35.

Another Way—I can also present the data as shown on page 57. In

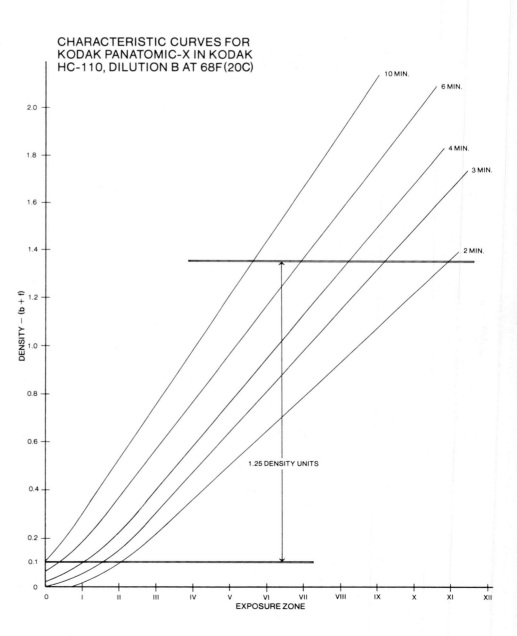

CHARACTERISTIC CURVES FOR KODAK PANATOMIC-X IN KODAK HC-110, DILUTION B AT 68F(20C)

this graph I've plotted negative densities as a function of development times. Curves are drawn through the data for *each exposure zone*.

You can see that the higher exposure zones are more sensitive to development times than the zones in the shadow areas because the steepness of the curves increases as zone number increases. By looking at a particular line, it is easy to see what print-tone shifts will occur when you change development times. For example, suppose I develop a Kodak Panatomic-X 35mm negative in Kodak HC-110 (dilution B) for 6 minutes rather than the normal 4 minutes. I know that a zone VII exposure will be promoted to a zone VIII negative density. This gives N+1 development.

Alternatively, with a reduction of development time to a little less than 3 minutes, a zone IX exposure is developed to a zone VIII negative density. This is N−1 development.

An advantage to plotting the data this way is that it's simple to see how many exposure zones are recorded on the film at densities below 1.35, which corresponds to a Zone VIII density on film. For the data shown, you can see that if I were to develop the film for 10 minutes, less than six zones will fall within the density range of 0 to 1.35.

At this point you may have a feeling that something is not quite right about what I have just finished summarizing. If you look at the graphs on page 56 carefully, you'll notice that zone I densities steadily increase as development time is increased. Yet I told you earlier that zone I densities and therefore film speeds were not particularly sensitive to development times.

Well, so I exaggerated a little! I did so because we had to start somewhere, and variation in film speed due to development time was a variable that we could ignore without creating a serious problem. Furthermore, we can correct for this complication without doing any more testing. However, this necessitates replotting your characteristic curves.

DEVELOPMENT TIME VS. DENSITY CURVES FOR KODAK PANATOMIC-X IN KODAK HC-110, DILUTION B AT 68F (20C)

DENSITY − (b + f)

DEVELOPMENT TIME (min.)

The graph on this and the previous page represent the *same* information. You can do your film-development-time analysis with either method, depending on which you think is easier. You want to derive the development times that give N, N−1, N+1, N−2, and N+2 development.

But first consider this. The only effect of using the wrong EI when you plot a characteristic curve is to shift the curve to the left or right. Nothing else about the curve changes. To put the individual characteristic curves in their proper positions, redraw the curve so the 0.10 density point occurs at the zone I exposure position.

Each full exposure-zone shift to the *left* requires you to *reduce* your assumed EI by a factor of two. I used an EI of 50 for Kodak 35mm Panatomic-X film in my tests with HC-110 developer. Therefore, the full-zone shift to the left that placed the curve in its proper location for 2 minutes of development means that the correct speed is actually EI 25 at these conditions. Similarly, for the 10 minute development time, the correct speed is EI 100.

The graphs at right illustrate the curves previously shown on page 56 with the data corrected to the proper EI for the different development times. I have redrawn only three curves to minimize crowding. Plotted in this way, it's easy to see that negative contrasts increase as you increase the development time. Remember, the slope of the straight-line segment of the curve is a measure of contrast. The greater the slope, the higher the contrast of the negative.

You can also replot the graphs on page 58 to reflect the adjusted EIs. Simply move the entire group of points up or down until the zone I density point lies along the 0.1 density unit line. I have done this for some of my data, shown on page 59. It is now a simple matter to read off the graph how many zones fall below the critical value of 1.35.

To Correct Or Not Correct EI?—Is it really necessary to use a different EI for every exposure/development situation that you encounter? To answer that question intelligently, you need to assess the penalties associated with ignoring the corrections theoretically called for.

If you do not increase EI when you plan to increase development time, all the densities of your film will be slightly greater than normal due to a systematic overexposure of all exposure zones.

The price that you will have to pay is not great—perhaps as much as a 50% increase in exposure time when you print your negative, and a very slight decrease in sharpness and increase in grain. In practical

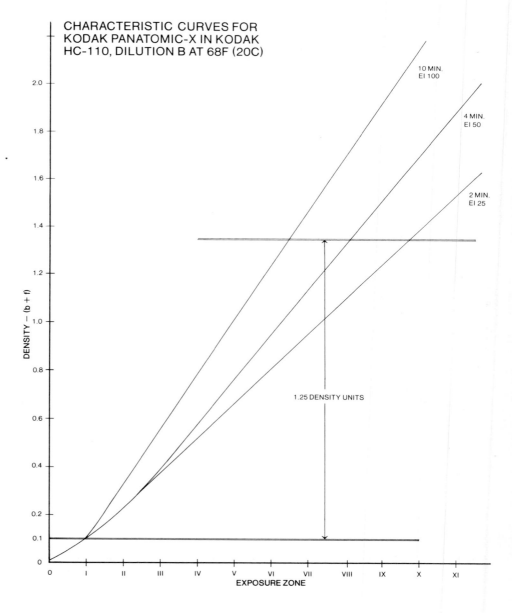

CHARACTERISTIC CURVES FOR KODAK PANATOMIC-X IN KODAK HC-110, DILUTION B AT 68F (20C)

terms, the effects are hardly noticeable with a 35mm negative and negligible for larger formats.

If you do not decrease EI when you use less-than-normal development time, the consequences are more serious. If there are important shadow regions that you want to record in the negative, there's a possibility that the densities of these areas may be lowered so much that details and texture are sacrificed or recorded on the toe at the curve, a low-contrast region offering slight tonal separation.

By now you will appreciate that making high-quality negatives requires a thorough understanding of your equipment, exposure evaluation, and optimum developing conditions. Some technical skill is necessary too. But there's a practical limit to how many facts you can usefully remember, as well as the danger of getting too involved in the technicalities. The artistic side of you may be swamped.

Therefore, I think that a compromise is essential. As a rule of thumb, if you plan to compress the brightness range when you photograph by using a less-than-normal development time, *halve* the EI.

If you plan to expand SBR by using a greater-than-normal development time, *double* the EI. There will be very few situations in which this procedure will not be satisfactory.

USING CURVE-FAMILY DATA

The most obvious utility of a family of characteristic curves is that they let you know immediately how many exposure zones will be recorded in a specific density range.

For example, an inspection of these graphs indicates that with normal exposure and development, a seven-zone range of subject brightness will be recorded in the density range of the negative in the span of 0 to 1.35 density units. A negative with these characteristics will produce a b&w print with a full scale of tones from black to white on a normal grade of photographic paper.

If development time is halved, zones 0 to X fall in this range—giving N−1 development. If the development time is increased by a factor of 2.5, less than a six-zone range (6.5−1=5.5) will be accommodated—giving N+1.5 negative development.

Use your data to determine how

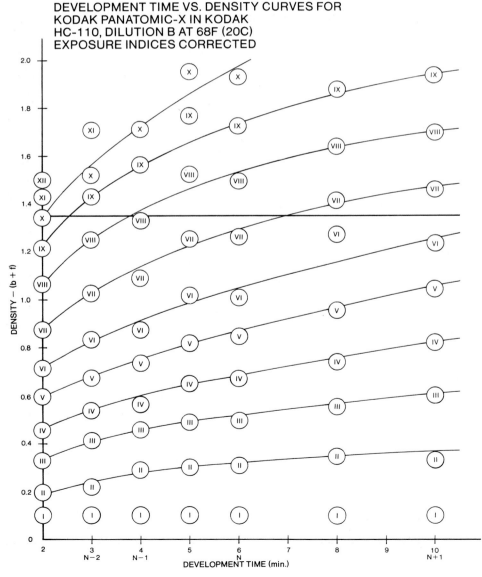

DEVELOPMENT TIME VS. DENSITY CURVES FOR KODAK PANATOMIC-X IN KODAK HC-110, DILUTION B AT 68F (20C) EXPOSURE INDICES CORRECTED

many exposure zones are recorded with each development time. Record this information because it tells you how to control *expansion* or *compression* of negative density.

Expansion—Suppose you are faced with a photographic subject that has a brightness range of 5-1/2 zones. If the print that you previsualize should range from black to white to convey what you want to show, expansion of the normal density range of the negative is necessary.

If my test results apply to your film and equipment as well, you would choose Kodak Panatomic-X or a similar slow, fine-grain film to photograph the scene.

If I were photographing a scene with a brightness range of 5-1/2

GETTING MAXIMUM NEGATIVE CONTRAST THROUGH TOTAL DEVELOPMENT

Total development gives maximum negative contrast with a film. It's a useful technique to use with subjects having a very limited brightness range—about two steps. The subject pictured here is part of a 250-year old wall painting in the dim interior of the San Xavier Mission in Tucson, Arizona. The brightness range of the faded painting was a couple of steps. When you want to get a full range of tones with such a low-contrast subject, do the following: Base exposure on a zone IV or V placement and develop the film for *five times* the normal development time. This produces a negative with the maximum possible density range and good tonal separation of zones. Typically, you can then print the negative on a normal-grade paper.

zones, yet previsualized that scene in a print that ranged from paper-base white to maximum black, I would need to expand the normal density range of my negative with N+1.5 development. I would do this by exposing Kodak Panatomic-X film at an EI of 100 and then developing the negative 2.5 times normal, for 10 minutes. The resulting negative would enable me to produce the photograph that I previsualized on a grade 2 paper.

By following this procedure, I increase the apparent contrast of the scene as well as tonal separation in the tonality of adjacent zones.

Compression—If, on the other hand, I encountered a scene with an extensive SBR spanning 9 zones, and I wished to record all of these zones in the photographic print, I would have to compress the normal density range of the negative with N−2 development. I would do this by exposing the film at EI 25 and cutting the normal development time in half.

A word of caution is in order here. You should avoid using a development time of less than four minutes because film development may be uneven. If you want to use a slow film in circumstances requiring compression of the SBR, you should dilute the developer by a factor of two or more and determine the development time necessary to produce a negative with the desired density scale. As a general guideline, I have found that with Kodak HC-110, diluting the developer by a factor of two—one part of water to one part of your normal working-strength developer—doubles normal development time.

You should do your own tests with diluted developers if you

RECORDING GOOD SHADOW
DETAIL THROUGH PRE-EXPOSURE

Intentionally fogging film uniformly and slightly prior to exposure is a useful way to improve shadow details in the negative. This is a good technique to use with a scene that has interesting subjects in both shaded and lit areas.

What you do is first expose the film *uniformly* on zone II. Meter a gray card and photograph the gray card with *three steps less* exposure than recommended by the meter reading. Then photograph the scene normally on the same film. The result is that all elements of the scene you photograph will now fall *above* the exposure threshold of the film, zone I.

The effect of pre-exposure is significant only on zones I, II, and III. Essentially it is a *localized* effect. Details that are normally lost in the darker zones will appear in the negative and print. Changing development time to expand or compress the density range on film is an *overall* effect.

The print at left was made from a negative shot without pre-exposure. Shaded areas show little detail. The negative used for the photo at right received pre-exposure. Shadow details are more discernible.

The prints were enlarged identically and without manipulation. Do not be misled by the fact that the print from the normal negative seems to have more "snap." It lacks subtle shadow details that *are* in the other print. With a little burning and dodging the print at right could be made much better. Remember, if there are *no* shadow details in a negative, no amount of printing effort can provide them.

want to use this approach. Most photographers prefer to use a fast film when compression is necessary because development times are convenient, and shortened development minimizes apparent graininess.

Determining the characteristic curve of every film/developer combination that you use will give you a maximum degree of control when you photograph. Let me cite a few interesting examples of the kind of information you can obtain from these useful experiments.

SOME EXAMPLES

Diafine is a two-bath developer that the manufacturer claims will produce fine-grain negatives and very high film speeds for *all* classes of films. My experience indicates that these claims are valid. A two-bath developer contains the reducing agents in the first bath and an accelerator for development in the second.

You soak the film in the first bath until the emulsion is saturated with this solution. You then transfer the film to the second bath, which is alkaline. Development proceeds rapidly until the reducing agents have been used up.

Some photographic literature about divided developers say that no development takes place in the first bath, and that beyond a minimum time necessary to saturate the emulsion with the reagents, development times and temperatures are not really critical. My tests indicate that these claims are dubious.

The manufacturer of Diafine states, "Diafine may be used within a temperature range of 70F to 85F (21C to 29.5C) with a minimum time of three minutes in each solution. Increased development times will have no practical effects on results."

An accompanying graph shows two characteristic curves for Diafine used on Kodak Panatomic-X 35mm film rated at EI 160 and de-

veloped at 80F (26.5C) for 6 minutes in bath A and 3 minutes in bath B; and 68F (20C) for 3 minutes in bath A and 3 minutes in bath B, respectively.

The curves are very different, indicating that by developing film for different times and at a higher temperature, negative contrast increased significantly. Densities for zone VII and VIII exposures increased to the point where they will reproduce as paper-base white in a print. From this experiment I can conclude that a negative developed in Diafine *is* sensitive to developer temperature and/or the length of time spent in bath A.

To illustrate the practical effect of these findings, I exposed a scene at identical conditions on Kodak Panatomic-X film (EI 160) and developed the two negatives differently as shown in the graph. These negatives were printed on a grade 2 paper so that the tonality of the sky is the same in both prints.

The contrast of the two photographs is very different. The print from the negative with the higher contrast (80F, 6 and 3 minutes) is an unacceptable interpretation of the scene because highlight details in the clouds wouldn't print. These areas of the negative are so

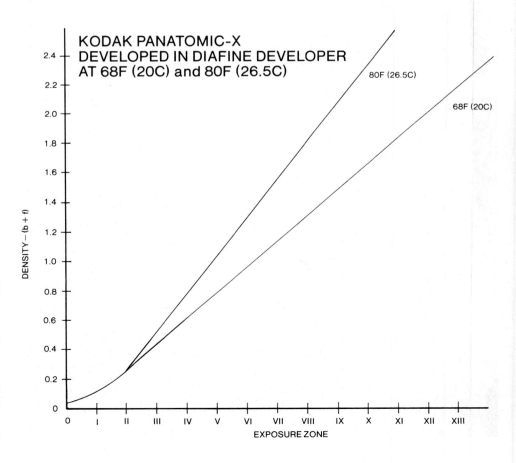

overdeveloped that it's not possible to print the texture in the clouds. This condition is referred to as *blocked highlights*.

This example proves that you need to control both temperature and development times with Diafine. This is not meant to be a criticism of the product, because it does deliver what is promised when you use it properly. I have cited this example to show you that you cannot simply accept *any* manufacturer's recommendations at face value and assume that if you follow directions carefully, you are *guaranteed* a perfect negative.

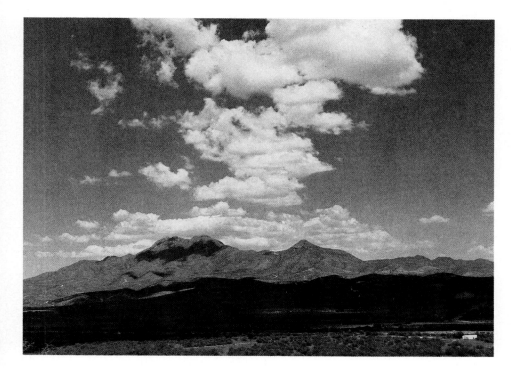

Characteristic curves summarize a lot of exposure-and- development information. But it's sometimes difficult to appreciate what they mean visually. To demonstrate how you can relate characteristic-curve data to a print, I photographed a scene containing shadows and brilliant cloud formations on Kodak Panatomic-X film. Different frames were developed in Diafine, Kodak Microdol-X and Kodak HC-110 (B). Film speeds were adjusted for each developer that I used.

The results with Diafine are on this page; the other two results are on the next page.

Diafine increases both film speed and negative contrast. At 68F (20C), the increase in negative contrast was enough to cause the loss of some highlight detail in the clouds. Printing the negative on a paper of lower contrast would reveal the cloud structure.

Using Diafine at 80F (26C) gave a contrasty negative in which all of the highlight details were "blocked". An increase in graininess is also apparent.

Another Example—At right is a family of characteristic curves for Kodak Panatomic-X developed in Kodak Microdol-X. Notice the significantly different shape of these curves compared to those I got using Kodak HC-110, page 58. There is a significant flattening of the curve as exposure zones increase.

The probable reason for this is that the developer is a low-energy developer containing no hydroquinone. Hydroquinone adds density to the highlight areas of a negative, so its absence results in a "shouldering" of the characteristic curve.

Consequently, there is less separation of exposure zones in the highlight areas of the negative—and the b&w print. The specific properties of developers are discussed in Chapter 7. These properties can be analyzed by examining characteristic curves.

By determining the characteristic curves for the film and developer at various conditions, all guesswork trial-and-error in the field is eliminated. To get negatives that have predictable qualities, the only sensible approach is to generate and study characteristic curves for the films and developers you use.

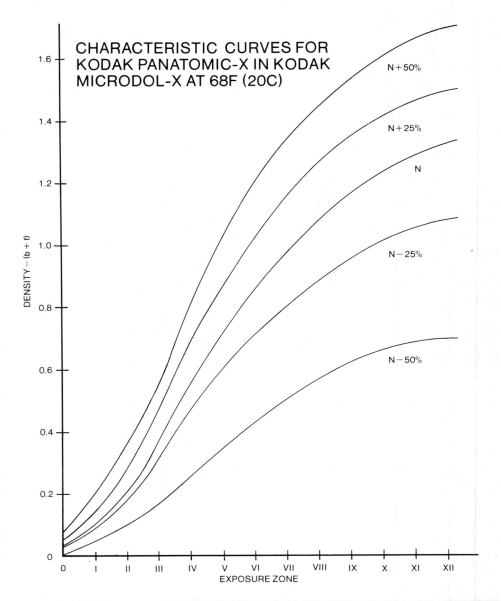

CHARACTERISTIC CURVES FOR KODAK PANATOMIC-X IN KODAK MICRODOL-X AT 68F (20C)

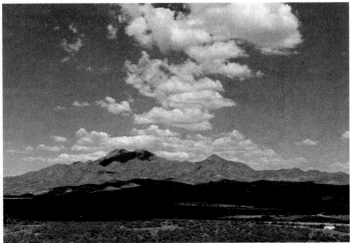

Kodak Microdol-X is a fine-grain, compensating developer that produces a characteristic curve with flat highlight regions—zones VII and above. In the print, cloud details are apparent. The tonal difference between the white of the clouds and the shaded area is the smallest among this set of developers. Grain is minimal.

Kodak HC-110 is a typical metol-hydroquinone developer. Details in both the shadows and the highlights are visible, but the tonal range of the print is slightly greater than in the first print. This occurs because hydroquinone produces greater highlight density in the negative than a developer such as Microdol-X, in which metol is the only developing agent.

EXPOSURE LATITUDE

Essentially, every b&w film available today has a straight-line portion of the characteristic curve that continues well beyond density ranges that we normally use in b&w printing. Some films have the capacity for a linear response to exposure 10 steps above the region of the gray scale where we place zone IX. At the other end of the curve, the toe, there is very little flexibility and we have almost no room for error at all.

Exposure latitude is defined as the ability to overexpose film and still obtain a useful negative. What happens is that with overexposure each zone gets denser as it shifts up the curve.

As a practical matter, do not overexpose more than three steps above the minimal exposure that you need to record shadow detail. The decrease in negative quality due to grain and loss of resolution becomes significant.

With all films, you must be certain that you gave the subject sufficient exposure to record all of the important details in the dark areas of the scene. With the exception of photographs that depend upon large black masses as design elements for graphic impact, you should avoid large featureless black or white areas. They're visually uninteresting. If you determine film speed accurately and use your light meter correctly, problems due to overexposure should be rare exceptions.

By knowing the properties of your film and the characteristics of your equipment, there's little need for you to rely on a film's exposure latitude. Nonetheless, you should appreciate in which direction forgiveness lies when you're uncertain.

RECIPROCITY FAILURE

As mentioned earlier, the reciprocity law for film exposure is true for shutter speeds between 1/2 and 1/1000 second. At exposure times longer and shorter, however, the law fails and the film responds as if underexposed. In addition, b&w film undergoes a contrast change. Fortunately, you can compensate for the effects of *reciprocity failure* in b&w film. An exposure and development adjustment is required.

With a short-duration exposure, such as 1/10,000 second, the film loses contrast and is underexposed. With long exposures, such as 10 seconds, the film is underexposed and contrastier than normal.

Typically, the film manufacturer gives exposure-and-development corrections to correct for reciprocity failure. See the accompanying table for Kodak b&w films. You apply these adjustments *in addition to* any non-normal exposure-and-development adjustments required by using the Zone System.

If you plan to extensively photograph subjects that lead to reciprocity failure, you should determine a characteristic curve for those conditions. It will automatically include corrections, so you can then adjust exposure and development for just Zone-System considerations.

SUMMARY

The Zone System of exposure and development control is an extraordinarily powerful tool for b&w photography. Obviously, it's most applicable to photography using sheet film because each negative is tailor-made, exposed and processed according to individual needs.

You can also use this system with fine results from both 35mm and medium-format cameras. If your camera has interchangeable backs, group exposures according to normal (N), normal-plus (N+) and normal-minus (N−) development. With 35mm cameras, use different cassettes by labeling them accordingly and rewinding them, noting frame numbers.

Regardless of how modified your technical approach to the Zone System becomes, your photographs will be significantly better than simply following a manufacturer's guideline. I urge you to do all of the experiments already mentioned for every kind of film and developer you use.

RECIPROCITY-FAILURE ADJUSTMENTS FOR KODAK B&W FILM

Indicated Exposure Time (sec.)	Open Aperture OR	Use This Shutter Speed (sec.)	Change Development Time
1/100,000	+1 f-stop	same	+20%
1/10,000	+1/2 f-stop	same	+15%
1/1000	none	same	+10%
1/100	none	same	none
1/10	none	same	none
1	+1 f-stop	2	−10%
10	+2 f-stop	50	−20%
100	+3 f-stop	1200	−30%

7
Choosing & Using Films & Developers

Monotone subjects, such as these leaves in the shade, have short brightness ranges. For a full-scale print, you typically have to extend negative development to increase image contrast. An average meter reading was used to determine the exposure setting. Because extended development (N+2) was in order, I used slow-speed 35mm film. The print conveys the impression of silvery brilliance, which was the effect I was trying to achieve.

Each of the many available b&w films has certain characteristics that you can use to your advantage. In addition, each developer has its own special properties—no two will react with a given type of film in the same way. As a result, the possible number of film and developer combinations is impressive—and potentially confusing too.

It's too easy to spend a lot of time looking for that elusive combination of film and developer that delivers ultrafine-grain negatives from fast film. In this chapter I'll discuss the properties of vari-

ous films and developers, so you'll be able to make choices that can satisfy your needs. I'll also discuss how to develop film correctly.

CHOOSING B&W FILM

When you choose a b&w film, you should base your selection on an appropriate balance of the characteristics mentioned in Chapter 5—film speed, grain and resolution, inherent contrast and tonal rendition. Spectral sensitivity, the film's response to color, is discussed in more detail in Chapter 8.

In the absence of other overriding considerations, you'll usually

want to choose a film with as low as possible film speed. The ultimate test of a film is the quality of the print that you can make from the negative.

Slow Film—From the discussion in Chapter 5, you'll remember that slow films—ASA 25 to 50—are fine-grained and have the highest inherent contrast. They are best suited for resolving fine detail in a scene. Films in this category include Kodak Panatomic-X, Ilford Pan F and Agfapan 25. These films are available only in 35mm and 120 sizes.

You must be careful when you expose and develop these films because overexposure, overdevelopment or both usually results in a contrasty negative with blocked, unprintable highlights.

Because of the high *inherent* contrast of these films, they are excellent for photographing subjects that benefit from expanding negative contrast (N+ development). Normal development times are short for slow films, and extending development time does not produce negatives with objectionable grain for moderate enlargement—about 10X.

Unfortunately, a short brightness range is usually the result of dim light levels, such as you encounter indoors or on overcast

days. Slow films require long exposures in these conditions, necessitating a tripod and perhaps reciprocity-failure correction, no matter which format camera you use.

Fast Film—These are ASA 320 and higher. They are the films of choice for general-purpose photography in dim light, or when fast shutter speeds and small lens apertures are necessary. Because of the low *inherent* contrast of fast films, they are ideally suited when you need to compress negative contrast (N− development).

This is easy to do by reducing normal film development time. Shortened development times produce the added benefit of less graininess. Grain size is directly related to development time, increasing as the time increases. I do not recommend that you use fast films for N+ development if you have another option. The resultant apparent graininess in the print can easily become objectionable.

In very dim light, one option is to rate your film at a higher-than-normal EI—two to four times normal—and extend normal development appropriately. This yields a grainy, high-contrast image that you can print to a normal contrast level by using a paper with a long exposure range—a low-contrast grade such as 0 or 1. Even though the photograph that you get may be less than ideal, it's probably the best that you can get in these circumstances.

By using an EI 400 film instead of an EI 25 film, you gain four additional exposure steps. This means that at a given shutter speed, you'll get much greater depth of field with the faster film. In large-format work in which the

degree of negative enlargement is usually small, depth-of-field considerations are important. They're so important that an EI 400 film is the film of choice for most photographers. Graininess is not a limiting factor in this case.

High-speed roll and sheet films such as Kodak Tri-X, Ilford HP5, and Agfapan 400 have been improved by their manufacturers to such a degree that the current products are no longer considered coarse-grain films. By carefully exposing and developing fast films, you can make superb 8x10 enlargements from 35mm negatives. Acceptable prints of larger sizes are possible.

Medium-Speed—Films with ASA ratings about 100 represent a compromise between slow and fast films. They have intermediate degrees of grain and resolution. Many photographers choose one of these as an all-around, general-purpose film and use slower or faster films as special-purpose alternatives.

Strategy—Whichever method you choose, I advise you to select as few films as possible when you begin systemizing b&w techniques. Explore each film's capabilities carefully. Rather than change brands of film and developers each time you take a photograph, you should select a single film and developer and observe photographic results carefully.

When you discover a film's limiting characteristics—such as grain, resolution and film speed—for subjects that you commonly

Because the depth of field required for this desert landscape was four feet to infinity, I used a fast film in my view camera. A camera with movements also makes composition control easy. Foreground detail reinforces the impression of texture in distant formations.

SOME B&W ROLL FILMS

Film	ASA	Grain	Resolution	Available Formats
Kodak Technical Pan 2415	25	Ultra Fine	Ultra High	35mm
Agfapan 25	25	Ext. Fine	Very High	35mm, 120
Ilford Pan F	50	Ext. Fine	Very High	35mm, 120
Kodak Panatomic-X	32	Ext. Fine	Very High	35mm, 70mm, 120
Agfapan 100	100	Ext. Fine	Very High	35mm, 120
Ilford FP4	125	Ext. Fine	High	35mm, 120, 220
Kodak Plus-X Pan	125	Ext. Fine	High	35mm, 70mm, 120, 220
Kodak Verichrome Pan	125	Ext. Fine	High	110, 126, 120, 620
Agfapan 400	400	Fine	High	35mm, 120
Ilford HP5	400	Fine	High	35mm, 120
Kodak Tri-X Pan	400	Fine	High	35mm, 70mm, 120, 220
Kodak Tri-X Pan Professional	320	Fine	High	120, 220
Kodak 2475 Recording Film	1000-4000	Coarse	Medium	35mm
Kodak Royal-X Pan	1250	Medium	Medium	120
Kodak High Speed Infrared	80	Fine	Medium	35mm

photograph, select an alternative. Put your new film, developer, or both through the same Zone-System tests and analyses. You'll soon identify a few combinations that meet virtually all of your photographic needs. In this chapter I'll present and analyze several commonly used film-and-developer combinations to help you make your choices.

Accompanying tables list a variety of readily available films along with a few relevant facts regarding film speed, grain characteristics, resolution, and the formats in which these films are available.

PROFESSIONAL FILMS

Kodak manufactures several b&w films labeled *Professional*. This does not mean that they're intended for sophisticated professional photographers rather than amateurs. Nor does it imply that they're manufactured or must be used with greater care. The Professional designation is given to films you can retouch on both sides of the film base. In addition, Kodak Professional Films are manufactured so that their characteristic curve has a long toe.

In a long-toe film, almost all of the exposure zones that we normally encounter fall on the curved portion of the characteristic curve. This means that the density separation between zones in shadow areas is *less* than it is in highlights. As exposure zones increase in value, the slope of the characteristic curve, and hence the contrast or separation between adjacent zones continually increases. The visual effect produced is frequently desirable. However, a word of caution is in order.

Flare is non-image-forming light caused by unwanted reflections and scattering inside the camera. Flare is almost always undesirable because it has the effect of fogging film. As a result, image contrast, especially in the shadow areas, is reduced. Minimize flare by using multicoated lenses and lens shades. If you are using a view camera, you should be certain that your bellows is free from pinholes and that internal reflections are minimized.

Essentially, all modern lenses are multicoated. However, you may have an old large-format lens that was never coated. If so, flare is a very real problem for you. If you have such a lens, you can have it coated by International Optical Service Corp., 231 South Jefferson, Chicago, IL 60606. The cost is $15 to $20 per glass-to-air surface.

Professional films are most useful in the studio because you can control the lighting, and hence, the flare. They are often favored by portrait photographers and photographers doing still lifes

for advertising. I do not recommend Professional b&w films for general-purpose work or outdoors.

PAN VS. ORTHO FILMS

B&W films differ in their response to light of various colors, or wavelengths. Pure silver-halide crystals are sensitive only to ultraviolet radiation and some blue light. To make film respond to more colors—corresponding to the light we see—sensitizers are added to the emulsion.

Ortho Films—Orthochromatic films, commonly called *ortho films,* are sensitive to blue and green light and blind to red. Red reproduces relatively dark in the print. Ortho films, though used for general purposes a long time ago, are now largely limited to photo-reproduction applications and for scientific work.

Because they are blind to red, you can handle them in a darkroom in much the same way as you process photographic paper—under a dark-red safelight. For example, many high-contrast litho films, such as Kodalith, are orthochromatic.

If you use an ortho film for general-purpose photography, blue skies reproduce white and cloudless in the print and red lips reproduce black. This sensitivity makes some scenes look a bit strange because we have grown accustomed to seeing b&w prints made from panchromatic film. Even so, ortho films are fine for some photographic applications in which the tonal distortion adds impact.

Panchromatic Films—Also called *pan films,* these are sensitized to make their photographic response to light approximate that of the human eye. Pan films are affected by light of all colors, but are not equally sensitive to all of the colors that we see.

Pan films are designated as type A, B or C, indicating their different sensitivities to red. Type C has a greater sensitivity to red than the others. Kodak Pan-

atomic-X, Plus-X and Tri-X films are Type A films; Kodak Technical Pan Film 2415 is Type C.

One of the most powerful creative controls that you have in b&w photography is the control of tonal contrast with color filters. Pan film offers the most control with this method. Because this topic is extremely important for creative photography. I discuss it in detail in Chapter 8.

Infrared-Sensitive Films—These have extended sensitivity to the deep-red portion of the visible spectrum and some invisible infrared wavelengths too. They're widely used in scientific applications, but they also have significant creative potential for general-purpose photography.

Technical Pan Film 2415—It's a special-purpose film designed for line copying. It produces an extremely fine-grain negative when you use it according to the manufacturer's directions. You can also use it for general-purpose photography if high resolution and minimum grain are important to you.

The trade-off is its slow speed—about EI 25—and its slightly higher-than-normal inherent contrast. Because the inherent contrast of the film is very high, you must develop it in a special low-

SOME B&W SHEET FILMS				
Film	ASA	Grain	Resolution	Available Formats*
Agfapan 100	100	Ext. Fine	High	c
Ilford FP4	125	Ext. Fine	High	a, b, c, d, e
Kodak Ektapan	100	Fine	Medium	a, b, c, d, e, f, g
Kodak Plus-X Pan Professional	125	Very Fine	High	a, b, c, d, e, g
Kodak Super-XX Pan	200	Medium	Medium	b, c, d, e, f, h
Agfapan 400	400	Fine	High	c
Ilford HP5	400	Fine	High	a, c, e
Kodak Tri-X Professional	320	Fine	High	a, b, c, d, e, g, i
Kodak Tri-X Ortho	320	Medium	High	c, d, e
Kodak Royal Pan	400	Fine	Medium	a, b, c, d, e, f, j
Kodak Royal-X Pan	1250	Medium	Medium	c
Kodak High Speed Infrared	80	Fine	Medium	c

* a = 2-1/4x3-1/4 inch; b = 3-1/4x4-1/4 inch; c = 4x5 inch; d = 5x7 inch; e = 8x10 inch; f = 11x14 inch; g = 9x12 cm; h = 10x12 inch; i = 18x24 cm; j = 12x20 inch.

energy developer that minimizes negative contrast. Kodak Technidol LC developer is designed for this purpose.

Technical Pan Film 2415 is available in 35mm rolls and as 4x5 sheet film. It's capable of producing enlarged prints with incredibly fine grain and image resolution. Prints made from 35mm negatives rival photos made from large-format negatives.

Getting this kind of quality requires special care. You must use a tripod at all times because film speed is slow. Any camera shake recorded on film will also be magnified when you enlarge the

negative. Even though I do not recommend Technical Pan Film 2415 for everyday shooting, it does have its uses. For example, it's very good for photographs in which fine detail is important, such as in landscapes and still lifes.

DEVELOPERS AND DEVELOPMENT

Correct negative development is as important as negative exposure. As shown earlier, development offers negative-contrast control that's fundamental to the Zone System. This section describes the effect of developers on film. The information will help

For an "orthochromatic effect," you can use either ortho film or a blue #47B filter with panchromatic film. Typical results with landscapes are white skies and dark reds and yellows.

Virtually all general-purpose b&w films used today are panchromatic. Generally, they reproduce brightness values similar to the original scene, but are usually more sensitive to blue than red. Compare this photograph to the orthochromatic rendering of the same scene.

Kodak Technical Pan Film 2415 can be used as a general-purpose film when processed in Kodak Technidol LC developer. Because of its ultra-fine grain, you can enlarge the 35mm negative up to 50X and still get fine-grain results. This photograph is a section of an enlarged 35mm negative.

you select and use a developer that's compatible with your film for the applications you have in mind.

When you expose film to light of sufficient brightness, a complex physical change occurs in the silver halides of the emulsion. Exposure produces a *latent image*—one that waits for development to become visible. This latent image is stable indefinitely on undeveloped b&w film if the film is kept dry and cool.

In fact, I've seen negatives that were developed *40 years* after exposure. They produced negatives of acceptable quality, though b+f density was higher than normal. To get the best possible negative quality, try to develop film as soon as possible after exposing the film.

Reducing Agents—During development, the developer converts the latent image to a visible one. Basically, the developer solution contains water as a solvent, and a reducing agent or agents. These react with the latent image on the silver halides and convert the silver halides to metallic silver.

Most film developers have high-energy and low-energy reducing agents that work in combination to produce negatives with a desirable balance between shadow and highlight detail. High-energy reducing agents build negative density in the highlight regions—densest areas—of the negative. Low-energy reducing agents develop the shadow areas of the negative.

Most film developers use a mixture of *hydroquinone* and *metol*. Ilford *Phenidone* acts like metol, but has a different chemical composition. Hydroquinone is a high-energy reducing agent used to quickly build contrast and highlight detail in the negative. It creates density in the high zones. Metol and phenidone are low-energy reducing agents that promote the development of shadow detail and low-contrast negatives. They slowly work on the low zones.

Generally, Kodak developers are formulated with Elon, a Kodak trade name for metol. Ilford products use Phenidone. Both kinds of developers can give excellent results when you use them correctly. Because some people develop a skin allergy to products containing metol, pheni-

done formulations are currently an attractive alternative.

Accelerators—Developers act very slowly unless the solution is made alkaline—pH greater than 7.0. Pure water is neutral—pH of 7.0—and development with metol/hydroquinone solutions will not occur at a useful rate in a neutral solution.

To increase the development rate, one or more basic reagents such as *borax, sodium carbonate* or *sodium hydroxide* is added to the developer. These *accelerators* increase the alkalinity of the developer, thereby increasing development rate.

In some towns and cities, the water supply can become abnormally alkaline. This can result in a much faster development rate than the manufacturer's recommendations would have you expect. Because of the uncertainties that exist in the quality of water supplies in many places, I recommend that you use distilled or demineralized water for your developer solutions. Either type of purified water is relatively inexpensive and readily available in most grocery stores. Using it removes one more variable that could prevent you from getting consistent, reproducible results.

Anti-Oxidants—Developers react with air and decompose through a process called *oxidation*. To prevent oxidation, which results in a loss of developer activity, the manufacturer adds a preservative called an *anti-oxidant*.

Sodium sulfite is the most commonly used anti-oxidant preservative. It has the useful additional property of producing mildly alkaline solutions, thereby also serving as an accelerator.

Sodium sulfite solutions are also considered to have a slight

ability to dissolve silver salts and inhibit the growth of large silver crystals. When you use a developer with high concentrations of sodium sulfite, the silver grains produced are smaller with edges and corners rounded. The result is finer negative grain with the sacrifice of some sharpness.

Restrainers—Metallic silver, which is produced by development, can trigger the development of adjacent *unexposed* silver-halide crystals. This results in chemically produced fog. Manufacturers minimize this undesirable side effect with restrainers.

Benzotriazole is a highly effective restrainer, though a small amount of less-expensive *potassium bromide* is most commonly used in general-purpose developers. Bromide salts not only minimize fog, but also inhibit development. Although this inhibition results in the loss of actual film speed, the overall effect is generally beneficial. It produces a *compensating*

effect during development. This means that development of shadow detail occurs while full development of the denser highlights is slightly diminished.

As silver halides are reduced to silver by the developing agent, bromide ions in the emulsion are released in the region where chemical reduction has occurred. These bromide ions slow the rate of further reaction in that region of the negative. Other areas of the film continue to be affected by the developer. As a consequence, development in the least exposed areas—the shadows—is favored relative to the more highly exposed areas—the highlights. This is another example of the compensating effect.

The degree of this compensating effect is influenced by agitation. With *constant agitation* of the film during development, fresh developer is always being washed across the surface of the film. A negative developed with constant agitation

shows an overall increase in density as well as contrast, relative to a negative that has been developed with *intermittent* or no agitation.

Intermittent agitation at either 30-second or 1-minute intervals promotes a desirable compensating action for most negatives. Either method of agitation can be used successfully, but most photographers prefer intermittent agitation. The important thing is to be consistent in your method, so your results are predictable and reproducible.

Some Other Chemicals—For developers intended for use at higher-than-normal temperatures, *sodium sulfate* is added to the formula to toughen the gelatin base. This inhibits softening of the support, emulsion deformation

Because infrared-sensitive film is sensitive to invisible infrared radiation, it can give special images. It's panchromatic, so for best results, you should block blue light from the film. When you use a red filter, green is rendered as white and blue skies are black.

called *reticulation,* and negative scratching.

Special hardening baths formulated with *chrome alum* can be purchased for high-temperature development. In addition, you can presoak the film in the bath before development to harden the emulsion. You should consider using a hardening bath if you must work with solutions warmer than 80F (26.5C).

DEVELOPMENT VARIABLES

When using any developer, you should control four main variables. These are developer temperature, development time, developer dilution and film agitation. Each has a big effect on results, so careful control is essential.

DEVELOPER TEMPERATURE

The developer temperature affects both development rate and negative contrast. There are two reasons for this:

1) Almost all chemical reactions proceed more rapidly as you increase the temperature of the reaction. With most developers, the best working temperatures are between 65F and 75F (18.5C and 21C), although satisfactory results are possible at higher or lower temperatures. A drawback to developing outside of this range is that development times can become inconveniently short or long.

2) Low and high temperatures have a big effect on hydroquinone. The reducing potential of hydroquinone used with metol or phenidone decreases at temperatures below 50F (10C) and becomes very reactive at temperatures above 80F (26C).

In the range of 65F to 75F (18.5C to 21C), the relative reactivities of metol or phenidone with hydroquinone are well balanced. Below this range, low-energy reducing agents—shadow-area developers—dominate the development process, giving nega-

tives with lower-than-normal contrast. At temperatures above this range, hydroquinone begins to have a disproportionate influence, so negative contrast is greater than normal.

When you develop film, it's important to keep the temperatures of *all* solutions as constant and as close together as possible. For example, I try to keep all solutions within 1F (0.5C) of each other. You should consider a similar tolerance. It's not difficult to have all of your solutions at the same temperature in a water bath and work in the temperature range of nearly room temperature.

Temperature is not an easy variable to control during the wash cycle unless your darkroom is equipped with expensive thermostatically controlled plumbing. I find that it's perfectly satisfactory to raise or lower the temperature of the film gradually to the ambient temperature of the water supply by changing the temperature of static water baths in 2F (1C) increments. I then continue to wash the film at the ambient temperature of the water supply.

DEVELOPMENT TIME AND AGITATION

From the discussion of characteristic curves in Chapter 6, you know that development time is a critical variable. This control offers you the best opportunity to manage negative contrast. To develop a negative correctly, you need to control both the total time that the film is in contact with the developer and the interval between agitation cycles.

Processing Roll-Film—If you develop roll film in a small tank, you should start the timing clock at the moment all of the developer is in the tank. A good way to do this is to fill the developing tank with developer to the correct level, turn off the room lights, and drop the loaded film reel gently into the tank. Start your timer at that instant. Cap the tank, turn on the lights, and begin the agitation

cycle you've standardized.

I recommend you agitate the tank by inverting it with a twisting of your wrist. Do this gently—you're not mixing a cocktail—and continuously for the first 15 seconds of development. Replace the tank in the water bath. At 30-second intervals, give the tank three inversions and then let it sit undisturbed in the water bath until it's time to agitate the tank again.

This procedure, which should be your standard agitation technique, assures a constant renewal of developer at the film surface. The undisturbed time between agitations gives some compensating action. For reproducible results, using the same agitation technique for each roll of film is as important as controlling the temperature and developer concentration.

Some photographers prefer to use mechanical devices that agitate the film constantly during development. Constant agitation yields negatives with more contrast than those produced from intermittent agitation. This is because there is always fresh developer in contact with the film surface and no compensating development. Either agitation method works—just be sure to be consistent.

About 10 seconds before it's time to end development, pour out the developer. Add the stop bath to the tank and continue the process.

Processing Sheet Film In A Tray—When you develop sheet film in a tray, I recommend that you *presoak* the film in a water bath for 30 seconds before development. Be sure the water is nearly the same temperature as the developer. This assures uniform development. And, if two sheets of film inadvertently stick together, you'll have an opportunity to separate them without causing uneven development. I speak from sad experience.

Mark the first sheet of film in the deck that you plan to develop by clipping a corner. Start your

timer as soon as you slip the clipped presoaked sheet into the developer. Add the remaining sheets sequentially as quickly as you can and begin agitation by removing the marked sheet from the bottom of the pile and placing it on top.

Continue this process throughout development. At the end of development, continue shuffling the films until the marked one is again on the bottom. Transfer the sheets one at a time—beginning with the bottom clipped one—to the stop bath at the same rate that you transferred them to the developer.

Processing Sheet Film In A Tank—If you prefer to develop sheet film using a deep tank and film hangers, simply start your timer the moment you immerse the films in the tank. Agitate the film at 60-second intervals by lifting them gently and tilting them as described at right.

Be careful when you do this because too vigorous agitation can dislodge the film from the film hanger. This is especially true with 5x7 or larger film sizes or with thin-base 4x5 sheet films from film packs. For this reason, as well as economy of solutions, I prefer to use tray development for sheet film.

The importance of consistent and effective agitation is something that I cannot overemphasize. If you allow your film to sit undisturbed in the developer, oxidation products produced during development will locally inhibit further development in that region. These products can run down the surface of the film and cause negative streaking.

Good photographs are too hard to come by for you to be careless about agitation during any part of development or fixing. When you are clearing the film with fixer, agitate the film constantly.

ABOUT DILUTION

Most developers are sold in powder form or liquid concen-

Here's a good way to agitate film when you use deep-tank development: For each minute of development, lift the hangers, tilt them to one side and put them back into the solution. Lift them out again and tilt them to the other side. Put them back in the tank. Photo courtesy of Eastman Kodak Co.

trates from which you prepare a *stock* solution. This is further diluted for a *working-strength* solution.

Dilution Ratio—This ratio, such as 1:2 or 1:3, represents the relative amount of stock to water. For example, when instructions recommend that you dilute stock developer 1:3 to make a working-strength solution, you add one volume of developer to three volumes of water. Suppose you want to make 16 ounces (475 ml) of working-strength developer using a 1:3 dilution of stock developer. Add 4 ounces of stock to 12 ounces of water.

To calculate correct volume of stock and water for any final volume of working-strength developer, first add the numbers in the dilution ratio:

$$1 + 3 = 4$$

Then divide the working-strength volume by that number:

$$16 \, oz. / 4 = 4 \, oz.$$

Multiply this number by each number in the dilution ratio to get the correct volume for stock developer and water:

$$4 \, oz. \times 1 = 4 \, oz. \text{ stock}$$
$$4 \, oz. \times 3 = 12 \, oz. \text{ water}$$

One-Shot Developers—If you develop film occasionally—one or two rolls a month—you may want to consider *one-shot developers*. These are sold as highly concentrated liquids that you dilute greatly, use once, and discard. They're more expensive than standard formulations that you use and replenish, but developers do not keep for more than a couple of months. It may be less expensive in the long run to use one-shot developers rather than discarding a large volume of unused, but oxidized, stock developer.

For example, Rodinal is a highly concentrated developer that can be diluted from 1:25 to 1:100. Because you usually need a small volume of stock solution, you must be careful when measuring the concentrate.

The best way to do this is with a calibrated syringe that you can purchase either at your photo store or a drug store. Withdraw the amount of Rodinal that you

need from the concentrate and add it to the correct volume of water at the proper development temperature.

Suppose you need 500 ml of developer at a dilution of 1:100. Take 5 ml—or 5 cc, it's the same thing—of concentrate and add it to 500 ml of water.

OTHER PROCESSING SOLUTIONS

Following is a useful review of what you should know about other processing solutions and steps. Each processing step demands good technique. For example, if you don't dry your negatives carefully, you'll waste all of your previous exposure and processing work.

STOP BATHS

After completing the development cycle, you need to stop the action of the developing agents abruptly. The easiest way is to transfer the film to an acidic solution, which inactivates the developing agents. A 1% solution of acetic acid—made by adding 10 ml of glacial acetic acid or 35 ml of 28% acetic acid to a liter of water—is adequate. The stop bath neutralizes any of the developer that is carried over from the previous step. If the stop bath is too acidic, pinholes may form in the negative.

Some manufacturers recommend that you do not use an acid stop bath and that a rinse in plain water is sufficient. I disagree, because water alone will not terminate development fast enough. Residual developer absorbed in the swollen emulsion continues to react until it is chemically neutralized or diluted to an insignificant concentration.

FIXING THE NEGATIVE

After stopping development of the latent image, you then remove *all* of the undeveloped silver halides. You do this by agitating

the film in a fixer solution, which contains a silver-halide solvent. The solvent most commonly used for this is *sodium thiosulfate,* sometimes called *hypo.* Rapid fixers contain *ammonium thiosulfate,* which works faster than sodium thiosulfate.

You must be careful not to fix film too long in any fixer, but particularly rapid fixer. Because thiosulfate ions can also dissolve metallic silver, you should not allow your film to soak in the fixer longer than necessary because the image will begin to bleach, particularly in the thin parts of the negative. These correspond to shadow areas in the print.

Other Fixer Chemicals—At the end of development, the emulsion is very soft and fragile. To minimize negative abrasion during handling, manufacturers add hardening chemicals to toughen the emulsion. Other reagents are added to control fixer acidity and to prolong its life.

Useful Life—Because fixers are not very stable over a long period of time, you shouldn't keep them for more than two months, even if you do not use them. They can decompose to form complex ions that are very difficult to remove from photographic film or paper.

Do not attempt to overuse a fixing bath. A general rule of thumb is to discard the fixing bath

when the fixing time is twice as long as that required when it was fresh.

To determine that time requires you to look at the film while it is clearing. You can do this safely after you have agitated the film in the fixer for about two minutes. At this point light will not affect the film adversely. Total fixing time is twice clearing time.

If you fix the film in an overused fixer, insoluble silver-sulfur complexes form that can't be removed from the emulsion. Over time, these decompose to brown silver sulfide, spoiling the negative for further use. Overusing a fixer bath is poor economy.

WASHING THE NEGATIVE

Correct negative washing is vital. It's made easier with *washing aids.* They speed up wash time by freeing the negative of most unwanted contaminants. Some useful washing aids are Kodak Hypo Clearing Agent, Heico Perma Wash and Beseler Ultraclear HCA.

Typically, you use a washing aid after a one-minute water wash after fixing the image. The water rinse removes some excess fixer still in the film. Then, soak the film in the washing aid for the recommended time with the recommended agitation. Carefully read the directions that come with

These two negatives were exposed and developed identically. The negative at left is lighter because it was in the fixer for one hour. It faded and lost much shadow detail. Fixing a negative for about twice the time required to clear it is adequate and safe.

the washing aid; they're based on tests made by the chemical manufacturer.

Next, wash the film in rapidly running water for at least 5 minutes. The flow rate of the wash water should be sufficient to assure at least 10 complete changes of water in those 5 minutes.

You can purchase a rapid film washer that insures a turbulent flow of water around the film during the wash. This type of washer is useful, but you can thoroughly wash negatives without one. Washing is a *diffusion-controlled process* so the important thing to control is changing water, not soaking the negative. Be sure to move the film about during the wash.

Solutions of ammonia and hydrogen peroxide are called *hypo eliminators*. They react with thiosulfate ions and convert them to chemically inert, water-soluble sulfate ions. There is no compelling reason to use a hypo eliminator because you can do the same thing with thorough washing.

After you wash the film, soak it for about 30 seconds in distilled water containing a few drops of Kodak Photo-Flo or a similar wetting agent. This reduces formation of water marks or residues from hard water on drying.

Wipe the film carefully with a damp, chemically pure sponge and hang it in a dust free place to dry. Store your negatives in suitable film sleeves when they are completely dry.

HOW TO PROCESS ROLL FILM

Developing roll film is easy, but if you want consistently good results, you must standardize your technique and control the variables of temperature, time and agitation. The following method works well for me.

1) Prepare all of the solutions you'll need and bring them to the correct temperature. Place the bottles in which you hold the solutions in a tray of water adjusted to the working temperature. The depth of the water should be such that at least half of the bottle is submerged. The tray of water will hold the solutions at a constant temperature during development.

Bring processing solutions to a uniform temperature before processing film.

2) Fill the processing tank with developer to a level about 1/4 inch below the rim. Place the tank in a tray of water at the developer temperature.

3) Set your timer for the appropriate development time, turn out room lights, and load the film onto the reel provided with your processing tank.

Put developer in the processing tank when it is at the correct temperature. Turn out room lights, load the reel with film, and put it into the tank.

4) *Gently* drop the reel into your processing tank, start the timer, and cap the processing tank.

5) Agitate the film by inverting the tank and righting it continuously for the first 15 seconds. Turn on the lights. Return the processing tank to the water tray between agitation cycles.

6) Agitate the tank by inverting it three times during five seconds every 30 seconds. Or, choose an agitation cycle you like better, but after you make a choice, be consistent.

7) About 10 seconds before the end of the development time, pour out the developer. This provides you with enough time to drain the tank at the end of the allotted development time. Pour the stop bath into the tank and agitate for 30 seconds.

8) Pour out the stop bath, pour in the fixer, and agitate the tank continuously for one minute. After that, agitate for at least 15 seconds every minute. When two minutes have elapsed, you can safely remove the lid from the tank and look at the film.

If the film has cleared, allow it to stand in the fixer for another two minutes with occasional agitation. If the film has not cleared, continue the fixing cycle and note the approximate time that it takes to clear the leader of the film. Continue fixing for twice that time. You will find that slow-speed films clear in less than two minutes in fresh fixer; faster films require about twice that time.

9) Rinse the film briefly in fresh water and then pour a washing aid into the tank. Allow the film to soak in this solution for two minutes or the time recommended by the manufacturer.

10) Wash the film thoroughly. You can do this in a number of ways, but whatever procedure you use, be certain that at least 10 complete changes of water occur.

The simplest way is to insert a hose that is connected to a faucet down into the center of the reel. Allow a stream of water to run through the tank for 10 minutes. If you do not use a washing aid, you should wash the film for at least 20 minutes.

The key to washing film is a turbulent flow of water over the film surface. One way is to insert a hose into the center of a spiral reel in the tank and use a forceful stream of water. You can also buy roll-film washers to do the same thing

11) Replace the wash water with distilled water, add a few drops of wetting agent to the tank, and allow the film to soak for a minute with gentle agitation. Remove the film from the tank and reel and attach a film clip to each end. Hang the film in a dust-free place.

Remove any excess water by wiping the film with a clean, damp sponge or by drawing a clean, wet squeegee gently down the length of both sides of the film. You can also run the film between two wet fingers, applying gentle pressure.

12) If you reuse your developer, replenish the developer solution and record the number of rolls of film that have been developed in that solution. Do not attempt to keep a developer for more than six months, even if storage conditions are ideal. The developer *may* still be good, but why take a chance?

13) When the film is dry, cut it into lengths that fit into glassine or polyethylene storage envelopes. Place the negatives in the envelopes and label each one with pertinent data and facts.

HOW TO PROCESS SHEET FILM

As with developing roll film, standardizing your working procedures is necessary if you expect to be able to achieve predictable and consistent results.

1) Prepare all of the solutions that you'll need and bring them to the temperature at which you plan to develop your film. Prepare enough developer so you will have about 100 ml (about 4 oz.) of solution for each 4x5 sheet of film that you develop. For 5x7 film, use 200 ml (about 8 oz.) per sheet and for 8x10 film, 400 ml (about 17 oz.).

2) Arrange four trays in sequence on top of your workbench. Make certain that there are no rough spots on the bottom surface of the trays that might scratch the film. The first tray should be half-filled with water at the same temperature as the developer, the second with developer, the third with your stop bath, and the fourth with fixer.

3) Set the timer and turn off the lights. On a clean and dry surface, remove the sheets of film from their holders and place them face down on the table. If you have films requiring different development times, devise a system of marking your film so the sheets can be identified in the dark while you are developing them.

I clip about 1/4 inch from the upper-right corner of the film if N+ development is called for and the same from the upper-left corner for sheets requiring N− development. Films for normal (N) development are unmarked. The manufacturer's film-code notches in the upper-right corner—when emulsion is up—help me to remember the orientation of the different sheets of film.

4) Stack the films into groups, according to whether they require N−, N, or N+ development. Transfer sheets of a group one at a time into the water bath so the emulsion side of the film faces down. Be certain to keep the hand that you use to pick up the sheets of film dry or you may find that you suddenly have a stack of sheet film that is all stuck together.

A light box is a convenient way to view and examine negatives. These negatives are stored and handled in transparent sleeves for protection.

If you want to process sheet film but don't want to use a deep tank or tray, consider the JOBO large-format tank. Each reel holds up to six sheets of 4x5 film. And, you can load two reels into the tank, shown in the background.

In my opinion, tray processing is the easiest and most economical way to handle sheet film. Agitate the film by sliding out the film on the bottom of the pile and placing it gently on the top. Continue this cycle throughout development. The emulsion side of the film should be toward the bottom of the tray during development to minimize the danger of scratching. When the code notches are in the upper-left corner, the film's emulsion is facing away from you.

Transfer the film from the hand with which you pick it up to your other hand and then gently submerge the film in the water bath. Continue this procedure until all of the film is in the water bath. Shuffle the films through one complete cycle by moving the bottom sheet to the top of the pile and so forth until the stack is back to its original order. You can recognize this by distinctively marking your lead film, for example by clipping a bottom corner. You must be very gentle as you shuffle through the pack so you do not scratch the emulsion.

5) Start the timer and begin transferring sheets of film to the developer, one at a time. Start with the sheet on the bottom of the stack in the water bath. Continue to shuffle the films during the entire development cycle.

If some of your film requires a shorter development time than others, transfer the sheets to the stop bath by picking them up with one hand, transferring them to the other, and placing them in the stop bath to stop further development.

Never put the hand that came into contact with the stop bath back into the developer without rinsing it in water first. You can use either a quick rinse from your faucet or the water bath for this purpose. It will not hurt the film that is in the developer to sit idly for a moment.

If you have a single sheet of film to process, agitation is still important. In this case, I recommend that you continually remove the negative from the tray and replace it, upside down. Maintain a slow and steady rhythm.

6) When all of the film has been developed for the required time, transfer the sheets to the stop bath for about 30 seconds.

7) Then transfer them to the fixer. Shuffle the film in the fixer. After two minutes you can safely turn on the lights. You must agitate the films constantly in the fixer for twice the time necessary to clear them. Otherwise, there's a possibility that they may selectively bleach in areas that receive more contact with fresh fixer. If this should occur, your negatives may be ruined.

8) After the negatives have been fixed, transfer them to the water bath to remove any excess fixer and then into a bath containing a washing aid. Shuffle the films for two minutes and then wash the negatives for 10 minutes.

Washing sheet films can be a bit of a problem. If you must wash them in a tray, you can wash only one sheet at a time or else you run the risk of sheets scratching each other.

A good way to wash 4x5 sheet film is to put individual sheets in film hangers. Stack these in a hard-rubber tank to wash the film. Or, if you can find one, get a bucket made by Polaroid for use with their positive/negative film. The bucket contains a rack that holds eight sheets of film at a time. You can put a hose down into the bucket and wash the film as you would roll film.

9) When you've completed the washing cycle, add a few drops of wetting agent to a tray of distilled water. Allow the negatives to soak for a moment and then remove

A Polaroid bucket for processing positive/negative films makes a convenient sheet-film washer—if you can find one. Unfortunately, the bucket is no longer made, but you may be able to fashion something similar. The rack holds eight sheets of film, and a hose inserted to the bottom of the bucket provides a turbulent flow of water.

them from the bath. Attach a film clip to a corner of the sheet and squeegee excess water from the film surface. Hang the film in a dust-free place to dry. Store and label each sheet of film in a glassine or polyethylene envelope.

Deep-Tank Processing— You can also develop sheet film in deep tanks, using hangers that hold the

The ZONE VI Sheet Film Rack (above) is another useful device for washing sheet films. It holds up to 30 4x5 negatives and fits into the ZONE VI Washing Machine (below) or the Archival Print Washer. These and other fine photographic items are available from ZONE VI Studios, Newfane, VT 05345.

film during the entire processing cycle. Though the procedure is simpler in many ways, it does require large volumes of solutions. Unless you develop large quantities of film, this can be an expensive use of chemicals. The procedure is as follows:

1) Set three deep processing tanks in your sink and fill them sequentially with developer, an acid stop bath and fixer. Set your timer.

2) Turn off the room lights and load the film into the film hangers.

3) Gently lower the hangers into the developer and start the timer. Agitate the film by lifting the hangers several inches and rocking them sideways at 30-second intervals.

4) At the completion of development, lift the hangers gently from the developer and transfer them to the stop bath. Agitate gently for 30 seconds and move the hangers into the fixer.

5) Fix the film in the usual way and wash the sheets of film by passing a hose into the bottom of a tank into which the film hangers have been set. I recommend the use of a washing aid before the wash cycle.

6) When washing is finished, remove the films from the hangers and finish processing them as previously described for tray processing. Do not attempt to dry the negatives in their holders. They will stick to the hangers and you are likely to damage them when you separate them from the holder.

CHOOSING A DEVELOPER

There is no universal developer that will deliver maximum film speed, very fine grain, high resolution and excellent tonal gradation for each kind of film you use. Some of these characteristics are possible only if you are willing to sacrifice others.

For example, to realize the maximum possible film speed for a film, you will need to settle for increased apparent graininess. Different developers will emphasize special aspects of a film, such as speed, grain, or resolution. Some are designed to give a compromise of these factors.

To help you to make some basic choices, I selected three films from the category of slow-, medium-, and fast-speed films. I photographed the same scene with each film and developed the films in seven developers representing different developer categories. Each negative was enlarged to a 15X linear enlargement and I printed an 8x10 inch segment of the photograph. I evaluated each print and report my findings here. The results are subjective, but highly informative.

This survey is by no means intended to be exhaustive. The absence of a film or developer from my tests is merely a reflection of my inability to test all possible combinations in a reasonable time. The developers evaluated are Agfa-Gevaert Rodinal, Diafine, Acufine, Kodak Microdol-X, Kodak HC-110, Ilford ID-11 Plus, and Edwal FG7.

Agfa-Gevaert Rodinal—This developer, commonly known as *Rodinal,* has been used by photographers for over a century. It is sold as a highly concentrated solution that you dilute just before use. Its reducing agent is para-aminophenol. Potassium hydroxide, a strong alkali, is used as the accelerator. Its continued popularity is a tribute to its remarkable properties.

Rodinal is a compensating developer. Compensating developers produce negatives that are well balanced in terms of highlight and shadow densities. This is an asset when you enlarge negatives a great deal.

Rodinal *is not* a fine-grain developer, but it produces the most sharply defined grain of any known developer. This makes it most effective with slow-speed, fine-grain films. Negatives from these films have incredibly good resolution of fine detail, overall image sharpness and definition in shadow details.

With medium-speed films, apparent graininess increases. For moderate degrees of enlargement, it is not distracting. For high-speed films, the images are extremely sharp, but the grain is so apparent that I find it distracting. In my opinion, Rodinal is an excellent developer for slow-speed and medium-speed films. There are better developers for high-speed films.

Diafine—Diafine is a two-bath developer containing reducing agents in one solution and an accelerator in a second. It produces fine-grain negatives and increases film speed for every type of film. At a given temperature, all types of film are developed to the same contrast. Therefore, you can develop slow-, medium-, and fast-speed films simultaneously in the same tank.

As I pointed out earlier, development in Diafine is exclusively temperature-dependent, so you can increase negative contrast by developing film at a temperature higher than 68F (20C). The higher the temperature, the greater the negative contrast. This is not an easy way to control contrast.

Diafine's simplicity to use and its exceptionally long shelf life make it a useful product. Diafine enables you to photograph in dimly lit places that would otherwise be tough to shoot in. In my opinion, the negative grain you get with Diafine is far less objectionable than that which you get by prolonging development in a standard hydroquinone/metol developer.

Diafine is an excellent choice when you need higher-than-normal film speeds and fine-grain negatives. As a compromise, you must be prepared to accept a limit on contrast control. If you are prepared to do some careful tests on the effect of temperature variation on the shape of the characteristic curve, you may be able to add another element of control.

Acufine—Acufine is a developer that produces fine-grain negatives with slow- and medium-speed films, while also delivering a boost in film speed of 2 to 3 times the ISO rating. Unlike Diafine, Acufine is a single-solution developer. You can vary the overall image contrast by increasing or decreasing development time.

In my experience, the results that I obtained with high-speed films were unsatisfactory due to excessive graininess. More satisfactory developers are available for these types of films.

Acufine is a member of a class of developers called *high-acutance* developers. They work on the surface of the film, making them useful with today's thin-emulsion films. You must be careful to avoid overexposure because the negative will become excessively dense and grainy.

For many photographers who use the 35mm format extensively, Acufine is the developer of choice with slow-speed films such as Kodak Panatomic-X, Ilford Pan F, or Agfapan 25. I found that it worked well with all of these.

Kodak Microdol-X—This developer produces very fine-grain negatives with *all* classes of films. The price that you have to pay for fine grain is loss of film speed—usually less than one exposure step, along with a slight but noticeable loss in image sharpness.

Microdol-X contains a high concentration of sodium sulfite, which seems to act as a solvent for silver compounds. The silver grains formed during development are smaller than normal and smooth so that the grain is difficult to see when you make an enlargement. A consequence of this is that lines and edges are not as sharply defined as they would be if you were to compare the image to one produced with Rodinal development.

With medium- and fast-speed films, grain is minimal. You can make an 8x10 print from a 35mm negative and find it difficult to see

any grain. I can recommend Kodak Microdol-X whenever fine-grain or a high degree of enlargement is a primary consideration.

Kodak HC-110—This product is a general-purpose developer delivering moderately fine grain at no sacrifice of film speed. The developer is sold as a highly concentrated liquid that you dilute to use. An advantage of this developer is that you can use it in a broad range of dilutions to control both development and graininess. Reduce grain by diluting the developer more. Another feature of HC-110 that I like is that it is convenient to use on a one-shot basis. You mix enough to develop the film on hand and discard it when you are finished.

Because HC-110 is not a fine-grain developer, I favor its use for 120 roll film or sheet film, in which grain is not a major concern. To make a stock solution of HC-110, dilute the concentrate with three parts of water.

The most common dilution is 1:7, called *B*. Prepare it by diluting one part stock solution with seven parts of water. For sheet film, use 100 ml (4 oz.) of dilution B for each 20 square inches (1 4x5 sheet) of film. In terms of convenience and all-around performance, HC-110 is very useful.

Ilford ID-11 Plus—For many years, Kodak D-76 and Ilford ID-11 were the standard developers for film against which all other developers were judged. The developers are practically identical except that D-76 is formulated with metol and ID-11 uses Phenidone in its place. For all practical purposes, their results are indistinguishable.

As a result of its research in color photography, Ilford has discovered that the addition of a small amount of a proprietary chemical complexing agent dramatically reduces the apparent graininess normally associated with ID-11. Though I was skeptical of this claim, I was delighted to find that it's true. And the effect is striking!

I exposed and developed Ilford HP5 (ASA 400)—which is comparable to Kodak Tri-X or Agfapan 400—in all of the aforementioned developers at film speeds recommended by manufacturers for their product. I compared 15X enlargements of the 35mm negatives.

The grain produced with Ilford's ID-11 Plus was *just* perceptibly

For still-life subjects, you don't need a fast film because the camera should be mounted on a tripod. Use a slow-speed film and a fine-grain developer. This combination promises excellent image sharpness and tonal gradation.

coarser than that obtained by using Kodak's Microdol-X, but I judged the image to be slightly sharper. Furthermore, there is *no* loss of film speed when you use Ilford ID-11 Plus.

In my opinion, these results are so impressive that I recommend Ilford ID-11 Plus as the developer of choice with fast films. This developer also works well with extended development times when you need to expand negative contrast. Ilford ID-11 Plus is also a fine developer for you to use with slower films, but its advantages are not as obvious with these because grain does not tend to be a problem.

Edwal FG7—This is a liquid concentrate that can be used in a variety of ways. My tests have shown that it will produce a fine-grain negative with all classes of film, but unless you dilute the developer with a 9% solution of sodium sulfite, the fine-grain effect is minimal. This takes away from the inherent attractiveness of a one-shot liquid concentrate.

An advantage of Edwal FG7 is that it doubles the normal film speed associated with most films while delivering very fine grain if you use the recommended dilution with a 9% sodium sulfite solution. It's a suitable developer to use with films requiring much enlargement.

Developer Summary—Throughout this book I have urged you to test your equipment and the materials that you use in a thoughtful and systematic way. I suggest that eventually you should do the same with every film and developer that you want to try.

But if you start out this way, you may get so tied up in tests that you never get around to photographing. And creating photographs is, after all, why you acquired a camera. Let me suggest a shortcut.

Select a slow-speed and a fast-speed film if you own a camera that uses roll film. If your camera uses sheet film, choose a fast-speed film.

For your slow-speed roll film, I recommend that you use any of the aforementioned developer classes that you believe will most often fit your photographic circumstances. For example, if sharpness is a primary concern and necessary to create images with the impact that you are seeking, you might select Rodinal. If fine grain plus speed is important, Diafine, Acufine, or Edwal FG7 may be a better choice. For fast-speed roll film, I recommend Ilford's ID-11 Plus. With sheet film, Kodak HC-110 is an excellent choice.

Regardless of what films and developers you decide to use, determine EIs and the development times necessary to expand and compress negative density, along with your normal development time as described. Then go out and photograph. Don't think about changing anything until you have taken several hundred pictures.

Never make a change until you are convinced that the materials you are using are incapable of producing what you need. Typically, problems occur because you are not using a product properly. However, if you are convinced that the weak link in the photographic chain is not you, then make a change of film or developer. This way, you'll be concentrating on making the best pictures you can rather than spending all of your time looking for a magic combination of film and developer.

CHROMOGENIC B&W FILMS

A recent innovation in b&w photography is *chromogenic* b&w film. Chromogenic *(color generating)* films are based on color-negative technology. With chromogenic b&w films, the mass of dye molecules that make up negative density are colored black.

The chemical processes that produce the chromogenic negative are different from those of traditional b&w processing, but the principles of exposure, development and using the negative are the same as with conventional films. Some interesting differences exist. Here's how the films work.

Chromogenic B&W Film Characteristics—A plastic film base is twice-coated with a blend of silver halides and complex organic molecules called *color couplers*. The two layers differ in their light sensitivity. The top layer is a high-speed emulsion, and the bottom layer is a slow-speed emulsion.

When the film is exposed to light, silver halides are "activated" and produce a latent image. The developer, which is different from conventional b&w types, reduces the latent image to metallic silver. The silver formed works as a catalyst on the color couplers and initiates generation of microscopic dye clouds around the silver crystals. At the end of development, developed silver and unexposed silver halides are removed by a bleach-fixing (blix) bath. The negative is subsequently washed free of the soluble residual chemicals.

A chromogenic b&w negative looks different from an ordinary b&w negative because the film base is colored—pink to plum or magenta—and the film base density is greater—about 0.25 to 0.30. However, you print the negatives the same way as silver-based b&w negatives.

At the time of this writing, two chromogenic b&w films are commercially available. These are Agfa-Gevaert Agfapan Vario-XL and Ilford XP1. Both films are nominally rated at ISO 400/27°. However, the manufacturers claim that you can expose the film at different speeds—which can vary from frame to frame!—and still get excellent image quality.

How This Works—Chromogenic b&w films have a unique property. Overexposure *reduces* the apparent graininess because as development proceeds, the buildup of negative density fills in spatial gaps between nearby dye clouds. Therefore, up

to two steps of overexposure actually gives you a finer-grained negative—at the expense of slightly increased enlarging times. A high-quality negative will result from an EI between 100 and 400. More than two steps of overexposure introduces an undesirable loss of image sharpness.

On the other hand, underexposure increases the apparent graininess of the negative.

Contrast Control—A limitation of chromogenic b&w films is that you cannot control negative contrast by varying development time. All negatives should be processed for the recommended development time.

Chromogenic developers are formulated to optimize film speed and grain characteristics. If you change the development time and temperature, negative quality will be compromised. Solve this limitation by taking advantage of the different contrast grades of b&w paper that are available.

Processing Considerations—Either Ilford XP1 or Agfapan Vario-XL can be processed by standard color negative processing kits, such as Kodak C-41, Agfa AP-70, Agfa Process F or Ilford XP1 kits.

Developer temperature should be 100F (38C). The agitation cycle you use is very important. Best results occur with intermittent agitation of 10 seconds every minute. This maximizes acutance and fine grain. Machine-processed negatives are processed with continuous agitation, giving negatives that are noticeably less sharp.

Even though I haven't done a quantitative comparison of all chromogenic films and developers, negatives I developed in Ilford XP1 solutions seem to have slightly better grain and sharpness. Agfapan Vario-XL seems to have a greater exposure range. These are my subjective conclusions based on the photographs I made. You should make your own tests and see what works well for you.

Chromogenic b&w films will not replace conventional b&w

These photographs were taken on the same roll of 35mm Agfapan Vario-XL film. The top one was exposed at EI 100; the bottom one at EI 400. Both negatives yielded good-quality 8x10 prints, though I judge the acutance of both as visibly lower than is normally possible with conventional b&w films. Notice that exposing the negative at a lower EI *reduces* negative—and print—contrast. Compare shadow details to observe this. With conventional b&w films, films with slower speeds tend to be more contrasty.

films in the near future, but they do represent an impressive addition to the arsenal of films available. Don't be afraid to test a few rolls—you may like the results.

SPECIAL TECHNIQUES

Despite the care you normally exercise in exposing and processing film, there will be occasions when your negatives are less than ideal. They may be significantly underexposed, underdeveloped, or too dense. The most effective way to deal with these problems is to go back to the place where you took the photograph and take it again.

Unfortunately, these disasters seem to happen most when that option isn't possible. In this case, you can try to salvage the negatives by enhancing density or reducing it.

Intensifying Negatives—If a negative is not usefully dense—called *thin*—due to underexposure or underdevelopment, you can extend the density range with *chemical intensifiers.*

An intensifier increases the overall density of the negative so you can obtain a better b&w print from it. However, an intensifier cannot add detail to negative areas where none exists.

Commercial preparations of intensifiers are available through camera stores. Most commonly used is chromium intensifier. It works by adding chromium metal to the layer of silver in the emulsion.

Kodak chromium intensifier consists of chemicals that you mix to give an acidic solution of potassium dichromate. You soak the negative in this solution until it bleaches completely. Don't panic when you see your already too thin negative disappear.

At this stage the negative has a light-yellow appearance. Wash the negative in running water until the yellow stain is completely removed. Now redevelop the negative in bright light, using a developer that does not contain a high concentration of sodium sulfite. A paper developer such as Kodak developer D-72 is excellent for this purpose. You can increase the degree of intensification by repeating the entire process again. Wash the negative after development— fixing is not necessary—and dry it in the usual manner.

The best you can expect from intensification is this: Thin areas of the negative build up density, but shadow regions still lack detail.

Reducing Negatives—Too-dense negatives can occur due to overexposure, or overdevelopment. The negative defect that results will not be the same in both cases. Overexposure produces a uniform density increase for all exposure zones. Overdevelopment increases negative contrast, giving a proportionally higher density increase in exposure zones greater than zone V. In both of these instances, you will want to decrease the density of the negative to simplify printing. For a negative that is overexposed, a *proportional reducer* is best. It acts with equal effect on the shadow and highlights.

With an overdeveloped negative, use a *superproportional reducer.* It cuts density more rapidly in the highlight regions of the negative relative to the shadow areas. These are not commercially available and unless you have some experience handling corrosive chemicals, you should not attempt to use them.

This series of prints illustrates underexposure and the effect of negative intensification. Above was made from a normally exposed, developed and printed negative.

This is the best print from a negative underexposed by two steps, printed on a grade 2 paper. Notice the loss of shadow detail in the window area.

There are several proportional reducers that you can use effectively, but you will have to mix them yourself, which requires a scale and handling dangerous chemicals. Consequently, I'll limit my discussion to Kodak Farmer's Reducer, a commercially available proportional reducer. It's relatively safe to use.

Farmer's Reducer is a mixture of potassium ferricyanide and sodium thiosulfate. It's an effective solvent for metallic silver. The reagents act as a proportional reducer when the two are mixed in water. Potassium ferricyanide oxidizes silver, converting it to an insoluble salt. This is dissolved by the sodium thiosulfate. The rate at which the silver dissolves depends on the concentration of the solution that you use. By diluting the solution, which is orange colored, you slow down the reaction rate.

When you use Farmer's Reducer, be certain that your negative has been thoroughly fixed and washed. I advise you to harden the negative in Kodak Hardener SH-1 before you begin reducing the negative.

Pour enough Farmer's Reducer into a clean, white tray to cover the bottom to a depth of about 1/4 inch. Fill a second tray with water. Wet the negative thoroughly in the tray of water and transfer it to the solution of reducer. While watching the negative closely, begin to tilt the tray sideways to move the negative gently in the solution. When the density of the negative looks right, transfer it quickly to the tray of water to stop the reducing action.

Reducing a negative is easy to do, but you need to be careful and patient. At first it seems as if nothing is happening, but do not be deceived. Watch closely or you are likely to reduce too much.

I strongly recommend that you practice on a few negatives you can throw away so that you can learn the process and see how fast it occurs. It is also useful to keep a reference negative in a water bath for comparison. A wet negative looks darker than a dry one and you may be deceived into reducing the negative too much. It is best to err on the side of too little reduction because you can always reimmerse the negative for a few more moments in the reducer. Don't try to reduce more than one negative at a time.

Local reduction is useful when you have a negative that is well exposed and developed but which has an area that is too dense to print easily. In this case, you may want to try local reduction of image density. I warn you that this is not for the faint-hearted, because if you are not careful, you'll ruin the negative. If you don't have any other options, try this, but make the best possible print first.

Prepare an ounce of Farmer's Reducer. Place the negative that you need to reduce emulsion side up in a white tray that contains enough water to cover the negative. Tilt the tray so the negative rests against the bottom of the tray out of the water.

Dip a cotton-tipped stick into the Farmer's Reducer and gently rub the area of the negative you want to reduce. Use a random motion and work the cotton swab into adjacent regions as well so you don't create sharply defined boundaries. Slosh water over the surface of the negative occasionally by tilting the tray.

Print made from an underexposed negative onto a grade 4 paper. The print has a greater tonal range, than the previous picture, but detail is still missing in the shadow areas.

Print from intensified underexposed negative made on a grade 2 paper. The improvement is impressive.

Never let droplets of reducer sit undisturbed on the surface for more than a moment. If you work slowly and patiently, your efforts will be rewarded. I strongly suggest you practice this technique on a few disposable negatives before you risk trying the procedure on an important negative. Remember, this is a last resort!

Removing Pinholes—One of photography's minor irritations is the appearance of pinholes in the negative. They are tiny clear spots in the negative due to imperfections in the emulsion. These may occur during manufacturing or processing. They reproduce as black spots in the print.

There are two ways to deal with pinholes. The first is to ignore them and make your b&w print as you would normally. After the print has been fixed, bleach out the black spots with Farmer's Reducer and complete print processing. When the print is dry, retouch the bleached area with spotting dyes until it blends in with the surrounding region.

A second technique is to spot the pinhole in the negative. Use a very fine brush and spotting dyes such as Spotone. Place the negative on a light table, emulsion side down, and tape the negative in place with masking tape across the corners. Use a magnifying glass if it helps you to see the pinhole better. Work on the base side so you can easily remove dye if you apply too much.

Carefully cover the pinhole by dabbing on successive applications of dye. Don't try to cover the hole with one application. Make certain that when you have finished, the area you've spotted is slightly darker than its surroundings.

When you print the negative, you will now have a white spot on the print instead of a black one. You can blend this into the surroundings by using spotting dyes. Both procedures work well. Use the one that is easiest for you. If you need to make a large number of prints, it is usually worth the effort to retouch the negative. If only one or two prints are needed, I prefer to retouch the bleached print.

REDUCING NEGATIVE DENSITY

I happened upon this mission late in the afternoon, just before a storm, and with a broken exposure meter. The sun was directly behind the mission so I had to guess at the exposure, using the "Sunny Day f-16 Rule." It says that in bright sunlight, these exposure settings, or the equivalent, are correct: f-16 at 1/ASA second. I applied the rule to this scene and gave another step of exposure because the building was backlit. There was only enough time to make two exposures before the rain began.

I developed the negatives normally and was disappointed to see that even though the mission and the foreground were well-exposed, the clouded sky was far too dense to print on any grade of paper. No amount of burning brought out a significant degree of cloud detail. The best print I could make is shown at left.

After numerous failures at printing the negative, I decided to risk local reduction of the sky and clouds by bleaching this portion of the negative with Farmer's reducer, applied with a cotton swab. By working slowly with a highly diluted bleaching solution, details in the sky were slowly reduced to normal densities—less than 1.5. A print from this negative is shown above.

Care and patience is required to salvage negatives of this type. I could have avoided all of this grief by giving the film additional exposure and then reducing the development time of the negative to make a negative with greatly reduced contrast.

8

Using Filters
In B&W Photography

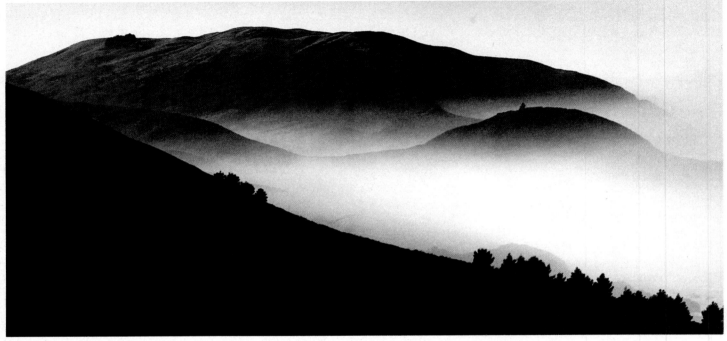

This scene of coastal fog at dawn was contrasty and had a brightness range greater than eight steps. I placed a spot-meter reading of the distant mountain on zone V, knowing that the foreground would fall on zone II or I.

I did not use a filter, however, because a yellow filter would have reduced negative density in the sky, causing it to print on a lower zone without burning in. Nor would the fog bank have appeared as dense as it actually was. A blue filter would have increased the impression of haze and fog, but the distant sky would then have printed as paper-base white.

Because the previsualized photograph depended upon sharply contrasting subject tones, I developed the negative normally. The fog bank required a slight amount of dodging during printing and the sky was burned in to about a zone VII tonality.

Although this is a chapter about filtration, I included this print because knowing when *not* to filter is just as important as knowing when to.

Visible light is a very small part of the *electromagnetic spectrum,* which also contains cosmic rays, X-rays, visible light, microwaves, radar and radiowaves.

We call the mixture of light that illuminates the world around us "white light." It is composed of light rays of different colors and energy levels. You can use a prism to separate white light into its components. At certain times water vapor acts as a prism and we can see the spectrum of visible light as a rainbow.

LOOKING AT A SCENE

When you look at a scene, your eye responds to both the color and brightness of an object. Analyzed scientifically, in daylight the maximum visual sensitivity of your eye occurs in the yellow-green region of the visible spectrum. The response of your eye decreases as colors approach either the blue or red end of the visible range of light. At dim light levels, such as you would encounter in the evening, the maximum sensitivity of your eye shifts to blue-green.

The way you react emotionally to colors does not necessarily correspond to the color sensitivity of your eye. For example, a dimly lit brilliant red may make a stronger visual impression than a well lighted green. In a b&w photograph intended to mirror reality, most people will accept a b&w image as realistic if gray tones parallel their concept of visual intensity of the colors in the scene. Often, the only way you can accomplish this is to use colored filters to absorb different colors selectively.

What Filters Do—Imagine a landscape consisting of a bright-red building surrounded by trees and accented with white cumulus clouds against a deep-blue sky. You would see the following if you photographed the scene with panchromatic b&w film: a dark-

gray building, dark-gray trees, and a light-gray sky spotted with barely distinguishable clouds.

Your b&w photograph would be most dramatic and appealing if the clouds were sharply defined against a dark-gray or black sky and the building stood out from the trees. You can accomplish just that by taking the photograph through a red filter.

If you wanted instead to lighten the trees relative to the building and downplay the contrast of the clouds and the sky, you could use a green filter. This chapter will teach you how to use filters to add impact to your b&w photographs.

RESPONSE OF FILM TO COLOR

The chemicals that create the latent image in a photographic emulsion are the silver halides. In their natural state they are sensitive only to radiation in the ultraviolet and blue region of the spectrum. For the first 50 years of photography, all photographs were made on this kind of emulsion.

In 1873, a chemist named Vogel discovered that the light sensitivity of silver halides could be extended to green by adding a dye to the emulsion. By 1882, films that could be exposed by both blue and green light were being sold commercially. They were called *orthochromatic (correct-color)* films.

Further research led to an extension of the spectral sensitivity of the emulsion to red light as well. These new films were called *panchromatic (all-color)* or *pan* films. Today, panchromatic films are the most widely used films for general-purpose photography.

In the 1930s, films that could be exposed by deep red and infrared radiation became available. As a result of these advances by chemists and physicists, we now have the ability to photograph objects with light that ranges from the invisible ultraviolet to the invisible infrared.

Panchromatic film comes closest to ''seeing'' the world as we do, but does not respond to the visible spectrum in exactly the same way as our eyes. Pan film is more sensitive to red and blue light than your eye and less sensitive to green.

USING FILTERS

Filters absorb colors selectively. Through the judicious use of filters, atmospheric effects due to haze can be accentuated—or deleted—in your photograph. With filters, you can lighten or darken the way colors reproduce as gray tones in your print.

Filter Factors—Most filters decrease the intensity of the light that reaches the film plane. To avoid underexposing your film, you need to correct your exposure to compensate for this light loss. Manufacturers recommend the normal exposure increase you should use with a given filter. These apply to exposures at midday at sea level. For ordinary b&w photography, these factors are accurate enough to use with confidence. However, there are circumstances in which you should alter these factors slightly.

Exposure corrections for filters are reported as *filter factors* or as *exposure-step increases* that you must make. A filter factor is a multiplier by which you must increase your exposure. A filter factor of 2 means that you must double your exposure when you use that filter. Do this by opening the lens one *f*-stop or doubling the exposure time. A factor of 4X requires a two-step increase, 8X a three-step increase, and so on.

Some manufacturers simply report exposure increases in terms of exposure steps (ES). For example, Tiffen filters recommend that for their Green 1 filter a correction of two steps (4X) is needed.

Filter factors, which are multipliers, and exposure-step increases are two different kinds of numbers. You must not get them confused. Decide which system you want to use, and label all of your filters accordingly.

You should be aware that filter factors are, in fact, variables that depend upon the light source that is illuminating the scene and the type of film that you are using—pan or ortho. Fortunately, for most ordinary photography such as landscapes and portraiture, these values are accurate to within 1/2 step of the reported values, which is usually within the exposure latitude of your film. You can reduce the exposure uncertainty if you remember a few basic facts about light and filters.

Filters pass light of the same color *without* reducing its intensity. A red filter is transparent to red light. This means that if you were to meter and photograph a red barn with a red filter and apply the filter factor of 8X to adjust your exposure, the barn would be three steps overexposed. The barn would appear as a brilliant white in your b&w print.

An object in the scene that is the same color as your filter reproduces much lighter in the b&w print than it would if shot without the filter.

During the hours around sunrise and sunset, the color of light changes drastically and is much redder than normal. As a result, you should *decrease* the filter factor for a red filter at these times. A correction of about 1/2 to 1 step is adequate. Later, I'll describe a procedure that you can use to determine the correction accurately.

At high elevations, such as you might encounter in the mountains or in an airplane, the surrounding light will be bluer than normal. This means that filter factors for yellow, green, or red filters will be *larger* than what the manufacturer suggests. If you *increase* the filter factor for these filters by 1/2 to 1 step, the results you obtain should be approximately correct.

After all of the tests that you made to determine film speeds and development times, the uncertainties introduced by varying filter factors may be disconcerting.

USING RED AND GREEN FILTERS

Red and green subjects typically reproduce in similar tones on panchromatic film. The subject here includes red and white roses with green leaves and stems. When no filter is used, the red roses have virtually the same tone as the green leaves.

With a green filter, the tonal value of the leaves is raised by about one zone while that of the red roses is lowered about two zones.

With a red #29 filter, the red roses appear white and the green leaves very dark.

This shows that filters freely transmit light of the same color without reducing its intensity. Conversely, filters reduce the light intensity of other colors. Notice that the filters have no effect on the tonal value of the white roses because the filter factor corrects exposure, making the tonal values of neutral colors unchanged.

NO FILTER

GREEN FILTER

RED FILTER

You can eliminate the uncertainly by doing a few simple tests. Results will give you a precise value for your filter factors.

DETERMINING FILTER FACTORS

Another way of thinking about filter factors is in terms of the shift in exposure zones that the filters produce. If you were to photograph a gray card first without a filter and then with a filter over the lens, the number of zones by which contact prints of the gray cards will differ corresponds to the filter factor at the conditions when you took the two photographs. This provides you with a straightforward procedure for determining filter factors.

If your camera accommodates a Polaroid back or if you have a Polaroid camera that takes b&w pictures and allows you to set exposures manually, do the following:

Set up and meter a gray card for a zone V exposure at the time and place for which you want to determine a filter factor. Photograph the card and develop the print. Place your filter over the lens, make an approximate exposure correction by using the filter factor suggested by the filter manufacturer, and photograph the gray card again.

Develop the Polaroid print for exactly the same time and at the same temperature as for the unfiltered print and compare them visually. If the print is too light relative to the unfiltered print, the gray card was overexposed and the filter factor must be decreased. If the print is too dark, do the opposite. Make additional exposures until you get a filtered print that matches the unfiltered one. The difference in exposure steps (ES) does not equal the filter factor (FF), but you can use it in the following formula:

$$FF = 2^{ES}$$

If you prefer, you can load your camera with film and photograph the gray card as you did with your characteristic curve or film speed tests. I recommend that you place the gray card on zone VII so shifts in negative densities that occur when you place your filters over the lens cover a convenient density range.

Photograph the gray card without a filter. Then sequentially place the filters you wish to evaluate over the lens. *Do not* change any of the camera settings. Develop your film as you would normally and measure the negative densities for each frame. From your previous experiments on characteristic curves, you will know how many zones a particular change in negative density corresponds to. This shift is related to the filter factor. I suggest that you use the same form that you recorded your characteristic curve data on for these experiments, noting the filter that you used alongside each exposure frame.

You will find that in most circumstances, filter factors do not differ by more than 2X (ES = 1) from the manufacturer's suggested value. Therefore, unless you plan to do most of your photography in an environment that differs significantly from the norm, these experiments are not worth doing and the general rules that I suggested for corrections earlier are adequate.

If your camera has a through-the-lens (TTL) metering system, you can often ignore filter factors altogether and follow the exposure recommendations of your metering system with the filter attached to the lens. This is *usually* a valid procedure, *but* it depends on the color sensitivity of your meter's detector cell.

I have found that with most cameras, TTL meters work well for yellow and green filters, but that orange and red filter corrections are as much as one or two steps in error. You can check out how well this approach works on your camera system by setting up a gray card, taking an exposure

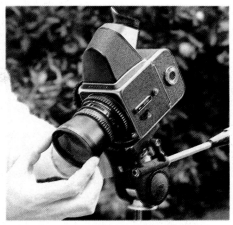

Screw-in filters attach to a lens by threads. If the threads are properly aligned, the filter is easy to attach. Do not force the filter or tighten it too hard. It is best to focus the lens after you have attached the filter because some filters can cause a focus shift.

reading with no filter, and then with various filters over the lens. If the indicated difference in exposure differs from the manufacturer's recommended value, don't rely on your camera's metering system to make exposure corrections with those filters.

GLASS VS. GEL FILTERS

Filters are sold in two forms—glass and gel sheets. One type of glass filter consists of two discs of glass that have an organically dyed layer of gelatin cemented between. Others, generally of slightly lower quality, consist of a single sheet of glass, ground flat, that has been dyed during the manufacturing process. Some glass filters have their surfaces coated like camera lenses to minimize internal reflections.

Glass filters are durable. With care, they will last a long time. They attach to the lens either through a screw-mount or bayonet fitting. A problem with glass filters is that there is no standard lens-mount diameter. As a result, most photographers rapidly acquire a large number of expensive and

bulky filters. You can solve this problem by purchasing a set of oversized filters to fit the largest threads of the lenses you have. Then get adapter rings that let you use these filters on any other lens up to the maximum diameter of the filter. This approach will save you a lot of money in the long run.

Glass filters can be used either in front of or behind the lens. When you use some filters, a noticeable focus shift occurs, so be sure to focus the image *after* you attach the filter.

Photographic filters are also sold in sheet form as gels. These are thin, tough plastic-like films that you slip into a filter holder. Gels are more fragile than glass filters, but their lower cost relative to large glass filters and high quality make them useful. Gels are available in a great variety of colors and strengths.

You can store them between the pages of a pocket-size notebook, which protects them from being scratched and makes them easy to carry around.

Filters for b&w photography are now available in plastic squares that you can use with a special holder. They come in an impressive variety, but they are of lower optical quality than either gels or

glass filters. I do not recommend them for fine work.

MATTE BOX

A matte box is a combination bellows-type lens shade and holder for gel filters. An adapter plate that screws into the lens filter threads comes with this accessory, and adapters from 49mm to 77mm are available. Matte boxes work on any kind of camera you can use for Zone-System photography.

If you acquire a matte box, look for one that has a clip over the filter slot. This will keep the filter from falling out if you use the box for handheld photography. Because a lens shade is an accessory that you should *always* use when you take a photograph, I find a matte box to be doubly convenient. It shades your lens from unwanted light, minimizing flare, and holds your gel filters at the same time.

UV FILTERS

All photographic film is sensitive to ultraviolet (UV) radiation. UV is actually invisible to the human eye. Most is absorbed by optical glass, but the small fraction that passes through your lens will expose film. The effect is most

noticeable in color photography, but you should not ignore it in critical b&w work. It has the effect of reducing negative contrast as if the scene were veiled with a light haze.

UV filters are sold in glass and gel form. They are particularly important to use at high altitudes, in landscapes where there is a distance of many miles between the foreground and horizon, and for snowscapes of all kinds. The level of UV radiation is usually high enough in these situations to bring about an apparent increase in atmospheric haze in your photographs, compared to what your eye actually sees.

A *skylight* filter is one variety of UV filter that many photographers leave on their lenses all the time. It is light pink in color and also absorbs some blue light. It serves to protect the lens from scratches or other kinds of abuse while acting as a UV filter.

If you follow this strategy, don't skimp on the quality of the filter. It makes little sense to spend a lot of money on a high-quality lens and then degrade the potential image by using an inferior filter. Glass filters made by the manufacturer of your lens are made to complement its quality. This may

A bellows lens shade is a useful accessory. With it you can minimize the effects of flare. Most models accept gel filters that you can insert into a slot at the rear of the bellows. When using this type of lens shade, be sure that it does not vignette the image. The SHADE + model for 35mm SLRs is shown below left. At right is the Hasselblad lens shade. Both are adjustable so you can use them with a variety of lenses.

or may not be true of other brands.

Color filters other than blue used for contrast control also serve as UV filters. If you use one of these, you do not need a UV filter, too.

NEUTRAL-DENSITY FILTERS

Neutral-density (ND) filters are gray filters that uniformly reduce the intensity of light without altering its color balance. Because of this, they are also useful in color photography.

Neutral-density gels are made in units of 0.1 ND. Each 0.1 unit decreases light intensity by 1/3 step. Therefore, a 0.30 ND filter is equivalent to a decrease of one full exposure step.

ND values are additive. For example, if you used a 0.20 and 0.30 ND filter together, they act like a 0.50 ND filter and cause a 1-2/3 step decrease in light intensity at the film plane. ND filters are also available in glass or screw-in filters for 1, 2 or 3 steps of absorption.

Neutral-density filters are useful when you are using fast film outdoors and need to photograph at slow shutter speeds, yet still use a large aperture. This circumstance might occur when you want to use a large aperture to limit depth of field in bright sunlight, and where the EI of your film normally necessitates a small aperture and fast shutter speed.

Alternatively, you may wish to use a flash in sunlight with a camera that synchronizes at shut-

ter speeds of 1/60 second or slower. Use the neutral-density filter to decrease the light intensity reaching your film so you can photograph at a practical lens aperture.

Neutral-density filters are also useful if you want to eliminate the presence of moving objects from a scene by making a very long exposure. For example, if you want to photograph a building that has a constant stream of people moving in front of it, but you don't want people cluttering up the scenery, use a 3.0 N.D. filter over the lens. This increases normal exposure by 10 steps! By adjusting your aperture accordingly, you can easily increase your exposure time to a few minutes. You will need to compensate exposure and devel-

Sometimes, you may want to increase exposure times to avoid reproducing moving subjects on film. Architectural photographers use this technique when photographing buildings crowded with people. A normal exposure, as at left, shows people in the scene. To eliminate the people, use a very long exposure time. This way no one is in view for long enough to be recorded on film.

Get a long exposure time outdoors by using an ND filter. For the photo at right, I used a 3.0 ND filter to get a 240-second exposure. None of the people who walked by are recorded. Remember that with exposures this long, you will need to compensate for long-exposure reciprocity failure.

For this architectural subject, Kevin Marks used an orange filter to increase sky/cloud contrast and slightly darken shadows.

opment for reciprocity failure. Under these circumstances, moving people will not be recorded on your film and only the motionless background will appear. Beware of loiterers!

CONTRAST-CONTROL FILTERS

Controlling development time is the usual way to control negative contrast. Development control alters the density difference between zones in direct relation to their relative brightness.

To control tonal contrast, you alter the tonal difference between elements in a scene based on their colors. Contrast-control filters are among the most powerful tools you can use in b&w photography. Use them to strengthen the impact of your photographs.

When you use a filter in b&w photography, the basic rule to remember is that a colored filter lightens its own color and darkens all others.

The accompanying table lists some common filters and indicates purposes for which they are frequently used.

Using The Filters—They are used most often in landscape photography to emphasize important areas of the scene. A major problem in landscapes is how sky and cloud formations will reproduce.

Without a filter, the sky in a photograph taken with pan film will be very light—zone VI or greater. This is due to the extreme sensitivity of film to blue and UV light. As a result, if the sky is clouded, the clouds will merge with the blue background in a b&w print.

A yellow filter absorbs blue, so you use a yellow filter over your lens to photograph a partly cloudy sky. The clouds will stand out more clearly in the print because the tonal value of the blue is selectively lowered due to absorption of blue by the filter.

You can control the tonal difference through your choice of filter. The difference in tones be-

USEFUL FILTERS FOR B&W PHOTOGRAPHY

Filter	Color	Uses	Exposure Adjustment (steps) Daylight	Tungsten
#6	Yellow	Darkens blue sky slightly to emphasize clouds.	2/3	2/3
#8	Yellow	Same as #6, but effects more pronounced.	1	2/3
#11	Green	Lightens green objects. Excellent for landscapes, outdoor portraits, natural-looking sky and clouds.	2	1-2/3
#13	Green	Same as #11, but effects more pronounced.	2-1/3	2
#21	Orange	Darkens blues and blue-green objects.	2-1/3	2
#25A	Red	Dramatic sky darkening; also used with infrared film.	3	2-2/3
#29	Dark Red	Same as #25A, but effects more pronounced.	4-1/3	2
#47	Dark Blue	Accentuates haze and fog.	2-1/3	3
#87	Black	For infrared film only; no visual transmission.	NA	NA
Neutral-Density	Gray	For uniform reduction of illuminance on film.	Variable	Variable
Polarizer		Eliminates reflections and glare from non-metallic sources; darkens blue sky.	2	2

NA: not applicable

tween the sky and clouds will increase in the color sequence of yellow to green to red. A light-yellow filter will have a less pronounced effect than a dark-yellow. The effect of a filter will be less on a hazy day than it will be on a clear day. This happens because the blue is much "whiter" than normal.

Using a yellow filter yields a print that most people will accept as a realistic interpretation of a scene. A green filter will have a slightly greater effect on increasing the contrast of a clouded sky and will lighten green foliage too. Green filters are also useful for outdoor portraits because they darken facial features and produce a pleasing "tanned" look that many people favor.

Orange and red filters cause the greatest difference in tones between blue sky and white clouds. A dark-red filter will lower the tone of the sky from zone VI to zone III or less. The effect that this creates in a b&w landscape can be very dramatic and pleasing.

A blue filter is useful when you want to increase the impression of

haze or fog. This may happen, for example, when you photograph a distant landscape and wish to emphasize the separation between ranges of mountains. Red filters absorb light in the ultraviolet to blue region very effectively. A red filter penetrates intervening haze and will resolve distant details on film that are not fully visible to the eye. The effect is even more pronounced if you use infrared film and a dark filter such as #29 or one of the visually opaque infrared filters.

Photos on page 94 illustrate how contrast-control filters can be used to alter the zones on which objects will appear in a b&w print. I photographed a lemon, a tomato, and a green pepper placed on a gray card. They were photographed without a filter over the lens and then with a red, a green, and a blue filter in front of the lens for different exposures. The 4x5 Polaroid prints that I got are reproduced here.

The blue filter I used drastically darkened the yellow lemon. Blue and yellow are complementary, so a blue filter blocks most yellow

93

NO FILTER

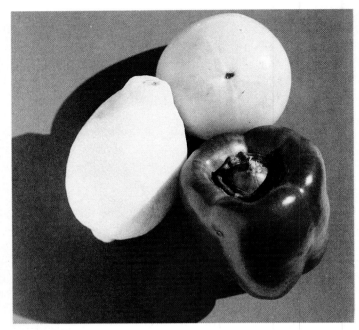

RED FILTER

GREEN FILTER

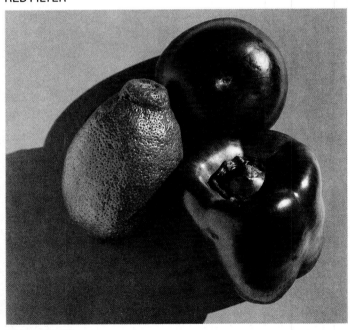

BLUE FILTER

light, and vice-versa. This blue filter made the film almost blind to the lemon, effectively "underexposing." it. The lemon reproduces as dark gray. Although red and green are not complements of blue, the tomato and pepper reproduce as black. This happens because a color filter passes only light of its own color and darkens others. In this case, there is practi-

cally no blue component in the light reflected from the tomato and pepper.

When I used a green filter, the pepper reproduced as a lighter gray. The tomato darkened slightly and the lemon lightened. The normal filter factor for this green filter, as determined from metering a gray card, was 2X. This means that objects with similar

colors will be promoted two steps in tone. This is what happened here. The green filter passed a large percentage of yellow light, but not a lot of red. This is why the lemon lightened and the tomato darkened.

The red filter dramatically lightened the tomato and lemon and darkened the pepper. The reasons are the same as those just de-

scribed. Remember, depending on the density and purity of the filter color, filters lighten their own color and darken others in the b&w print.

These photographs are not meant to be works of art, but are presented to show you how drastically you can change a photographic print by your selection of a filter. The key is to learn to use them creatively. Learn what the general characteristics of each filter are and use them extensively at first. Take the same scene with and without filters and make the best prints you can. Evaluate your prints carefully by comparing tonal values produced by the different filters and keep notes on what visual effects are pleasing. Soon you'll gain enough experience to use filters in a way that will add impact to your photographs tastefully and effectively.

On pages 95 and 96 is a sequence of photographs I took with different filters. These will help you to appreciate the effect that contrast-control filters have in rendering clouds. Doing this yourself is the quickest way to master the use of filters.

Reproducing Shadow Details—A simple fact about contrast-control filters is often overlooked by photographers. The filters strongly influence the zone in which shaded areas fall.

It is not always possible to predict where these shadow areas will fall because the filter effect is subject to the "color" of shade, which we unthinkingly regard as neutral. It's not. In a shaded forested region, most of the surrounding light comes from the open blue sky, so the shade has a strong blue cast. You can see this easily in a color slide, but your eye will not normally notice this unless you consciously look for it. With a red or yellow filter, the shaded region of your photograph will be considerably darker than you would expect from reading your exposure meter and applying the normal filter factor.

There really isn't much you can do to prevent this from happening. I mention it to make you aware that when you use filters, you must also recognize an inevitable tradeoff. If you attempt to drama-

tize a shaded mountain forest by using a dark red filter to darken the sky, you may lose important shadow detail in the forest. You will need to balance one effect against the other. Perhaps a green or yellow filter would represent a reasonable compromise.

POLARIZED LIGHT AND POLARIZING FILTERS

Light behaves like a wave. It has a frequency and wavelength that is characteristic for each color. An ordinary beam of light consists of numerous waves of light vibrating in all directions along the line of travel.

Some crystals and a few man-made materials are transparent only to light waves that vibrate in a narrowly defined plane. They behave like microscopic Venetian blinds—light will pass through only if the plane of vibration is parallel to that of the slats. Materials that have the property of filtering out light that does not vibrate in a specific plane are called *polarizers*. Light that passes through these filters is called *polarized light*.

These and the photos on page 96 give you a general indication of what various filters will do to panchromatic photographs of a scene with blue sky and clouds.

NO FILTER.

YELLOW FILTER Y2.

In nature, some of the light that we see is polarized. A portion of the blue sky is polarized. The degree of polarization is greatest at a 90° angle to the sun as you face in its direction. Reflected light from any surface other than metal can be partially polarized also. By using a polarizing filter, you can screen out reflections partially or completely. This way you can use a polarizing filter to darken a portion of the sky without changing the relative brightness of other parts of the scene.

When you use a polarizing filter to darken the sky, you must be careful, especially if you are using a wide-angle lens. The sky is not uniformly polarized from horizon to horizon, and you could take a photograph in which one side of the sky is much darker than the other. To avoid this, look at the scene carefully *through the polarizing filter.* Your eye sees exactly what the film will be exposed to, so be certain that what you see is what you want in your photograph!

Polarizing filters are mounted in rings that you can rotate after you attach the filter to your lens. The visible effect that you observe as you rotate the filter corresponds to what the film will record. The effects are often pronounced and the filter provides you with a unique creative control. Photos on page 97 are photographs I took over water with and without a polarizing filter. Note how the surface of the water changes and how details of the island become visible when the polarizer is used.

The filter factor for a polarizing filter is 4X. If you use an SLR with through-the-lens metering, you will see that the exposure indication changes as you rotate the polarizing filter. You should ignore these variations and simply apply the recommended filter factor or else you may negate much of the darkening effect of the filter.

With some camera metering systems, the results can be even more disastrous. If your camera uses a polarizing device to determine exposure, a polarizing filter can lead to erroneous exposure recommendations.

The safest procedure when you use a polarizing filter is to take an exposure reading without the filter over the lens. Correct the setting recommended by a factor of 4X—a two-step exposure increase. Then attach the filter and rotate it until you see the effect that you want. Do not change the exposure at this point, regardless of what your meter indicates.

You can use a polarizing filter in combination with a contrast-control filter. The photographic effect of the two filters will be additive. To determine the correct exposure when you use two filters, you must multiply filter factors or add exposure-step equivalences. For example, if you use a yellow filter—filter factor 2 (1 step)—along with a polarizer—filter factor 4X (2 steps)—the exposure correction is 8X, three steps.

RED FILTER #25.

BLUE FILTER #47B.

CHOOSING A FILTER

Other than the general guide-lines mentioned, there are no hard-and-fast rules about which filter is most useful. Filtration is a matter of experience and taste. Some beginning photographers overfilter photos because of the many effects possible. It takes a while to realize that a black sky or white leaves are not appropriate for every photograph.

Photographs made at high altitudes or near large bodies of water usually need an assist from filters. Typically, distant details are obscured by haze and surface reflections increase flare. Both reduce image contrast. The ability of filters to penetrate the atmosphere increases in the order of yellow, green, orange and red.

The top photo was made without a filter. For the other, I used a #25 red filter and a polarizing filter. Exposure correction was five steps—three for the #25 and two for the polarizer. You can see that the clouds are defined more pleasingly and dramatically, and that details on the distant island are clearly defined. Without the polarizing filter, surface reflections from the water would have been pronounced and distracting.

9

The Zone System
In The Field

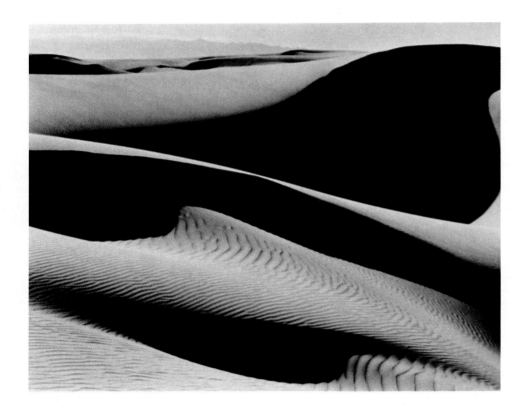

Oceano, 1936 by Edward Weston, ©1981
Arizona Board of Regents, Center for
Creative Photography.

A most critical step in photography is exposing film; all subsequent steps depend on it. The time and thought you spend taking the picture pays big dividends in photographic quality and and easier darkroom work.

The mechanics of taking photographs are easiest to discuss if I divide photography into two broad categories—*landscape photography* and *photojournalism*. These arbitrary categories represent distinct ways of shooting, but the objective is the same—photographs with impact.

All serious photography begins alike—with careful thought by the photographer. Until you get in the habit of *thinking* while shooting, your better photographs will be no more than random accidents.

LANDSCAPE PHOTOGRAPHY

This category includes subjects that are relatively motionless, such as nature, still-lifes, people, and architectural subjects. The key difference between techniques used by good landscape photographers and photojournalists is the element of time. Photographing the natural scene usually permits you to study it deliberately, analyzing the merits of differing viewpoints, filters, compositional elements, and so on, before making an exposure. A photojournalist

seldom has this luxury and must act quickly and instinctively.

Changing weather, cloud patterns or a setting sun may put some time pressure on the landscape photographer, but often the same scene will be there tomorrow. Even so, you should always approach a subject with a sense of urgency—as if you will have only one chance to do it right.

See The Subject—When you decide to make a landscape photo or take a portrait of a person ask yourself, "What is it about the subject or scene that attracts my attention?" Until you can answer that question, you should leave your camera alone. Thinking about the question while looking at your subject forces you to identify the emotional elements in the scene that tempt you to photograph.

To this end, you must learn the distinction between *looking* and *seeing*. *Looking* is a mechanical process requiring no more than open eyes. *Seeing* demands a response from the viewer. It's analogous to the difference between hearing and understanding.

As you begin to sort out emotional keys to a scene, you should give thought to *composition*—the strongest way of seeing the subject and translating its emotional impact to your photograph.

Consider camera placement and subject position. What camera position shows the subject to best advantage? After you make a preliminary determination about camera and/or subject placement, look at the scene through a Wratten #90 viewing filter, as described in Chapter 1.

The viewing filter will help you visualize the scene in terms of gray tones. Notice whether important scene elements merge into indistinguishable tonalities. If they do, decide whether you can correct it by using a contrast-control filter or if another camera angle will solve the problem.

A spot meter is a big help in evaluating tones that you can expect to see in a photograph. Light intensities you can measure will closely parallel print tones and negative densities when you use panchromatic film. Print tones can be altered significantly during printing by dodging and burning—discussed in Chapter 11—but try to minimize the need for these corrective steps by careful negative exposure. It makes printing the negative much easier.

The effect of merged gray tones is one of the most important reasons that potentially fine photographs rarely become better than ordinary. A background of beautiful flowers may provide a flattering setting for a lovely young lady. Unfortunately, in a b&w photograph the flowers may appear to be growing out of the model's hair and ears!

Similarly, an architectural photograph in which the building is indistinguishable from the background sky or foreground shrubbery won't please you or anyone else. These errors will plague you when you start b&w photography—everyone is affected by them—but you can minimize the frustration they cause if you make *seeing* and careful thought part of your photographic decision-making process.

Compose The Subject—Compose the scene in the camera and choose filters, if any. Your next decisions are exposure-and-development conditions. To make an intelligent judgement about this, you must meter the scene carefully. Then decide what tonal range is appropriate for your subject in the b&w print you intend to make.

If the photograph you visualize has a full range of tones spanning maximum black to paper-base white, you will probably want a negative in which the tonal range from black to white spans seven zones—II to VIII, inclusive.

If the scene has a brightness range less than seven steps, you will probably want to expand the density range of the negative by in-creasing normal development time.

If the brightness range of the scene exceeds what you hope to convey in the print, you will want to increase negative exposure and decrease development time. Having done the tests described in previous chapters, you now know how exposure and development-time variations influence negative characteristics and how these changes are translated in photographic prints.

Practice—Just reading about exposure-and-development control and doing a few tests to determine characteristic curves won't make you a master photographer. After you understand what the controls can do for you, you will have obtained the keys to making technically fine photographs. Opening the locks takes practice in the field.

I suggest that you find a convenient, immobile subject near your home that you can practice on. This could be a building, a landscape or a smaller subject such as a tree. Photograph the subject on bright and overcast days and use different exposure and development conditions.

Keep careful notes about what you are doing. Print all of the negatives that you get on the same contrast grade of your favorite paper and compare the results. These tests will accelerate your understanding and mastery of the principles of exposure-and-development control. They'll eventually become routine. You'll be able to apply this knowledge confidently during serious shooting sessions.

AN EXAMPLE: MISSION SAN XAVIER DEL BAC

Several years ago I published a photographic essay on one of the older and most beautiful missions in the Southwest. Because it was primarily an architectural study of the building and statuary, I exposed mostly 4x5 negatives.

The building is an awesome landmark that transcends religious feelings. Its exterior is brilliant white and it stands in stark contrast to the surrounding monochromatic desert and deep blue sky, which are characteristic of southern Arizona. These factors influenced my thinking as I approached the project.

The rear of the Mission contains a courtyard and garden, enclosed by a wall. An outer wall consisting of a sequence of connecting arches forms an entryway to the back of the Mission. The building's brilliance and the skyward thrust of the towering domes draw the eye like an inescapable lure.

The Mission—I made a photograph of the garden wall and Mission to convey my impression of the brilliant light and to illustrate the graceful curvature of the roof lines against the sky. I used a #25 red filter to darken the sky and set it off as a dramatic backdrop.

In retrospect, I think that the effect of the #25 filter is too strong. The black wrought-iron crosses topping the two domes are difficult to distinguish. On the other hand, not using a filter would have resulted in a very light sky, diminishing visual impact. In my opinion, using a yellow or light-green filter would have been a better choice by darkening the sky a bit less in the print.

This rear view of the San Xavier mission, was made with a #25 red filter to darken the sky.

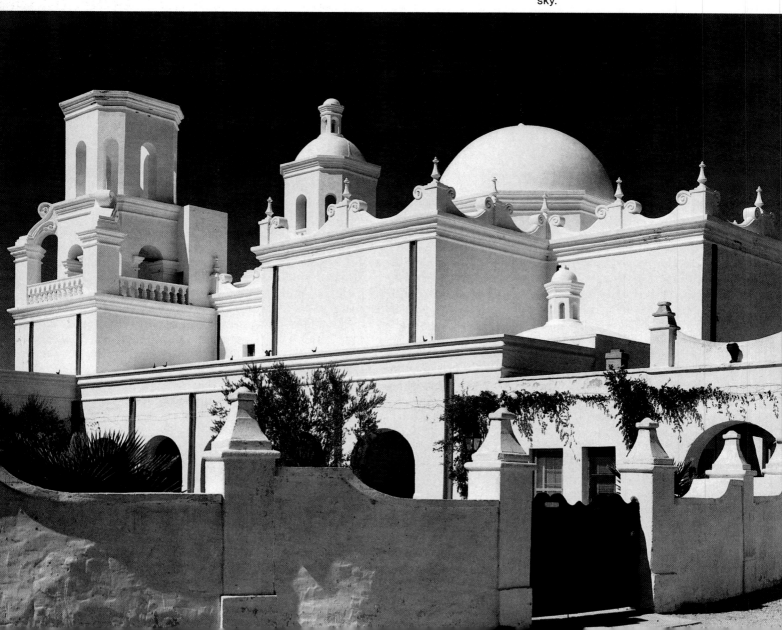

The Courtyard—A second photograph, taken from within the courtyard shows some of the interior details of the Mission. I used a green filter for this photo. I think that the tonal value of the sky is better than in the previous example. Notice how the green filter also lightened foliage. One problem with the photo is slight tonal merging of the dome with the edge of the roof in the foreground.

Two Towers—For the photo of the two towers, I used a long-focal-length lens. A red filter reduced the normal tonal value of the sky. The feeling of glowing light is due to reflections of the sunlight from one part of the roof on another. I consider this photograph to be successful because all of the essential details in the

Because foliage was in the scene, I used a green filter to both darken the sky and lighten the foliage.

The photograph was taken at noon, when the interplay of light with the towers is most dramatic. A #25 red filter darkened the sky. The back of the view camera was kept parallel to the towers and the front raised. This required maximum use of lens covering power.

photograph are easy to "read" visually.

I pointed my view camera up toward the subject at about a 45° angle. The camera back and the lensboard were both vertical, making the towers appear normal on film.

Photographing architectural subjects well requires a camera that allows you to tilt and swing the back of the camera as well as the lensboard. This photograph would have been impossible with a 35mm camera, even if you had a perspective-control lens. The necessary adjustments are too extreme. There is a *best* camera for every kind of subject, and you should attempt to use the camera designed to meet the photographic challenge you face.

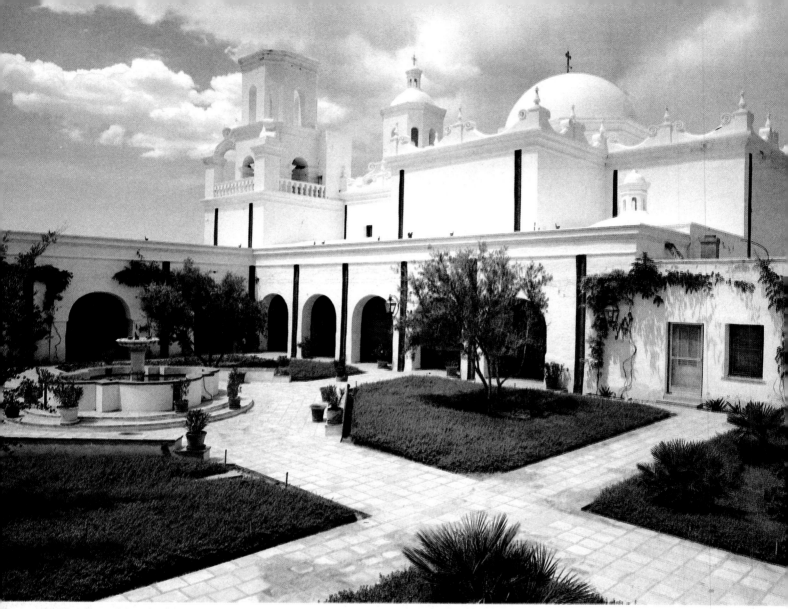

In this photo of the mission courtyard, a #25 red filter darkened the foliage, but had little effect on the sky due to the high humidity and haze.

Wide-Angle Courtyard—Another photograph of the courtyard is more successful than the first. I used a wide-angle lens and a red #25 filter. Notice the relatively minor effect that filtration had on the sky. Typically, the red filter dramatically darkens the sky. But in this case, high humidity increased the effects of haze, decreasing the normal color saturation of the blue. The green foliage is darkened considerably by the use of the #25 filter.

I carefully chose the camera position to make maximum use of the structural elements provided by the crosswalk. Pre-exposure of the negative might have provided more photographic detail under the arches, but I don't consider this to be a serious defect.

Arches And Dome—The last photograph I made of the back of the mission shows the dome through the arches. I think it is the best of five because its structure and simplicity give it visual impact. The dome's curvature is reinforced by the arches, as well as the foreground wall. The print captures the feeling of brilliant light. The remaining tonal values are realistic and strengthen the photograph's composition.

The gateway through which I photographed the dome and tower has seven arches. I selected the one pictured because it offered the most interesting frame for the main subject.

To frame or not to frame the principal element in a photograph is a question you have to consider often. It's a compositional device that is easy to overdo.

The prominence of the posts in the foreground add balance and a feeling of texture. Cover the post on the right and notice what happens to the photo—it lacks interest.

Camera height was determined by what I thought to be the most pleasing spatial separation between the top of the domes and the arch. I used both swings and tilts of my view camera to achieve the correct perspective for horizontal and vertical lines, and to get maximum

depth of field. Using the swing feature was important because the depth of field needed to extend from about three feet to infinity.

I used a spot meter to measure the reflectance of all important elements in the scene. Readout values for key parts of the subject were as follows: dome highlight, 18.2; sky, 16.9; shaded wall, 16.4; stripes on posts and iron work, 13.6. A Polaroid photograph taken from approximately the same position at a later time shows how these readings translate into print tonalities.

I wanted a darker sky as a backdrop for the dome, so I used a #25 red filter to darken the tonality of the sky. To increase tonal contrast between the dome and the foreground walls, I decided to expand the density range of the negative. I calculated exposure by placing the dome on zone VII and reading the appropriate exposure settings on my meter. That is, after correcting for the red filter, I gave the film two steps more exposure than the meter indicated because it's calibrated for zone V.

The film received N+1 development to raise the negative density of the dome to a zone VIII value. The final print was made on Ilford Ilfobrom, grade 2 paper. Minor burning and dodging were necessary during enlarging.

In the foregoing discussion I have tried to give you a sense of the thinking process that I use in landscape photography. This is not an after-the-event rationale but a recollection of the thoughts that accompanied the photographic session. With a little experience, these considerations become second nature.

Mastering technique enables you to concentrate on the art of photographing. It makes it fun and assures you that your photographs will mirror your vision.

I selected this view through the rear gateway after seeing the image on a Polaroid print, reproduced below. The fine print is a finished interpretation of the scene.

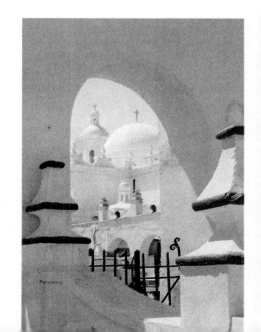

PHOTOJOURNALISM AND THE FINE PRINT

When I speak of photojournalism, I mean more than just newspaper and magazine photography. I'm also considering "situational" photography requiring fast action and mobility to capture events as they happen. This is different than landscape or portrait photography in which you control the events.

There is a striking contrast between an aim-and-shoot photographer and a skilled photojournalist. A professional photojournalist will approach a subject in much the same way as a landscape or portrait photographer. The professional will *understand* his subject before he begins to photograph. For example, look carefully at the work of W. Eugene Smith. The feeling that the photographer had for his subjects is evident from the impact his photos have. They aren't the result of "take enough and a few are bound to turn out well."

A good photojournalist must develop strong photographic instincts. Composition is often a gut response to elements that congeal for the briefest moment—"the decisive moment" that Henri Cartier-Bresson describes and photographs.

You and your camera must be ready to react and respond. There's no time to consider things such as zone placement. These issues should be settled before you begin picture taking. The principles of exposure-and-development control still apply, but also be aware that circumstances force some compromises. Later you'll have to overcome them by compensating during development or printing.

Equipment—When you approach a journalistic subject, you need an SLR camera that is portable, versatile, and reliable. Lenses should be easy to change and focus and should be fast.

In fast-moving situations, cameras are abused more than normal. If possible, have two or three camera bodies loaded with different film types. This will increase your options if the light changes.

Attitude—A good photojournalist follows these rules:

1) Above all, get a picture, even if you know that it won't be as good as you'd like.

W. Eugene Smith was a master of photojournalism. His essays were powerful and emotional statements about special and ordinary people. The photos here are from an essay about Albert Schweitzer called *A Man of Mercy,* first published in *LIFE* magazine in 1954.
Schweitzer in the Leper Village, ©1954 W. Eugene Smith.

2) Then get a better picture of the same thing.

3) Then concentrate on getting the best picture possible.

This is not the same as exposing film as fast as possible. Take a picture as quickly as you can, simply because circumstances might not give you a second chance. After you have a "record shot," look around carefully to see how you can improve on it. Try to isolate the important elements in the scene and work toward presenting them with more impact in subsequent exposures.

Don't be afraid to turn around and take some photographs of any onlookers—often they're as interesting as the event. Don't be bashful, but don't use your camera as an excuse to trample people's feelings and privacy.

Planning—As with any photographic assignment, the more you know about the subject and place you're photographing, the better your results are likely to be. For example, if you are photographing a sporting event—such as a track meet—visit the site beforehand. Find out where the events will take place and try to determine what locations are likely to produce the most interesting photographs. So you can walk around freely while the meet is in progress, get permission from those who are in charge. Find out what you'll be allowed to do and where you can go.

Remember that the event is not being staged solely for your benefit. The best way to assure that you will be welcome in the future is to behave responsibly at all times. Thanking people and dropping off some photos afterward are good investments for the future.

Editing—Because photojournalists take a large number of photographs during a typical session, editing is especially important. Make a good set of contact sheets and study these carefully.

Next, make a set of small enlargements of the images that look particularly interesting. See if they carry the message that you are trying to convey. After you've narrowed down your choices, give attention to how the photographs can be improved by cropping. This is almost always a necessity. The pace of the photographing session often leads to inexact compositions.

Self-Assignment—A good way to learn photojournalism techniques is to assign events to yourself. They can be anything from a birthday party to a day at the races.

Think about putting together a story that can be told only with pictures. Give it a logical introduction, let it flow naturally, and bring it to a satisfactory conclusion.

With a little practice, you'll be able to develop a technique that is comfortable for you. Most important, you'll approach an assignment by *thinking* about it before you start snapping randomly with your camera. The commonality of good photographers, regardless of personal preferences in subject matter, is an organized and well-conceived approach to photography.

Untitled print from
A Man of Mercy, ©1954 W. Eugene Smith.

AN EXAMPLE:
THE TARAHUMARA
INDIANS

Several years ago I co-authored a book on the Tarahumara Indians of northern Mexico. The text was an historical review of what is known about the tribe and what their culture is like in present-day Mexico. To prepare myself, I began by reading all I could find about life in the Tarahumara communities.

This gave me insight to the unique aspects of Tarahumara culture. I gained an appreciation for the rituals I would see and, more important, I found out that the people were extremely shy and wary of photographers. Breaking down that resistance was an obvious problem.

The entry to Tarahumara life that I needed came from an acquaintance who had lived and traded with the tribe. He introduced me to a circle of friends who in time came to trust me. A key to communication and understanding (we couldn't speak a common language) was a Polaroid SX-70 camera and an ample supply of film. I began all meetings with a few quickly taken SX-70

photographs that I immediately gave away to the Indians. It helped create a relaxed atmosphere conducive to trust and photography.

Over a period of weeks, I got to know and photograph the tribe in many settings. A strong series of images emerged. These included landscapes as well as people at work and play. A few examples follow.

Tarahumara Girl—This young shepherdess was sitting beside her aunt, who was weaving a basket. I photographed her with a medium-format camera, using a large aperture to throw the background out of focus. A considerable amount of burning in of the background was necessary. The intensity of eye contact is the key element in the photograph.

Even informal portraits, like this one of a Tarahumara girl, are capable of becoming fine prints. I used a handheld medium-format camera.

The Violinist—The impression of motion in this portrait resulted from using a flash along with a 1/2 second shutter speed. The photograph was an accident because in my haste I forgot to check camera settings. When I developed the negative, I liked the effect and printed it.

Don't be afraid to take advantage of happy accidents. There will be many occasions when carefully planned photographs won't pan out, so be grateful when the laws of chance work in your favor.

Here, a combination of flash and ambient light gives the image a feeling of motion.

Tarahumara Man—This portrait was made with a 35mm Nikon fitted with an 85mm ƒ-1.8 lens. The light was very dim—just before dawn—and everyone was exhausted from a long night of dancing. I slightly brightened the man's eyes in the print by bleaching them locally with Farmer's reducer, applied with a fine brush.

This low-key portrait was taken in dim pre-dawn light after an all-night dance ceremony. A serious mood prevailed, so the dark tonalities are consistent with the spirit of the occasion. I used camera-recommended exposure settings and developed and printed the negative normally.

I used bounce flash to light this sleeping boy with bright, even illumination.

Sleeping Boy—The boy and the basket were photographed with a flash attached to the camera. Even though most photographers prefer to work with available light, sometimes you don't have any choice. A direct flash with the light pointed at the subject results in contrasty lighting and sharply defined shadows. In this case, I bounced the light off a nearby reflecting surface. This led to soft shadows that flatter the subject.

SUMMARY

In a photo essay, you are trying to tell a story. Even if a single photograph may be very strong, the overall impact depends on the message in your collection of images. An effective photo essay will have a breadth, variety, and depth of visual experiences. This is a luxury that the landscape photographer generally does not have. Usually, the entire emotional message of a landscape photo is contained in a single image.

The circumstances described in this section represent extremes. In most picture-taking situations you will either not have as much time as you imagined or you will have more time than you hoped for. If you train yourself to deal with the most demanding situations you can imagine, routine ones are easy to cope with. And if you prepare yourself to photograph in trying conditions, you'll be ready to capture the great moments that come your way.

USING FLASH FILL

An apparently small light source, such as the sun in a clear sky, leads to dense shadow areas. As a result, the brightness range is ordinarily too great for film to record both shadow and highlight detail.

Sometimes, you can solve the problem by using flash to illuminate shaded areas, reducing the brightness range to normal. To do this, calculate the *f*-stop that you'd use *if* you were going to ignore all other light but that of the flash. Find it by dividing the flash guide number by the flash-to-subject distance. Now determine the shutter speed that corresponds to that *f*-stop if you were going to make an exposure by the ambient light. Set the camera's shutter at one step *slower* than that value, and close the lens aperture one additional *f*-stop. If using a focal-plane shutter, make sure that your shutter speed synchronizes with electronic flash. Leaf shutters don't present this limitation.

This method results in settings that generally give good exposure for both light sources. If you used a larger aperture, shadows would reproduce unnaturally bright. Alternatively, if you use too small an aperture, the effect of the flash fill would be lost. For close-ups and portraiture outdoors in sunlight, flash fill is often essential.

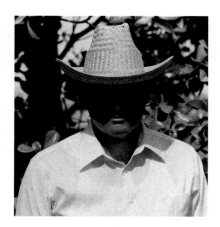

108

10

B&W Printing: The Darkroom

Ansel Adams has frequently re-marked that a photographic nega-tive is like a musical score, and the print is analogous to its perfor-mance. The ultimate objective of tonal control in b&w photography is an expressive print conveying the mood and emotion you felt when you took the picture. After making a high-quality negative, you've come a long way toward that goal. The next two chapters teach you how to make an expres-sive print. I begin by discussing darkroom organization.

The skills involved in b&w printing are easy to master. The judgments you make become more straightforward as you gain experience. When you are learning to print, it's helpful if you have access to a collection of fine b&w photographs or high-quality repro-ductions of some well-known masterpieces.

By studying originals or good reproductions carefully, you'll obtain an appreciation for the qual-ities that make a fine print better than an ordinary snapshot. There's a richness and tonal range in a fine print that makes it special. You must strive toward this goal if you want your photos to have impact. Do it by working diligently and systematically.

A carefully made negative is the "score" you need to "perform" the fine print. With this analogy, your darkroom becomes the "instrument" you play. This chapter will give you good ideas about appropriate darkroom equipment and techniques.

DARKROOMS

Darkrooms exist in many shapes and sizes. Many people are forced to adapt available space into a temporary darkroom. If you have the luxury of a spare room for darkroom work, here are several important considerations you should keep in mind.

Darkroom activities are divided into two categories—dry and wet. Dry activities include negative and print inspection, enlarging and trimming prints, and mounting and handling of prints. Wet work involves developing and process-ing prints all the way to the drying step. This includes bleaching or toning.

If possible, use separate areas for dry and wet work. For exam-ple, do not put your enlarger next to your sink. The inevitable spills and splashes can contaminate dry areas.

Have a large table area free for trimming, spotting, and mounting prints or examining negatives and contact sheets. If you must use the same work bench for printing and all other operations, try to plan your work. Devote one darkroom session entirely to printing and processing negatives and prints, and another session to finishing operations.

It's imperative to get in the habit of cleaning the darkroom thoroughly at the end of each session. This helps avoid contaminating prints so they won't deteriorate with age. If you use the approach I describe, your prints should last as long as the paper—several hundred years. This is called *archival permanence.*

Processing for archival permanence requires little extra effort, so why not be sure that a photograph you really care about lasts? You will be wasting a lot of effort if you process a print for archival permanence in one session and fill the air with fixer dust in the next. More about this later.

DARKROOM DESIGN

The accompanying illustration is a schematic diagram of a practical darkroom. Wet and dry areas are separated by an aisle, and basic equipment is arranged in a convenient sequence. Wasted motion is minimized.

Before you begin to lay out your darkroom, carefully measure the space you have to work in. Also measure the dimensions of your equipment so you'll know how much space is needed by the enlarger, trays, and so on. Think about where you'll need electricity, how many outlets you require, what your source of water will be, and how you can drain off used water.

Layout And Design—After you know the limitations of your space and budget, sketch out possible arrangements on a piece of graph paper. Mark the outside dimensions of your darkroom to scale. A convenient scale is one inch of paper for one foot of floor space.

Then make a set of to-scale cutouts of the equipment as viewed from above. Place these cutouts in locations you think may be appropriate. This way you can see how well they fit. Does the arrangement leave enough room for you to move around comfortably? Is your enlarger near an electrical outlet?

When you are satisfied that you have determined the most practical arrangement of equipment within the confines of your room, give an equal amount of thought to the best use of wall space.

Can you use space under your enlarger to store prints and unexposed photographic paper? Where should you put the timer, lights, and drying racks for your prints? What is a comfortable working height for your benches and tables? A standard table height is 36 inches, but you may not be a standard-size person. You may be a lot more comfortable working at a table that's a few inches higher or lower.

Will your enlarger bump against the ceiling when it is raised to its maximum height? If so, lower your enlarger table.

Obviously, each darkroom is unique. Yours should reflect working conditions that are both comfortable and affordable. I urge you to think carefully about this before making a decision. Visualize yourself in the space going through darkroom manipulations. Lay out your floor and wall plans before you begin to tear down walls and drive nails in a burst of enthusiasm. You'll be spending more than a few hours in your darkroom, so make it pleasant and functional. Here are more details worth considering:

About Lighting—Lighting is an important aspect of darkrooms—there's no need to work in a darkroom one step removed from a cave. Except for handling film, you can do most darkroom work under a fairly bright light. Of course, the color of the light you use should not expose photograph-ic paper. You can test for this.

Place a coin on the emulsion side of a sheet of b&w photographic paper that has been exposed to a zone VIII negative density. Let the coin sit on the enlarging easel for five minutes with just the safelight on in the darkroom. At the end of this time, develop the paper normally and look for the outline of your coin. If you can see it, your safelights are too bright or are the wrong color. This is the most sensitive safelight test because a slightly exposed sheet of paper is more sensitive to additional exposure than an unexposed sheet.

You can reduce the light intensity by getting a different safelight filter, using a lower wattage bulb, lowering the voltage with a rheostat, or by shielding the bulb.

Most photographers prefer to have a safelight near the developing trays so they can watch the image appear. In this case, you should be certain that your print is not fogging during development. Check this by developing a piece of lightly exposed paper—exposed to about zone VIII—in your darkroom with all of your lights out and compare it to a similar piece developed with your safelights on. If you can see a density difference, you need to reduce the intensity of your safelights until the light intensity does not influence textured highlight areas. If your safelights are too bright, prints will lack maximum brilliance.

An excellent safelight source is a sodium-vapor lamp. These generate a bright-yellow light, in a part of the visible spectrum that will not fog most photographic paper. Sodium-vapor lamps come equipped with filters that you can use to alter the color of the light. The lights are expensive, but they last for many years and enable you to work in amazingly bright light.

This schematic illustrates one way to plan a darkroom. This design is simple and efficient.

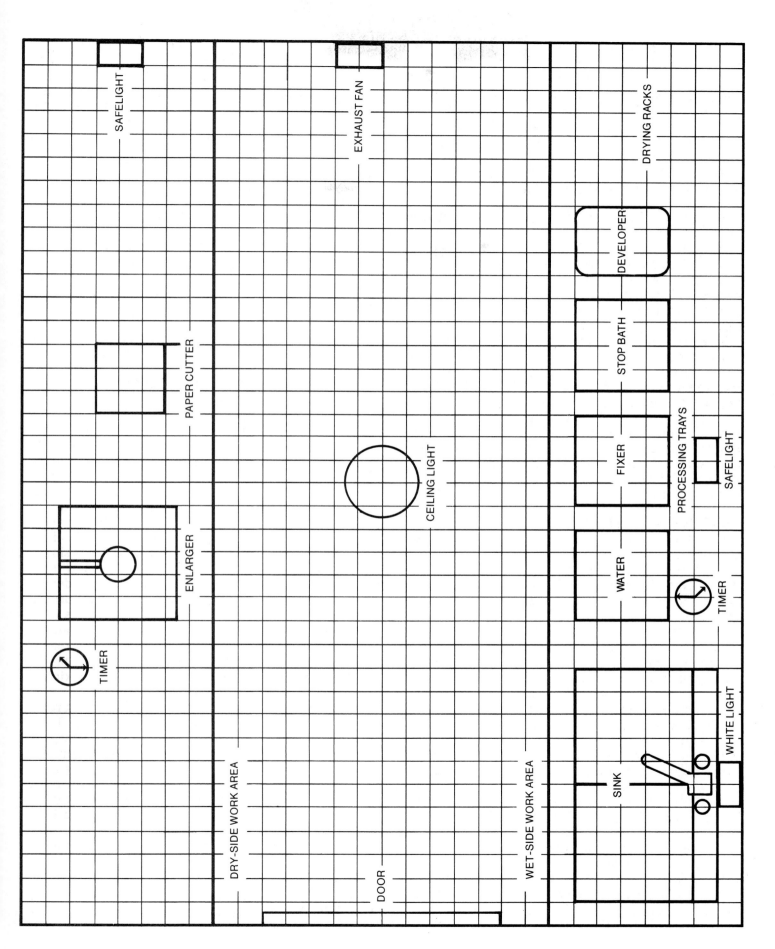

SAFELIGHT

EXHAUST FAN

DRYING RACKS

DEVELOPER

STOP BATH

PAPER CUTTER

FIXER

PROCESSING TRAYS

SAFELIGHT

CEILING LIGHT

WATER

ENLARGER

TIMER

TIMER

DRY-SIDE WORK AREA

WET-SIDE WORK AREA

DOOR

SINK

WHITE LIGHT

Less expensive safelights are available from your photo dealer. You can control both the intensity and color of the light by your choice of bulb and the color and density of the safelight filter used over the bulb.

In my opinion, it's a good idea to have a safelight over the developing tray. Also, place a white fluorescent light source—5500K if possible—over the fixer or holding tray so you can critically inspect a print after fixing it. The light should be bright, but not excessively. Otherwise, you'll be misled about the brilliance of a print that is in fact too dark when viewed under normal illumination. Generally, an 18-inch fluorescent tube about four feet from a print provides good brightness for judging print tones.

A darkroom need not be painted black. Light-colored walls are fine because they reflect safelight to give a more pleasant place to work. Black matte walls are sometimes recommended because they minimize unwanted light reflections. This is true, but if you're careful that your enlarger does not scatter stray light all around, there should be no *unsafe* light in your darkroom. If necessary, cover the surfaces above and behind your enlarger with black paper or paint.

Walls painted with a matte finish tend to collect and hold dust. A smooth or semi-gloss finish is better than a rough surface.

Ventilation—Good air circulation in a darkroom is important, especially if you work with color-processing chemicals. Generally, these are more toxic than the chemicals you use with b&w materials.

Though the toxicity of most chemicals for b&w work is relatively low, it will certainly not improve your health to work in an atmosphere of acetic acid fumes and various chemical dusts. Install a ventilating fan if possible.

Your local photodealer can advise you about what is available

in light-tight air filters and fans specifically designed for darkroom use.

Floors—A darkroom floor should be easy to clean, impervious to spills, and comfortable to stand on for an extended time. A rough concrete floor is durable, but it is tiring for your feet and legs. In addition, it gathers dust and dirt that will find its way to your drying negatives and prints.

If your floor is rough concrete, paint it with good-quality deck paint, such as glossy gray enamel. Rubber-floor matting is an excellent investment that you'll appreciate after just one darkroom session. In addition to providing considerable comfort, a rubber mat insulates well, keeping your feet warm if you have a basement darkroom or concrete floor.

Because spills inevitably occur, you should mop the floor occasionally to keep chemicals from accumulating and turning to airborne dust.

Water And Electricity—Wet hands and feet don't mix with electricity. Avoid putting electrical outlets next to water taps. Make certain that your outlets are grounded and that your wiring can safely handle all of the electrical devices you use. Unless you know exactly what you are doing, I advise you to hire an electrician to wire your darkroom.

You'll need electricity on both wet and dry sides of the darkroom. Switches activated by floor pedals are great for your enlarger and print-viewing light over the fixer. It will also save you the trouble of washing and drying your hands every time you need to turn on a light.

If possible, have hot and cold running water in your darkroom. Get a mixing valve with a temperature regulator. Any good plumbing-supply store can order a thermostatically-controlled regulator for you.

It's possible to get molded-plastic or fiberglass sinks designed especially for darkrooms—many

sizes are available. These one-unit sinks have space for trays and a deep sink for print washing. The advantages of molded sinks are low cost and ease of cleaning.

A stainless steel sink is top quality and easy to maintain. It's very expensive, but will last a lifetime. If your darkroom will be used extensively, seriously consider a stainless steel sink.

The best way to use your processing trays is in a long, shallow sink fitted with splash boards about six inches high all around the edge. The sink should be long enough to accept four trays of the largest print size you normally make. Use wooden slats of 1x3 inch lumber on the bottom of the sink to insulate the trays. When you have completed your darkroom session, you can simply dump your solutions in the sink and hose them down the drain. Wash the sink and trays thoroughly, and you'll be all set to go again next time.

If you do your processing on a table or counter top, I recommend that you cover it with a plastic runner designed to cover a carpet, or use a plastic table cloth. Either protects the surface and makes cleanup easier. Formica or a similar material is excellent for countertops because it is durable and easy to clean and maintain.

DARKROOM EQUIPMENT

Darkroom equipment can be classified as either necessary, useful or useless, according to your tastes and needs. I won't attempt to describe all of the available gadgets, but will confine my discussion to common equipment important for making fine prints. As with most items, good quality does cost a little more, but it usually represents a wise investment in the long run.

Enlarger—The enlarger is one of your most important tools. It makes little sense to own fine cameras and lenses and have an enlarger and lens that can't translate your negatives into prints of equal

quality. Here are some critical features that you should consider before you purchase an enlarger.

Above all, an enlarger must be *stable*. If it vibrates like a reed in the wind every time you touch it or walk nearby, you'll find that it is difficult to make consistently sharp prints.

To test an enlarger's stability, raise the enlarging head to the top of the column and balance a glass of water on top of the head. Walk around the room, tap the table top gently, and do the kind of things that you might normally expect to occur when you are making an enlargement. Watch the surface of the water and see if it ripples. If it does, determine the source of the enlarger vibration and solve the problem. Make certain that all screws are tight, especially those that connect the enlarger column to the base board.

Occasionally, room vibrations can cause a problem if they are transmitted to your enlarger. If passing traffic or building machinery creates vibration, try standing the enlarger table on thick rubber padding. Another solution is to place a sheet of high-density foam rubber or polyurethane under the enlarger base.

Modern enlargers with twin-beam columns, such as the Beseler 45 MX series, are very stable. Newer models produced by Durst, Omega, and Vivitar feature heavy metal channel posts, giving vibration-free operation.

Excellent values are often available in used enlargers. Because little can go wrong with an enlarger, you need not worry about hidden repair bills. Check the enlarger for alignment and for the condition of the bellows. If these seem to be satisfactory or can be easily adjusted or repaired, the enlarger should do well.

A handy enlarger feature is a rotating head, allowing you to project the image onto a wall or the floor. This is useful when you want to make big enlargements. Most enlargers won't make prints

Making sure that your enlarger is level is an important step in getting fine prints.

bigger than 16x20 inches on the baseboard.

I strongly recommend that you try to buy an enlarger that accommodates 4x5 inch negatives, regardless of the format you are currently using. Your needs may change with time, and while you may be perfectly content to work with 35mm negatives now, someday you may try a larger format. If stepping up to a larger format requires scrapping your old enlarger, you will quickly realize that it would have been more economical to invest in a more versatile enlarger at the outset.

About Alignment—To make a photographic print that is sharp from corner to corner, be sure that the planes of the negative, enlarging lens, and the baseboard are parallel. Check these with a level. After you have assembled your enlarger, place it on the table or bench where you intend to use it. Rest the level on the baseboard so it is parallel to the front edge and in the middle of the baseboard.

If necessary, wedge enough non-compressible shims—such as metal washers—under one side of the baseboard to center the level bubble. Now rotate the level 90° and do the same. Check your first reading again to make certain that the second adjustment did not alter the first. If it did, continue to make adjustments until the baseboard is level in all directions.

Next, check the alignment of the lens-plate holder. Do this by holding your level firmly against the bottom of the lens plate mount. If it is not parallel to the baseboard, the level bubble will not be centered. You then need to adjust the lens-housing unit. This can be done with set screws that either tilt the entire enlarger column or just the lens housing. Your enlarger's instruction manual will indicate how to make the appropriate changes.

Last, check the alignment of the negative carrier to assure that it is level. Make necessary adjustments in the set screws. At this point, the planes of the baseboard, lens, and negative carrier are parallel.

Enlarging Lenses—The most

critical component of an enlarger is the lens. You should purchase the highest quality enlarging lens you can afford. Do not expect a $25 enlarging lens to produce the same quality prints as a premium-quality lens. Buying a cheap enlarging lens is the worst kind of economy. Excellent lenses designed for enlarging are El-Nikkors, Schneider Componons, and Rodenstock Rodagons, although this list is not meant to be all-inclusive.

A good enlarging lens will produce a sharp image from corner to corner at maximum aperture. It should also have sufficient covering power so the image is not vignetted and the intensity of the light in the center of the image is within 1/4 step of that at the edge. These features are easy to evaluate.

A qualitative way to evaluate your enlarging lens is to take a completely blackened piece of film and make a series of hairline scratches in the emulsion across the diagonal with a fine needle. Make a series of 8x10 enlargements at various apertures, starting with the maximum aperture and working down. Focus on a scratch close to the center of the negative image. Examine the enlargements carefully, especially at the edges and corners.

With a good-quality enlarging lens, the images of the scratches should be uniformly sharp, from center to edge. At two *f*-stops below maximum aperture, your enlarging lens should perform at its maximum capability—in terms of resolution and image contrast. If the image is not uniformly sharp at this aperture, your lens is not very good. Consider purchasing another.

As a general rule, you should use the longest lens focal-length that you can in your enlarger, considering factors such as how easy it is to make a normal-size enlargement on the baseboard of your enlarger at the maximum elevation of the enlarger head.

For example, with lenses of

RECOMMENDED ENLARGING LENSES FOR DIFFERENT FORMATS	
Negative Format	Minimum Enlarging Lens Focal Length
35mm	50mm
2-1/4 square (6x6 cm)	80mm
4x5 inch	135mm
5x7 inch	210mm
8x10 inch	300mm

comparable quality, you will get better results if you enlarge a 35mm negative with an 80mm lens rather than a 50mm lens. Here's why:

With the longer-focal-length lens, you are using a greater percentage of the central part of the lens, so edge definition will be superior. A limitation of this approach is that the length of your enlarger column may make it impossible for you to project an image of the desired size onto the enlarger baseboard. An accompanying table lists negative sizes and the minimum focal-length enlarging lens normally used.

Purchase a lens with click-stops, preferably at half-step intervals. Without this feature, it is very difficult to duplicate aperture settings.

Condenser Enlarger—Enlargers are classified by the type of optical system they have. The two general categories are *condenser enlargers* and *diffusion enlargers*.

In a condenser enlarger, a simple lens system above the negative focuses an image of the light source in the aperture of the

To evaluate your enlarger lens, photograph a wire screen against a plain background. Use the best camera lens you have at an aperture three stops smaller than maximum. Use a tripod to minimize camera movement.

Make a contact print of the negative to serve as a standard. Then make a series of enlargements of the negative with your enlarging lenses. Vary lens aperture from wide open to the smallest aperture possible and examine the enlargements critically. Evaluate how sharply the lines at the corners are defined relative to the center of the enlargement, in addition to the uniformity of tones from edge to corner. You will find most lenses perform best at two to three *f*-stops smaller than maximum aperture.

In this example print made at the maximum lens aperture, the negative corners are less well resolved than the center.

enlarging lens. The enlarger lens then projects a bright, evenly illuminated image of the negative onto the enlarger baseboard. This way, a condenser enlarger produces a brighter image than a diffusion enlarger—if all other factors are equal.

With a condenser enlarger, it is important that the diameter of the optical condensing system exceed the diameter of the negative to assure even illumination over the entire negative area. If the condensers are too small, the corners of the image will be cut off or the light intensity at the edges will be several steps less than in the center of the image. Both of these would limit the usefulness of the enlarger to the central portion of the image.

Diffusion Enlarger—With diffusion enlargers, the light passing through the negative is diffuse and unfocused. You can turn a condenser enlarger into a diffusion enlarger by putting a piece of opal glass above the negative. The illuminated glass plate then "becomes" the light source so the light reaching the negative is uncollimated and randomly scattered. Because the intensity of the light is reduced,

enlarging times are longer than ·with the condenser mode.

Cold-cathode light sources, or *cold lights,* use fluorescent-light tubes. These generate an intense white light, rich in blue or blue-green light. Regular b&w printing papers are highly sensitive to these colors, so using a cold light does not lengthen printing times.

Cold lights have advantages over incandescent lamps in that they remain cool during use, reach their full light intensity quickly, and provide a uniform and intense field of illumination. Aristo Grid Lamp Products, Inc., 65 Harbor Road, Port Washington, NY 11050; 516-767-3030, manufactures cold lights for enlargers. These high-quality light sources are ideal for a diffusion enlarger. You can also convert a condenser enlarger.

The spectrum of light emitted by a cold light differs from an incandescent light bulb. Therefore, if you use Kodak Polycontrast enlarging paper or a similar product, you should insert a special filter immediately below the lamp. This makes the illumination similar to the spectral profile required by variable-contrast papers. You can

avoid this situation by using single-grade papers.

Comparing Condenser And Diffusion Enlargers—The performance differences between a condenser and diffusion enlarger depend on the light source used in the condenser enlarger.

The difference is greatest when a *point source* is used in a condenser system. A point source is a small bulb that produces very bright light. A significant percentage of the light striking the negative is reflected when light strikes a silver grain. This has the effect of increasing the apparent contrast of the negative in areas of high silver content—the highlights—because light transmission is *decreased* by this reflection. The phenomenon is called the *Callier effect.*

The result is an apparent increase in negative contrast and tonal separation in highlight areas. For this reason, a negative that prints well on a grade 3 paper with a diffusion enlarger may require a grade 2 or lower paper contrast for printing with a condenser enlarger.

With a diffuse light source, light passes through the negative from many angles. The light transmission by the negative will closely

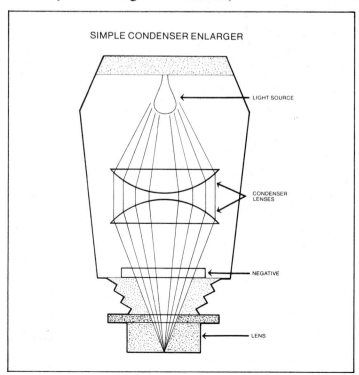

SIMPLE CONDENSER ENLARGER

LIGHT SOURCE

CONDENSER LENSES

NEGATIVE

LENS

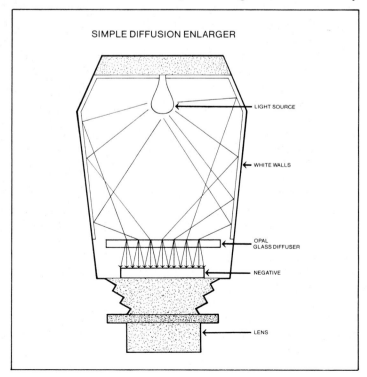

SIMPLE DIFFUSION ENLARGER

LIGHT SOURCE

WHITE WALLS

OPAL GLASS DIFFUSER

NEGATIVE

LENS

match the *diffuse density* of the negative, as measured with a densitometer. As a consequence, scattering occurs in all directions and print densities correspond to negative densities. Black in the print corresponds to a clear portion of the negative and vice-versa.

In the shadow areas of a print, there will be no perceptible tonal difference if you use a condenser or diffusion enlarger. However, in the highlights, tonal separation is greater with the condenser system.

If you fit a condenser enlarger with a large-area light source, such as a normal light bulb, the enlarger will perform as an intermediate between a point source and diffuse enlarger.

A point-source enlarger produces the sharpest image possible in a print. Unfortunately, this attribute is also the major reason that it is not used to make fine prints. A point-source enlarger yields prints showing every grain of silver, every scratch on your negative, and any speck of dust. Few negatives print best under these circumstances.

Also, you can't control the intensity of illumination on the baseboard by stopping down the enlarging lens. You must use the lens at a large aperture or else color fringing due to diffraction effects may distort and degrade print sharpness. And, most enlarging lenses do not perform optimally at maximum aperture! To control the brightness of a point source, connect it to a rheostat and vary voltage. Reducing voltage reduces brightness and changes color.

Most photographers making fine prints prefer to use enlargers equipped with *cold lights*. These provide diffuse light and minimize contrast in the highlights of the print. As a result, details in the whites of your print are discernible and have pleasing tonal transitions.

Another major advantage of a diffuse light source is that negative defects such as grain, scratches and dust spots are minimized in

the print. The price you must pay for these advantages is a small increase in enlarging exposure times, but this increase is minimal—usually within a factor of two.

Even Illumination—You should be certain that the light projected on the enlarger baseboard has uniform brightness from the center to corners. The brightness should not vary by more than 1/4 exposure step.

To check this, focus a negative on the baseboard and then remove the negative from the carrier. Use an exposure meter or an enlarging meter at several aperture settings of your enlarging lens. Measure the light at the center of the baseboard. Measure corners and edges too. If the readout varies significantly from place to place, your light source may not be properly centered, or the fault could be in the condenser system or enlarging lens.

A difference of less than 1/4 exposure step is easy to handle by burning in print edges during enlarging. If the brightness variation exceeds 1/4 step, find the problem and fix it. You may have the wrong focal length lens for the negative you're using. Also, check the bellows extension to make certain that it is at the appropriate setting for the enlarging lens you're using. If this is not the problem, systematically change the enlarging lens, remove the condensers, change the enlarging light and check to see that it is centered properly. Continue until you solve the problem.

When your enlarger is working as well as you believe it can, make a print *without* a negative in the carrier so that the center of the print is nearly zone VI. Check the uniformity of print tone from center to edge.

Do this at the largest and smallest apertures of your enlarging lens, and for a setting in the midrange. Examine each for uniformity of tone. These enable you to proceed in confidence when you

print, or make you aware of the magnitude of correction needed when you are printing a negative.

Enlarger Heat—Incandescent enlarger lamps generate a considerable amount of heat. This can buckle your negative during enlargement and, with long exposures, can physically damage the negative by softening the emulsion, thereby permanently distorting the image or destroying it altogether.

Avoid this kind of catastrophe by inserting a piece of heat-absorbing glass immediately below the lamp housing and above the condenser column. Many enlargers are sold with a plate of heat-absorbing glass as part of the system. If your enlarger does not have one and if you intend to use an incandescent bulb for a light source, get a piece of heat-absorbing glass from your camera dealer. Beseler manufactures this glass in a variety of sizes that can be adapted to most popular enlargers.

If your enlarger is fitted with a cold-light source, you don't need to worry about heat from the light source.

Negative Carriers—Generally, negatives up to 5x7 inches can be satisfactorily enlarged in *glassless negative carriers*. These are metal frames that support the negative along all four edges. For most purposes, this type of carrier is preferable if it confines the negative to a plane. If the negative sags in the center, you can't make a sharply focused image on the baseboard unless you stop the enlarging lens down to a small aperture.

Negative carriers for enlargers are sometimes equipped with two high-quality glass sheets to sandwich the negative. These keep the negative from buckling, but you must keep all the glass surfaces clean and dust-free.

A problem you may encounter with glass negative carriers is Newton rings. These are rainbow-like fringe patterns that appear at points of contact of the negative

and the glass. These can print with the negative image, ruining the print. Avoid Newton rings by making certain that the negative and glass are free of oils of any kind, including fingerprints. If a thorough cleaning of the negative and carrier does not get rid of the Newton rings, try masking the negative around the edges with a border of thin paper. This usually provides enough separation between the negative and glass to solve the problem.

Easel—The simplest easel to use is an inexpensive piece of galvanized iron sheet metal. Have a heavy gauge of sheet metal—about 1/64 inch thick—cut to a size two inches longer in each direction than the largest print you usually make. Sand the edges of the sheet with emery cloth so you won't cut yourself. Or, cover the edges with electrical tape. Clean and dry the surfaces of the metal thoroughly, and, if you wish, paint it black, using a matte-finish spray paint.

Starting from the center, rule in common paper sizes. Glue some sponge-rubber pads to the backside of the sheet metal to keep the easel from slipping around on the baseboard. You can hold the enlarging paper in place by putting a

Using a sheet-metal easel is easy. Hold the paper flat with magnets in each corner. In addition, you can hang this type of easel on a wall when you want to enlarge negatives a great deal.

small bar magnet on top of it at each corner.

The easel is very practical if you use your enlarger to project an image sideways instead of down. Drill a couple of holes in the corners of the sheet metal and hang it on the wall as you would a mirror, opposite your enlarger. Project the

image of your negative on the easel like projecting a slide on a movie screen. Focus the image by controlling the distance between the enlarger and the easel. The bar magnets are adequate to keep your photographic paper in place on the vertical easel. Frequently, this technique is the only practical method of making very large enlargements from your negatives.

Three types of commercial easels are commonly used: *fixed-size, two-blade* and *four-blade.* Fixed-size easels, such as Speed-Ez-Els or Saunders Single Size are designed to accommodate standard paper sizes from 2-1/2x3-1/2 inches to 20x24 inches. You need one for each size, so the cost can add up quickly if you acquire a complete set. The printing paper slides into a frame with non-adjustable borders. Fixed-size easels are useful for high-volume production in standard formats, but they lack versatility.

In addition, they can be difficult to load if you use sizes bigger than 8x10 inches because the photographic paper curls slightly, making it hard to slide into the

A four-blade easel, such as this Saunders model, allows you to crop your image precisely on the print paper. Saunders makes a variety of four-blade easels, the largest accepting 20x24 inch paper.

frame of the easel.

Two-blade easels are manufactured by numerous companies. Prices vary considerably, reflecting the quality of the product and its convenience and versatility. Most contain two fixed blades and form two margins. Some models can be adjusted so two of the margins can be set anywhere from 1/4 to 1/2 inch wide. The remaining two margin widths are controlled by shifting two movable blades.

With many two-blade easels, it is difficult to be certain that the paper is loaded squarely in the easel. Consequently, the print borders are often crooked. Some easels have slots into which you can insert the printing paper or clamps that hold the paper in place as you begin to lower the blades of the easel. These features minimize misalignment problems. With a little care, two-blade easels work well and are a good value for the money.

Four-blade easels allow you to adjust the size of all four print margins. You slip the paper into a fixed channel and adjust each blade individually. Borders can be varied from a hairline thickness on up. In terms of speed and versatility, I prefer four-blade easels to all others I have used. Because an easel will last you a lifetime, choose one that is easy to work with, rather than a constant source of irritation.

Be certain that any easel you use has non-skid pads on its base. This prevents the easel from shifting around every time you put in a new sheet of paper.

Focusing Aids—Focusing an enlarged negative can be a problem with the unaided eye. A focusing magnifier is a useful accessory. The types that enable you to focus on the grain of the projected image are best and easiest to use. You should try to focus on an area of the image about one-third of the way out from the center of the image. This minimizes the effects of deviations from flatness of field caused by a non-ideal enlarging

lens. Focus the negative image at maximum aperture and then stop down the lens to the aperture you intend to use for enlarging.

To compensate for the thickness of the enlarging paper, focus with the enlarger aid standing on the back of an old print. This is usually convenient, because the back of an old print is a useful area on which to crop and plan your enlarging strategy. If you prefer to carry out these activities on the easel surface, glue a piece of double-weight paper onto the base of the magnifier.

A good focusing aid helps guarantee sharp prints. This Paterson model is designed for prints larger than 11x14 inches.

Timers—For consistent print exposure and development, an accurate timer is a necessity. Modern digital electronic timers are precision instruments that provide you with versatile and repeatable performance—at a price. You can get along with simpler devices very nicely. A mechanical or electric metronome and a clock with a second hand will work well.

To use a metronome as an enlarging timer, set it to sound out one beat per second. With the cap over the enlarging lens, turn on the enlarging light, hold a piece of cardboard directly beneath the lens, and remove the lenscap. When you are ready to expose the paper, quickly shift the cardboard

to one side and start counting beats.

To end exposure, slip the cardboard back to shield the lens and replace the lenscap. An advantage of this approach is that your enlarger lamp is always on during a printing session and you'll minimize problems due to the time it takes for the enlarging lamp to reach maximum intensity. This should only be done with a cold-light source because the heat generated by an incandescent bulb over an extended period can cause damage to your negative and enlarger.

For developing photographic paper, any clock with a sweep-second hand that you can see in dim light will suffice. Gralab manufactures an electric timer that can be set from one-second to 60-minute intervals and it can be used to turn your enlarger and safelights on and off, if you choose. There are also many other excellent digital interval timers available that feature a bright LED readout. These can be activated either by touch or with a foot switch.

Because of the wide variance in price and features on timing devices, you should determine what features are necessary and desirable before you make a purchase. Mechanical timers are less precise than digital ones, but they are also less expensive. If your budget is limited, I recommend that you invest your money in a quality enlarger and enlarging lens rather than an expensive timer.

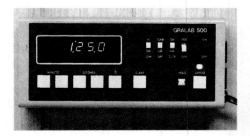
Modern digital timers, such as the Gralab 500 Digital Timer, are very convenient. They are easy to see in the dark and are programmable.

Modern print washers hold prints apart in a large tray. Water moves around the prints uniformly because the prints do not move. The Paterson Automatic Print Washer shown above holds up to 12 prints. Three sizes are available. The largest will accept 11x14 inch prints. The ZONE VI Archival Print Washer, below, also comes in a variety of sizes. The largest accepts 20x24 inch prints.

Print Washer—You want your photographic prints to last for many years. The key to photographic permanence for b&w prints is to get rid of unwanted fixer chemicals from the paper base and the emulsion. This prevents future degradation of the image from physical abuse or atmospheric agents that can react with the silver in the emulsion. Unwanted chemicals can be removed by careful and complete washing of the print.

To wash a photograph free from contaminants, a washer must give numerous *changes* of water, and a constant *flow of water over the surface of each print*. Allowing a pile of prints to sit in a tray of running water for an hour does not guaran-

The best way to dry paper-base prints is by air-drying them face down on plastic-mesh screens. You can make a simple rack from 3/4-inch plywood. Leave about 4 inches between screens so the air can circulate freely. I used 3/4-inch quarter-round moulding for the screen supports and attached the sides to the top with a 2-inch L bracket. It is easy to take apart for storage.

tee that your prints are free of fixer. In fact, this is probably the worst way to wash prints. If you must wash your prints in a tray, agitate them frequently and turn them every five minutes or less.

Regulate the water flow so the volume of wash water is replaced *at least* once every five minutes. Wash as few prints at a time as practical. Do not allow your prints to spin in a pile as water circulates in the tray—this accomplishes little, because fresh water is unable to get at print surfaces that cling together. You will be better off building a rack that keeps prints separated in a wash tub. Or, invest in a washer capable of washing your prints quickly and completely. This is the best way.

Drying Prints—Print driers are commercially available, but unless you are involved in high-volume commercial production, I don't recommend them. Most driers use a heated drum. The print is kept in contact with the drum by a tightly wrapped canvas cloth. Unless you wash all prints well, chemicals can accumulate in the cloth, so all prints may become contaminated.

Air-drying prints on screens is the best way. Plastic screens are

inexpensive and can be custom made for you at a screen and door shop or a hardware store. The screens should be large enough to accommodate at least 6 8x10 inch prints—18x36 inches is a convenient size. Scrub the screens well with soap and water before you use them and rewash them periodically. Use a wooden rack to stack a series of screens. A rack enables you to dry a large number of prints at one time in a minimum amount of space. The rack is easy to disassemble after you are through.

After washing prints, drain them on a clean sheet of plate glass and squeegee them free of surface water. Do not soak them in a print-flattening solution because the archival effects of these chemicals are uncertain. Dry prints are easy to flatten in a slightly warm dry-mount press.

Place the squeegeed prints face down on the screens. They will usually dry flat in a few hours. Hurry drying if you wish by directing the air from a fan over the surface. To dry RC papers, place them emulsion side up to avoid leaving screen marks on the surface. This is not a problem with fiber-base papers.

11

The Craft of Making A Fine Print

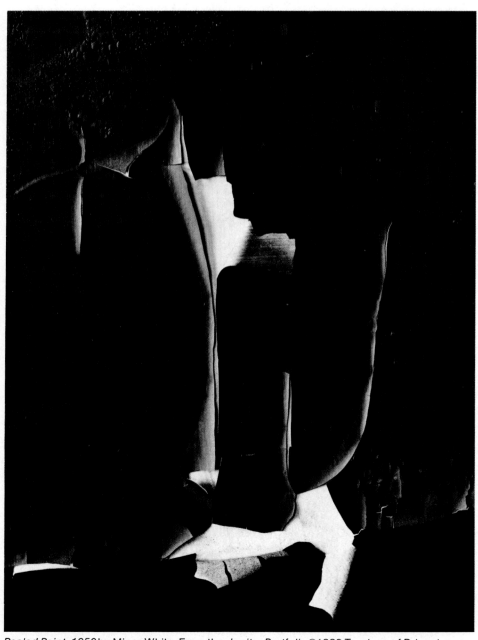

Peeled Paint, 1959 by Minor White. From the *Jupiter Portfolio* ©1980 Trustees of Princeton University. Courtesy of the Minor White Archive, Princeton University.

A fine print is like a persuasive statement. It contains well-conceived thoughts delivered with eloquence. Nothing important is omitted; nothing unnecessary is included. And the presentation is flawless!

When you have a negative containing tones of a scene that impressed you enough to photograph, you are on the verge of achieving your objective—the fine print. All that remains is for you to translate the information in your negative to photographic paper. This chapter shows you how.

PHOTOGRAPHIC PAPER

In past decades, dozens of different kinds of photographic papers have been created. Photographic printmakers have varied the metals used to form the positive image. They've used everything from silver, platinum, and palladium to copper and iron salts. All of these efforts, each of which was successful in its own way, had an element in common: The photograph was made on a paper base. Paper, properly made and treated well, is known to last for centuries.

Today, commercially available b&w photographic papers are manufactured as either *fiber-base* or *resin-coated (RC)* papers. Photographic paper is an extremely high-quality paper with proven age stability. Experience has shown that fiber-base paper will last longer than the photographic image itself. RC papers *may* also

be able to withstand the ravages of time, but this has yet to be proved to the satisfaction of photographers, museum curators, or the manufacturers themselves. All of them are concerned with archival preservation of photographs.

Because of the uncertainties, I suggest that you make all of your fine prints on fiber-based papers. Use RC papers for photographs that don't need to meet the test of permanence.

Photographic papers consist of an emulsion of silver halides suspended in gelatin and coated on a high quality paper base. As with film, the emulsion is light-sensitive and, after exposure, the latent image can be developed chemically. The major difference between comparing a photographic negative or transparency and a b&w print is that in the first case our eye is responding to an image revealed by *transmitted light;* in a print we see *reflected light.*

Earlier, I discussed the characteristic curve as a way of recording the response of film to exposure to light. A transmission densitometer is used to measure the densities of negatives. A modified instrument that works on a similar principle is the *reflectance densi-*

tometer. It measures the ability of a surface to reflect light and reads out a number called *reflection density.* The *higher* the reflection density, the *darker* the surface.

Density Range And Characteristic Curves—If you plot reflection density as a function of the relative log exposure—which is analogous to what you did when you plotted film density as a function of exposure zone—you will again get a characteristic curve.

When you do this for photographic paper, the shape of the curve is similar to what you observe with film. The accompanying illustration below left shows a family of typical characteristic curves for various paper grades.

You'll also see the characteristic curves of three different surfaces of a typical grade 2 paper, below right. These graphs demonstrate two important facts worth remembering.

Exposure Range—The first is that for a given paper surface, the reflection-density range from paper-base white to maximum black is the *same* for all grades of paper exposed and processed similarly. What changes as a function of paper grade is the *exposure range* of the paper.

The exposure range of photographic paper is easy to measure. If you take a calibrated negative strip with standard density steps and print it so the clear edge just produces maximum black— remember, this is what I defined as the standard printing time (SPT)—you will see a number of steps between maximum black and paper-base white in the print. The density of the step in the negative strip that is just rendered as paper-base white minus the density of the clear film is equal to the exposure range of the paper.

For a grade 5 paper, the exposure range is typically about 0.5; for grade 0, it can be as high as 1.7. Let's think about the implications of this in more detail.

If you have a negative with a density range of 0.5, you can print the negative on a grade 5 paper and the print will span the range of paper-base white to maximum black. If you print the same negative on grade 0 paper, the density range of the print will be very limited. For example, if you print the negative so the least dense portion is rendered as maximum black, the densest segment will be dark gray.

Alternatively, if you print the

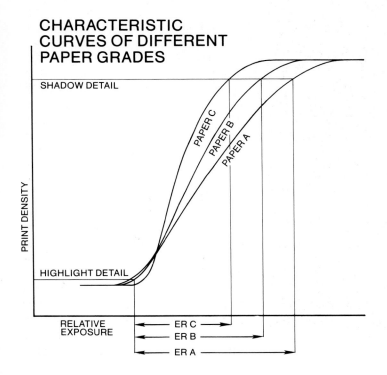

CHARACTERISTIC CURVES OF DIFFERENT PAPER GRADES

SHADOW DETAIL

PAPER C
PAPER B
PAPER A

PRINT DENSITY

HIGHLIGHT DETAIL

RELATIVE EXPOSURE

ER C
ER B
ER A

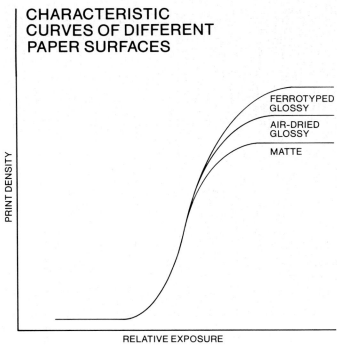

CHARACTERISTIC CURVES OF DIFFERENT PAPER SURFACES

FERROTYPED GLOSSY
AIR-DRIED GLOSSY
MATTE

PRINT DENSITY

RELATIVE EXPOSURE

In these photographs, the same negative was printed on paper grades 1, 2, 3 and 4, respectively. This demonstrates how you can fine-tune your previsualization to make the best possible print.

GRADE 1

GRADE 2

GRADE 3

GRADE 4

negative so the densest segment is paper-base white, the thinnest part of the negative will record as a light gray. As a third possibility, you could print the negative for a mid-gray tone. Again, the full range of gray tones in the print will be quite limited.

The accompanying illustration shows the results just described. A little thought should convince you that if you attempt to print a negative with a density range of 1.5, for example, on a grade 5 paper (exposure range 0.5) only a small fraction of the negative will be printed as a tone other than maximum black or paper-base white. The result is a contrasty print.

Photographers often refer to the various grades of paper in terms of

"contrast." A grade 0 paper is called *low contrast,* a grade 2 *normal contrast* and a grade 5 *high contrast.*

Paper Surface—The second thing to remember about photographic papers is shown on page 121—reflectance-density range of paper is dependent on the type of paper surface or finish. The range is greatest with a ferrotyped glossy paper—about 2.1—and lowest for a matte surface—about 1.5.

Most photographers who make fine prints for exhibition purposes use glossy paper and air-dry them. Prints made this way have almost the reflectance-density range of ferrotyped prints, but they lack the glass-like finish that can obscure the image due to undesirable surface reflections.

Even though many photographers use glossy papers, you may also want to use some of the other available surfaces. If the paper surface complements the subject matter in your print, don't be afraid to try it.

PAPER DEVELOPMENT TIME

When you develop a negative, you control development time to control the slope of the straight-line segment of the characteristic curve, thereby establishing negative contrast. You have carefully exposed the negative so the maximum density is at a predetermined value. The rule for the exposure of photographic paper is the same as it is for film, but the strategy for development differs. When a photographic paper is fully developed, the slope of the characteristic curve is the maximum value achievable for that particular paper grade.

For almost all types of papers, this point is typically reached anywhere from 1 to 3 minutes with regular paper developers at 68F (20C). If you develop the paper for longer than this time, all that happens is that light print zones get uniformly darker. Fortunately, print "overdevelopment" pro-

ceeds slowly and when an image is fully developed, the rate of change in the print decreases sharply. This means that if your print is fully developed after 1-1/2 minutes, it won't look *too* much different after 2 minutes in the developer.

But if you pull the print out of the developer after 30 seconds when 1-1/2 minutes are required by the paper for full development, the print will look radically different from a fully developed print. Image contrast will be lower because you haven't given the paper sufficient development for maximum density.

When you are enlarging or making a contact print, *do not* attempt to correct an exposure error by altering print development time. *Do not* attempt to control the contrast of your print by changing development times. Contrast is best controlled by paper-grade selection and, to a lesser degree, the developer you use. Control overall print density with exposure. I'll discuss how to do all of this a bit later.

Maximum Development Time—There is a practical limit to paper-development time. This limit, the *maximum development time,* is the time beyond which chemical and safelight fog begins to darken print highlights. You should determine this limit for each paper/developer combination you use at the conditions you work under in the darkroom.

Cut an unexposed piece of paper into five strips. Number them with a pencil from 1 to 5. Set up your trays of developer, stop bath and fixer as you would for printing. Place strips 1 to 4 in the developer and develop them for 2, 3, 4 and 5 minutes, respectively. Place strip 5 directly in the fixer and complete fixing, washing and drying all of the strips.

Examine all four processed strips under a bright light and compare them carefully to the fifth. Look for the strip that has a tone just noticeably darker than the fifth strip. The development time

for this strip is greater than the maximum development time. For example, if the strip developed for 4 minutes shows tonality, but the one for 3 minutes does not, maximum development time is between 3 and 4 minutes. You can find the limit more accurately by repeating the test using development times between 3 and 4 minutes.

These tests tell you the maximum development time you can use to produce maximum density for a paper/developer combination without producing chemical or safelight fog in paper-base white. It's valid only for *your* darkroom. Do not exceed this time when making a print.

PAPER EMULSION CHARACTERISTICS

B&W printing papers fall into three basic categories, determined by the chemical composition of the emulsion. These are *chloride* papers, *bromide* papers and *chlorobromide* papers.

Chloride papers are formulated with a silver-chloride emulsion. They are slow-speed papers, so they require longer exposures than other varieties. They are typically used for making contact prints and are characterized by a long exposure range that gives excellent tonal separation. Kodak Azo and Velox papers are chloride papers.

These papers are developed in the normal way, but develop relatively rapidly. In Kodak Dektol, for example, development is complete in 45 seconds. Rapid development is a characteristic of all chloride papers.

A special type of chloride paper is *printing-out paper (POP).* POP is usually used for studio proofs, because they are not permanent unless they receive special after-treatment. POP does not require a developer because the image is formed by a photochemical reaction during exposure. A bright light containing UV radiation, such as sunlight or a sunlamp, is

needed to expose the paper.

A POP can produce exceptional prints from very contrasty negatives because the image is produced during exposure. The developing image serves as a mask, inhibiting further development in negative areas of low density. While this happens, denser regions of the negative continue to be printed.

Bromide papers are the fastest enlarging papers available and produce images with a neutral-black tone. These are difficult to tone to a different color directly, but you can tone with special bleach-and-redevelopment toners.

Because bromide papers are fast, they are also easier to fog with safelight. Generally, a *light amber* Kodak OC filter or equivalent can be used with bromide papers. Development times are about 1-1/2 minutes. Agfa Brovira is a high-quality bromide paper that has long been a favorite of photographers. It produces rich blacks with a neutral tone and has a brilliant white paper base.

Chlorobromide emulsions have a mixture of silver-chloride and silver-bromide crystals in the emulsion. Depending upon the combination, image tones can vary from warm brown-black to a cold blue-black. Paper speeds are between those of chloride and bromide emulsions. Kodabromide, Ilfobrom, Kodak Medalist, and Agfa Portriga Rapid are chlorobromide papers.

Ilford's premium-quality paper called Galerie merits special attention. Galerie has a higher silver content than ordinary papers, yielding black tones capable of separating subtle shadow details more effectively. Galerie costs about 50% more than Ilfobrom, but the superb prints you can get justify the additional cost when you are making fine prints for exhibition. Galerie is available in sizes from 8x10 to 20x24, and in grades 1, 2 and 3.

Variable-Contrast Papers—These are produced by compounding two emulsions, one on top of the other. Each layer contains a dye that limits the light sensitivity of that layer to a relatively narrow color range.

For example, Kodak Polycontrast paper has a blue-sensitive emulsion and a yellow-sensitive layer. The contrast of the b&w image is controlled by varying the color of the light you use for printing. A blue light exposes the higher-contrast emulsion layer, and yellow light exposes the low-contrast layer. You control the color of the enlarging light with a set of special filters.

The advantage of variable-contrast papers is that you do not need to stock a large number of papers with different contrast grades. One supply of paper can give you access to grade 1 through 4 at 1/2 grade intervals simply by varying the color of the enlarging light.

You can also alter the contrast of parts of a print by using different filters to print different areas of the negative. In this way, you can change the print contrast of shadow or highlight areas selectively. For example, if you are printing a landscape, the foreground may require a number 2 filter and a number 4 might lead to a better rendition of the clouded sky. Do this by first printing the foreground with the number 2 filter in place, and then turning off the enlarger light. Replace the filter with a number 4 and turn on the enlarger again to complete the exposure of the sky while dodging the bottom. You can't do this with single-grade papers.

Paper Tonality—The black tones in b&w prints are seldom "neutral." Typically, they have a distinct tone. It can vary anywhere from slight green or blue to brown. Many photographers find that the color cast inherent in the emulsion often distracts the viewer from the image itself.

Image tone depends on the composition of the emulsion and the developer. Fortunately, you can alter image tone by using either warm-tone or cold-tone developers.

The final print tone should complement the subject matter in the print. For example, a warm tone might be suitable for a portrait and a cold tone good for a snow scene. Judgments of this nature are largely a matter of personal taste.

Toning B&W Prints—Finely divided particles of silver, such as those present in the photographic emulsion, are highly susceptible to attack by gases present in the air. Just as silverware will tarnish when exposed to sulfide fumes, a photograph will change if it comes into contact with these vapors. In our highly industrialized societies, this is almost impossible to avoid. To prevent the photographic image from being altered by atmospheric contaminants, you should tone your prints. Several useful methods are available.

The simplest and most widely used toning procedure is selenium toning. After the print has been fixed and washed briefly, you can soak the print in a dilute solution of Kodak Rapid Selenium Toner. A short treatment—about 2 to 5 minutes—gives a neutral-black image a blue-black cast. The toning process enriches the quality of the shadow areas noticeably and seems to enhance shadow detail in a subtle way that must be seen to be fully appreciated. The print is also darkened a little during the toning process, so you will need to make a print that is slightly lighter than normal if you plan to tone the image. The procedure is detailed a bit later.

If you continue to tone a print in selenium toning solution, it will take on a purple-black cast that shifts to a red-black color if toning is continued further. The physical process that occurs during selenium toning is not completely understood, but tests have shown that the silver selenide formed protects the silver image from reacting with atmospheric gases.

Selenium is poisonous, so you should follow the manufacturer's directions carefully when you use the toning solution. If you exercise reasonable care, you need not be overly concerned.

Not all papers tone with equal ease or to the same degree with selenium toner. Chlorobromide papers tone most easily and produce beautifully toned images very rapidly. Bromide papers such as Agfa Brovira tone very slowly. The effect is slight, but perceptible; the same is true of Ilford Galerie. Ilfobrom tones very well. Polycontrast papers are almost impervious to selenium toner. You will have to test each paper yourself and judge accordingly.

If you know that all or part of your print will require bleaching with Farmer's Reducer as part of an aftertreatment to correct print defects, it is important for you to do this *before* you attempt to tone the print. If you are in doubt, omit the toning step and simply wash and dry the print. It is a simple matter to wet the print and tone it later, although this will mean rewashing the print.

For many years, photographic prints were protected with gold toning solutions. Gold toning also produces a stabilized image that is blue-black in color after moderate toning—about 10 minutes. Prolonged toning results in an image with a slight red cast. Because of the price of gold, gold toning is no longer as widely used as it once was.

Use either Kodak Rapid Selenium Toner or Berg Gold Protective Solution to help prolong the life of a correctly processed and washed fiber-base print.

SOME FIBER-BASE B&W PRINTING PAPERS

Paper	Available Grades	Image Tone	Paper Weights
Kodak Azo	1-5	n	sw
Kodak Velox	1-4	c	sw
Kodak Ad-Type	2, 3	n	lw
Kodak Kodabromide	1-5	n	sw, dw
Kodak Medalist	1-4	w	sw, dw
Kodak Polycontrast	1-4	w	sw, dw, lw
Kodak Ektalure	2	w	dw
Kodak Mural	2, 3	w	sw
Ilford Ilfobrom	0-5	n	sw, dw
Ilford Ilfobrom Galerie	1-3	n	dw
Luminos Bromide ZF	0-5	c	sw
Luminos Bromide	2-4	n	dw
Luminos Charcoal R	2	w	dw
Luminos Deluxe Rapid Portrait	2, 3	w	dw
Luminos Mural	2, 3	w	sw, mw
Agfa Brovira	0-5	n	sw, dw
Agfa Portriga Rapid	1-3	w	dw
Oriental New Seagull	1-5	n	sw, dw, mw
Oriental Center	1-4	w	dw
Unicolor Baryta Base	2, 3	c	sw
Unicolor Exhibition B&W Paper	2, 3	n-w	dw

n: neutral c: cold w: warm

PAPER SPEEDS

As with films, photographic paper emulsions vary in their light sensitivity. Paper speeds are measured and defined, but they are of little practical value because establishing the speed number is complex.

However, when you've determined the proper exposure for a paper in a given developer, you can change papers and adjust your original exposure settings on the basis of the differences in speed ratings. In this way, paper speeds compare as ASA film speeds compare.

Kodak sells a simple dial calculator that makes the necessary exposure change easy to determine. This is particularly convenient when you are using Kodak Polycontrast papers because each filter that you use to alter paper contrast also alters paper speed.

CHOOSING A PAPER

When you select a paper, consider paper surface, print tone, and paper-base color. These choices are largely a matter of personal taste. Different photographers choose widely differing papers to interpret their negatives. Nonetheless, some general guidelines may help you to make initial choices from the large variety of papers that are available.

Any print that calls for a wide range of print densities for impact should be printed on a paper with a glossy surface. This includes most landscapes, advertising photographs, and some portraits.

Commercial portrait photographers often prefer to use warm-tone papers with a warm-white or cream-white base. Textured surfaces are also favored for portraits, and when these are used tastefully, the results can be very attractive. A good rule to follow is that the surface of the photograph should *complement* the subject, *not compete* with it for attention. Don't try to salvage a bad picture by printing it on a paper with a noticeable texture. That only serves to call attention to a photograph that is better off being ignored or unprinted at the outset.

Manufacturers of photographic papers provide your dealer with sample prints on the various paper types and surfaces made. The prints are usually well made and are selected to show the products at their best. I recommend that you study these samples carefully, because they can help you to make an intelligent choice of printing papers. As with films, I advise you

to select a brand of paper and use it until you have an understanding of its capabilities before you go hopping about from brand to brand.

Photographic prints made for photomechanical reproduction purposes, such as for posters, magazines or cards, should be printed on a glossy paper. Otherwise, any texture from the surface of a print will show up in the reproduction. A print for reproduction should be printed on a paper that has a white base and neutral blacks. Otherwise the reproduction will be a poor facsimile of the print. To reproduce a highly toned print requires color-reproduction techniques.

A print should also have well-defined highlights and shadow details because it is difficult to reproduce subtle differences in these regions.

PAPER DEVELOPERS

Developers for photographic papers are compounded of the same chemicals used in film developers—though the specific formulations differ. The developed silver in a print is very fine grain, so grain is not a consideration when you choose a developer for paper. The major factors you must consider are the print tone produced by the developer and the effect the developer has on tone.

Paper developers are classified as warm-tone, cold-tone, or universal. You can, in practice, use any paper developer with any paper and get a print. But by using a cold-tone developer with a paper that is manufactured to produce cold-black tones, you will optimize the paper's potential for producing an expressive print. The same holds true for warm-tone developers and warm-tone papers.

Warm-tone paper developers are formulated with little or no hydroquinone. As with film developers of similar composition, the absence of this chemical results in a low-contrast developer.

It provides you with a way of

SOME B&W PAPER DEVELOPERS	
Paper Type	Developer
Cold-tone	Kodak Dektol Edwal G Print Developer Unicolor B&W Print Developer Ilford Bromophen Paper Developer
Universal	Acufine Posifine 16 Paper Developer Edwal Platinum Paper Developer Edwal Super 111 Edwal T.S.T. Edwal LPD Kodak Ektaflo Developer Nacco Printol 12 Patterson Acuprint FX-17
Warm-tone	Kodak Ektanol Kodak Selectol Kodak Selectol Soft

controlling image contrast or the exposure range of a paper through developer choice. A warm-tone developer will extend paper exposure range by about one paper grade. For example, a negative that produces a satisfactory print on a grade 2 paper with Kodak Dektol as the developer will require a grade 3 paper with Kodak Selectol Soft. This is useful because some papers are available in only a few contrast grades and by changing developers you can frequently expand or compress that range considerably.

You can also fine-tune prints by using developers in combination, either by mixing them together or by using them sequentially. In this way, you can actually vary the effective contrast grades by half-grade intervals. I'll discuss exactly how you do this in the section on printmaking.

You can get virtually all of the potential available in any paper by choosing one cold-tone and one warm-tone developer. I recommend that you use Kodak Selectol Soft for the latter.

Print Capacity—Before you begin to develop prints, you should know the developing capacity of your solutions. This is usually stated in the literature that accompanies the product. Some typical print capacities per gallon of developer for Kodak products are 120 8x10 inch prints for Dektol, diluted 1:2; and 80 8x10

inch prints for Selectol Soft, diluted 1:1.

Print capacity is a function of the type of print that you are making and your working conditions. A dark print requires more developing agent than a light one because more silver needs to be produced, thereby using up more of the active chemicals in the developer. Lengthy exposure to air of the developer in the tray will accelerate its oxidation and decrease the lifetime and capacity of the solution.

An exhausted developer turns brown due to the oxidation products formed. If you continue to use a developer beyond the recommended limits, there's a danger of print staining. It is impossible to remove these stains. You must also take care to avoid contaminating your developer with any stop bath or fixer bath because this lessens developer activity. If you develop your prints with your hands rather than by using print tongs, you should rinse them thoroughly after putting them in fixer.

You can use paper developers to vary print contrast. For the photos on the next page, I exposed two sheets of grade 2 paper identically. The print at top was developed in Kodak Dektol, dilution 1:2. The print at bottom was developed in Kodak Selectol Soft, dilution 1:1. Its contrast is about one paper grade lower than the one at top.

Developer Temperature—Try to keep the developer in the range of 68F to 75F (20C to 24C). The developer's chemical composition and rate of reaction is designed to produce optimal results in this range.

If developer temperature drifts considerably, full development time will vary and you'll have difficulty matching results from one print to the next.

Evaporation from an open tray—which is a cooling process—can be rapid when the humidity is low. It is not unusual for the temperature of a tray of developer to fall as much as 10F below room temperature on a dry day.

To keep your developer at a constant temperature, or at least in the recommended range, place the developing tray in a larger tray containing water at a slightly higher temperature than the target—about 1F to 2F higher. This slightly insulates the developer and provides a mild heat source for the tray. You may decide to invest in a tray with a built-in heating unit.

Temperature control for your stop bath and fixing solutions are not as critical, though you should try to keep them in the range of 68F to 75F (20C to 24C).

Agitation—Print agitation during development is important. You should keep the print, or prints, in motion at all times. Begin development by sliding the paper quickly into the developer when you start the timer.

If you are developing a single print, agitate the print by turning it over repeatedly at a slow, steady pace. Tongs can be used to handle prints in solutions, but you need to be careful not to damage the print. If you are making a fine print, I think it's safer to use your hands to agitate the print and transfer it from one bath to the next. For a single print, rocking the tray randomly also works.

If you are developing several prints at one time, slide them into the developer in rapid succession and start the timer when the first print has been immersed. Agitate the prints, cycling the bottom print to the top of the pile in continuing fashion. You may want to clip the corner of the first print so you will know which print went into the developer first.

At the end of development, transfer each print to the stop bath in the same sequence. To avoid developer contamination, carefully remove the prints from the developer with one hand and place them in the stop bath with the other.

Incorrect and inadequate agitation can lead to unevenly developed prints. You'll also find that unless you are consistent about agitating prints as they develop, it will be difficult for you to make several identical prints from the same negative.

The Factor Method Of Development—Each print you make partially exhausts the developer. As a result, the next print you make requires a slightly longer development time. If you're working with a large volume of developer, the time increase from one print to the next is usually minimal. But this is not always the case.

If the developer temperature gradually changes during a darkroom session, you'll find that the time required to produce a fully developed print changes. If the developer cools, you need to extend the development time. If the solution warms, development time will be shortened.

You can sidestep these complications by using a development technique known as the *factor method*. It is based on the observation that the ratio of the time necessary to produce a fully developed print to the time required for the developer to produce the first visible black tone is a *constant*. Therefore, the ratio is independent of developer temperature or dilution.

Master printmakers such as Ansel Adams use this method to their advantage when making identical prints from a negative. I strongly recommend that you use it too. The factor method assures consistent results as you print. The procedure works as follows:

When you have finally determined the correct exposure for your print through exposure tests, note the time required (in seconds) to fully develop the print to the point where it has the tonal values that you want. Call the total development time *T*. Now take a print that has received the *identical* exposure and develop it, face up. Look at the paper carefully and when the first tone is visible, note how many seconds have elapsed. Call this time *T1*.

Divide the total developing time (T) by the time required for the appearance of the first tone (T1). Your development factor (F) is:

$$F = T / T1$$

For example, if it takes 140 seconds to develop a print completely and the first tone appeared after 20 seconds, the development factor is 140 divided by 20, or 7.

To make additional prints of this image, expose them the same and individually immerse them in the developer. Note the time at which the first tone appears and multiply that time by 7. The product is the total development time required for that particular print.

For example, suppose that the first sign of development tone occurs at 22 seconds. Total development time in this case is 22x7=154 seconds, or 2 minutes and 34 seconds. It works, and you'll find that development factors are reasonably consistent for a given brand and grade of paper. When you use this approach, you'll find that your prints are more consistent because problems stemming from moderate temperature variation and developer exhaustion are minimized. However, don't let the factor method give you a false sense of security. It won't work if the solution is excessively exhausted.

Except for the statuary's lighted edges, the scene's brightness range was narrow. The key to a negative that was easy to print was an exposure that held detail in the highlights and shaded areas.

I measured the luminance of the sunlit portion with a spot meter and placed the value on zone VII. With this placement, readings from the shaded wall indicated that most of it fell on zone IV. If I had taken a meter reading from the shaded wall and placed it on zone V, the highlights would have become an unnecessarily high negative density, making it difficult to print. A small amount of dodging during printing raised the tonal value of the central section of the image.

POST-DEVELOPMENT PROCESSING

After developing a print, you need to finish processing to assure that your efforts are not undone. Development must be stopped at the proper time. The image must be fixed and toned for permanence. The print must be treated and washed to remove any residual chemicals. Take each step with as much care as you give development.

Stop Bath—A stop bath does two things. It stops print development by neutralizing the alkali in the developer. It also helps protect the fixer from premature demise because fixers work best when acidic.

Dilute acetic acid is usually used as a stop bath. Concentrated acetic acid—glacial or 28%—can cause your skin to blister. If you spill any on yourself, flush the contacted area thoroughly with cold running water. The fumes are noxious, so open bottles of the acid in a well ventilated space.

You can purchase stop baths containing an indicator that changes color when the stop bath has been neutralized. These are useful, but unnecessary. I recommend that you purchase a stock of glacial acetic acid or a bottle of 28% acetic acid from your photo dealer and mix your own stop bath. It's much more economical. Measure 45ml of glacial acetic acid or 190ml of 28% acetic acid. In either case, add the acid to a little less than one gallon of water.

It's safest to add the acid to cold water. Adding water to the acid can generate heat and cause the acid to splatter.

The acid bath you prepare this way can neutralize about 80 8x10 prints, or an equivalent print area. Even though the concentration of acetic acid in the stop bath is not critical, if you make it too strong, your prints are likely to develop a mottle in the paper base. Agitate prints for 30 seconds in the stop bath before you transfer them to the fixer.

Fixing Prints—Fixing prints is accomplished with the same chemicals that you use to fix film but you should *not* use the same batch of fixer for both film and paper. Here's why:

Fixing film adds iodide ions to the fixer solution. This inhibits the rate of fixation and the useful life of the fixer. Fixer used for film has a shorter lifetime and a smaller capacity for fixation than does fixer used for paper.

Fixer is one of your most useful chemical solutions as long as you

use it properly. It dissolves unexposed and undeveloped silver halides by converting them to silver thiosulfate, which is soluble in water. If the silver salts weren't removed, they'd slowly darken when exposed to light and spoil the print. Essentially, fixing a print desensitizes it.

Unfortunately, at high concentrations of silver thiosulfate, complex reactions occur that produce *insoluble* silver salts that are deposited in the emulsion of the print and in the paper fibers. In time, these silver salts decompose to silver sulfide, an insoluble brown precipitate. The print will turn yellow or brown and the image will eventually fade.

The only way to assure permanence of your print is to fix it properly and wash it free of excess fixer chemicals after fixation. What you cannot see *can* eventually hurt. Two procedures for fixing prints are currently used and both work well. The most common procedure uses two fixing baths in succession.

Set up two one-gallon baths of fixer solution in adjacent trays. After removing your print from the stop bath, place it in the first fixing bath and agitate the print for 3 minutes. Drain the print and place it in the second fixing bath for 3 minutes. Agitate the print continuously while it is in the fixer and then transfer it to a tray containing water.

You can leave the print in this *holding* tray until you are ready to complete remaining processing steps. When you have processed 200 8x10 prints or the equivalent area, discard the first bath, move the second bath into the first-bath position and prepare a fresh second fixing bath. After five such cycles, discard both fixing baths.

Never allow your prints to remain in either fixing bath longer than necessary because the fixer will act as a mild bleach and dissolve silver. The effect is most noticeable in the highlight areas of the print.

Recent studies on archival processing have led to a better way of obtaining thiosulfate-free prints. The problem with the two-bath technique is that the time required in the fixing baths enables the thiosulfate in the fixer to saturate paper fibers. A loose chemical bond between the paper and the chemicals forms, making it difficult to get rid of the last traces of thiosulfate, *regardless* of how long you wash your prints.

To avoid this situation, you can fix prints very quickly in a concentrated bath of a *non-hardening* fixer. If you do not allow the chemicals time to bind to the paper fibers, you do not need to worry about getting them out. I recommend that you use the following procedure to fix prints that you want to be permanent.

Prepare a fresh solution of a non-hardening fixing bath by diluting a product such as Kodak Rapid Fixer (without adding the small bottle of hardener solution), Edwal Quick Fix, or Ilford Ilfobrom Fixer with three parts of water. Transfer your print from the stop bath to the fixer and agitate the print for 20 to 30 seconds—but no longer!

Rinse the print for two minutes in fresh water and then soak the print in a washing-aid solution for the recommended time. Wash the print in a washer that uses a small volume of rapidly changed water. A tray that has an efficient drain will work well. Wash the print for 5 minutes and dry. You can wash the print for a longer time, but it's not essential.

I recognize that those of you tied to tradition will be nervous about the effectiveness of this fixing process, but it does work. It produces prints that have a tested lower residual fixer level than those processed by the two-bath method and washed for *two days*.

Washing Aids—After a print has been fixed, it must be washed free from residual chemicals. You can do it by prolonged washing, but a prewash treatment of the print with a washing aid reduces the time required for washing and saves water. Edwal "4 and 1" Super Hypo Eliminator, Kodak Hypo Clearing Agent, Heico Perma Wash and Beseler Ultraclear HCA are effective when you use them as directed.

Rinse the print for about two minutes in running water before putting it in the washing aid. After the recommended time in the washing aid, the print is ready to be washed. If you plan to tone the print with selenium toner, you can add the toner to the washing aid and combine these two steps. Prints should be toned for maximum permanence.

Testing For Residual Silver Or Fixer—The Kodak Hypo Test Kit enables you to estimate the residual fixer concentration in your prints or film. You place a drop of solution on the edge of your print or film and match the discoloration that occurs with a test chart. A similar test is available to estimate residual silver levels. These are worth doing to make certain that your prints are up to archival standards.

THE PROOFING PROCESS

Making a fine print involves a series of successive steps that bring you to the final goal. The contact print is like a painter's sketch—it contains all of the information you want to consider before you proceed to the fine print.

After you make preliminary decisions based on study of the contact print, you will want to make a work print. A work print is usually a cropped enlargement that reflects your preliminary exposure and development determinations. Making and analyzing a work print is the most important step on the way to a fine print.

A fine print is the culmination of what began when you were in front of a scene previsualizing the final photo. A fine print will require all of your printing skill. It may involve burning and dodging,

The Paterson Proof Printer is fast and easy to use. It has a hinged cover glass, a sponge backing for the print and a convenient mask so non-image areas print white. Shown is the 6x6 cm model. A 35mm model is also available.

bleaching and spotting as well as toning. These techniques are easy to learn and will enhance your skill as a photographer.

The Contact Print—Contact prints of your negatives are the raw material to consult before you begin to make a fine print. Contact prints provide you with an opportunity to evaluate the quality and content of your negatives, to select images that you believe should be enlarged or contact printed as fine prints, and to make some preliminary decisions regarding cropping and image presentation.

Photographers use two strategies to make contact prints. One school of thought says to print on a standard grade of paper, such as grade 2, and evaluate the image on that basis because you've controlled the negative density range to print well on this paper. The potential difficulty is with negatives that have an extended density range due to unusual subject matter or processing errors. The contact print may not show important shadow or highlight details that would influence your evaluation of the negative—and its potential for making a fine print.

Another school suggests that you should make contact prints on a paper with a long exposure range (low-grade paper) so all shadow and highlight details appear in the print. The disadvantage of this method is that your prints will look very flat and you may find it difficult to visualize what a fine print will look like.

I think that the best procedure for you to follow is to make your contact sheets on a normal grade of paper and reprint on another grade of paper any negatives that deviate widely from your norm. This works well because you should be exposing and developing your negatives to print on a grade 2 paper if you adopt the methods described in this book.

Proofing Frames—Proofing frames designed for making contact prints range from about $10 to $30. They consist of a hinged piece of glass that closes onto a foam-backed plate.

Clean the glass thoroughly on both sides and place a sheet of photographic paper in the frame, emulsion side up. Place the negatives in the frame, emulsion side down, and close the frame. Most frames have a slot to accommo-

date both the paper and negative so they won't shift during this operation.

Set your enlarger head to the height that you marked on your column when you determined standard printing time (SPT). Expose the paper and process it using your normal procedure.

Analyzing Contact Sheets—Contact sheets are work sheets worth studying. Look at them for a while before you decide to make enlargements. You'll find that this will save you a lot of paper that might otherwise be wasted.

All of us can get overly enthusiastic about our photographs when we first see a print. You want to judge your work with enthusiasm, but you must discipline yourself to be objective and critical. If you continue to be excited about an image after a day or two of looking at it occasionally, you should plan to make a good print of it—but probably not before.

Contact prints of 35mm negatives are the most difficult to evaluate because the image is so small. You should look at them closely through a loupe or magnifying glass. Make a preliminary choice of which frames you think you may want to enlarge and circle those, using a red marking pen.

Think carefully about aspects of composition. Could you make the photograph more effective by cropping off certain segments? Are elements in the foreground of the photograph separated from the background or do the tones merge, thereby making image interpretation confusing? Do the picture edges bleed off into nowhere? Can you fix that by skillful burning in? Do some areas of the print look too dark? Would they be improved by dodging? Don't hesitate to make notes on the contact sheet or in a separate note-

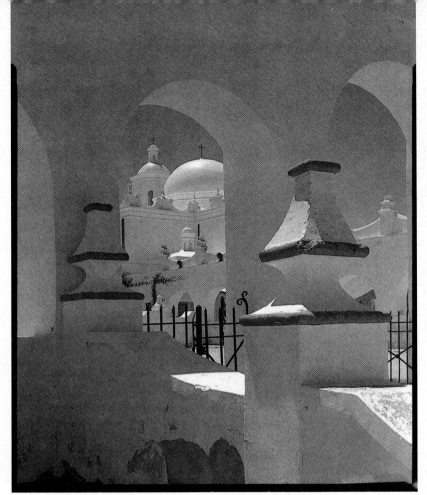

MAKING A FINE PRINT: The following set of numbered photos show the key steps of making a fine print.
1) Here is the contact print of the negative. With it you study the image carefully and make preliminary judgements regarding negative cropping and tonal values that you want in the print.

paper, or you can use the values listed in the table on page 48 as an approximation.

Select the paper grade you think is appropriate from your examination of the contact sheet and negative. If you are in doubt, you can measure the density range of your negative, but it may be just as easy to make a trial print on your normal grade of paper and then make whatever adjustment is called for. Deciding on paper grade becomes easy with a little experience.

Clean the negative as thoroughly as possible. Anti-static brushes, blower brushes, or compressed air are useful for removing dust. For problems such as fingerprints or dust that won't move, try wiping the negative with a lint-free hand-kerchief moistened with a drop of film-cleaning fluid. Examine the negative at a sharp angle to a bright light source to be certain that all of the dust is gone. A few extra minutes making sure that

book. The more effort you put into studying your contact sheets, the better the first enlargement will be.

MAKING A FINE PRINT

When you have selected a negative that you want to enlarge, the first decision you must make is which paper grade to use. Ideally, if the print is to contain the extremes of black and white, the density range of the negative should closely approximate the exposure range of the printing paper. Your exposure-and-development tests showed you how to expose and process negatives to obtain a desirable density range. Contact prints that you can make with a step tablet will define the exposure ranges of your printing

2) Use cropping L's to help decide how to crop the negative.

the negative is spotless will save time later.

Exposure Tests—Insert the negative carrier into the enlarger. Compose and focus the image on the back of an old piece of photographic paper that has been placed in your easel. Cut a sheet of fresh paper into 2-inch wide strips and place one in an area of the image that contains textured highlights (dark negative area). Or, you can use a whole sheet of paper.

Expose the strip in steps for a series of intervals that will produce one approximately correct exposure. At first, this will involve an educated guess.

I recommend that you set your enlarger lens at three *f*-stops below the maximum aperture. Expose your strip for 5, 10, 15 and 20 seconds by covering a section of the strip with an opaque card after each time interval. Develop the strip in your normal developer and fix it as you would normally. Examine the strip carefully and determine the *minimum exposure* that produces a brilliant white highlight with clearly discernible details. You will probably need to make several test strips before you determine the correct exposure.

Place a full sheet of enlarging paper in your easel and expose the paper using the just-determined exposure time. Do not attempt to dodge or burn any areas of the print at this time. What you want to judge from this print is whether you have an appropriate match between the density range of your negative and the exposure range of your paper.

Process the print according to your usual procedure, rinse the print and examine it carefully under a bright light that corresponds with the intensity you would find in a well lit room. If your viewing light is too dim or bright, you will misjudge how the print will look under normal viewing conditions.

Notice whether the midtones and shadow areas are rendered in

3) Make a series of stepped exposures to determine the basic exposure time for the print. Base this on the time required to produce correct highlight tones.

their previsualized tonal values. If they are too light, you must decide whether this defect should be remedied by burning in those portions of the print, or if a paper with a shorter exposure range is needed.

If you were to remake your print on the next highest grade of paper and give the print the same exposure—assuming that the paper speed is the same—the highlights will have the same tone but the midtones and shadow areas will be darker.

Conversely, if the midtones and shadow areas are too dark in your first print, you need to decide whether you should try to lighten these regions by dodging, or make another print using a paper with a longer exposure range—one with

a lower contrast grade.

As a general guideline, you should vary paper grade until you find the grade that most closely produces the print tones that you believe are appropriate. This lets you fine-tune the print with minimal burning or dodging.

By now you may realize that with negatives you basically expose for the shadows, develop for the highlights. When you make a print, you expose paper for the highlights and choose paper grade to get good shadows. After you use this approach for a short time, you'll be able to analyze your negatives and prints quickly and decide what must be done to improve the photograph.

Altering The Developer—You'll occasionally encounter negatives

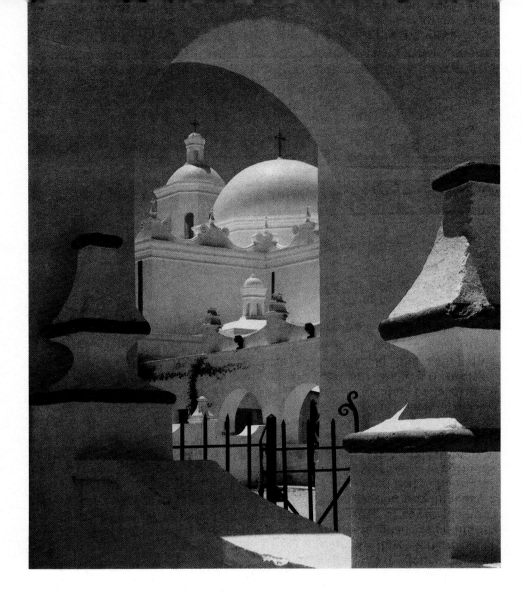

4) Make a straight print—no burning or dodging at this stage—and see if the grade of enlarging paper that you're using yields the tonal range you want in the print. If it doesn't, change paper grade to increase or decrease the range. The final result of this step is the *work print*.

When you have made a print that has the general characteristics you are looking for, determine the development factor for the print, as described earlier and shown at right. This enables you to reproduce your results later. If you are forced to choose two developers in sequence to obtain your print, the factor method will not be as useful because you can only apply it to the first developer.

LOCAL PRINTING CONTROLS

I recommend that you study the dried *work print* carefully before you continue in your quest for a fine print. Here's why:

Using the Zone System gives you a negative that will be as close to what you can reasonably expect in terms of information content and appropriate densities for the photographed scene. It will be unusual indeed, however, if your work print cannot be improved considerably through intelligent use of *local printing controls*.

that will not print well on any grade of paper because the density range falls between two adjacent paper grades. For example, a print on a grade 3 paper may be too contrasty, or "hard," while a print on a grade 2 is not contrasty enough, or too "soft."

In this case, you can alter the exposure range of the paper by altering the paper developer. The easiest way to do this is to mix your normal developer with an equal part of Kodak Selectol Soft—a low-contrast developer. Expose your negative on the paper with the shorter exposure range—higher paper grade—and develop it in the mixed developer. You can fine-tune the print by varying the relative proportions of your normal developer and Kodak

Selectol Soft. The higher the percentage of Selectol Soft, the lower the print contrast.

Another method is to develop the exposed print for half of the normal development time in Selectol Soft and then complete development in the normal developer. Each of these variations requires some experimentation, but it is this kind of effort that distinguishes a fine print from one that represents an unimaginative interpretation of a negative. The luxury of printing is that if you don't get it right the first or fifth time, you can go back and try again until you get a print that can satisfy your harshest critic—you. You can't always do that when you expose a negative. That should be right the first time.

5) When you determine the basic exposure time and the correct grade of paper, determine the exposure factor. Do this by dividing the total development time by the time it takes for you to see the first clear signs of an image after you immerse the exposed paper in the developer. For this image, that time was noted when the print looked like this. Use the factor that you determine for making all subsequent prints of this negative. Write it in a notebook so you won't forget.

These involve dodging, burning, and perhaps post-printing operations such as selective bleaching of the image with Farmer's Reducer. As you gain printing experience, you will be able to look at a work print and make decisions about what local controls will enhance your image. But at first this is difficult. Most photographers prefer to study a work print for a while and view it as a sophisticated evolution of the image on the contact sheet. Pin it to a bulletin board and look at it occasionally. Analyze it carefully.

Until your skill in judging prints is good, I think this is a sensible procedure to follow. It will save you the money and effort involved in making a fine print that you later decide you don't really like and could easily have improved.

Fine-Tuning The Work Print—
The most important part of fine-tuning your work print is *critically* studying the b&w photograph you have produced. All of us have a certain "pride of authorship" in anything creative we do. This is

natural. It provides the creative driving force we need to photograph, and it's the satisfaction we get from our work. Unfortunately, it can also cloud our critical abilities and make it difficult to look at our own work with a detached, professional eye.

If your work is going to be of the highest quality you can produce, you need to develop your critical abilities and a sense of detachment from your photographs while they are in the formative stages. Work prints are yours to criticize and improve upon until they "feel right." After that, turn your prints loose for the world to see.

When you look at your work print, try to judge if it would be improved by selectively lightening or

darkening areas of the print. Does the print meet your standards for image sharpness or grain? Does the photograph carry well in the size of enlargement that you have chosen to make? You will find that some photographs need to be big if they are to have impact, while others are best in the intimacy provided by a small format. Mark the work print with these notes if you want to.

After you have finished evaluating your work print and have the fine print firmly visualized, you are ready to begin again.

Burning In—If there are small areas that need to be darkened, cut a small hole in a piece of 2-ply mounting board or an old double-weight print. By keeping the white surface of the card several inches

6) Record dodging and burning instructions and other printing variables on the work print for future reference when re-printing the negative.

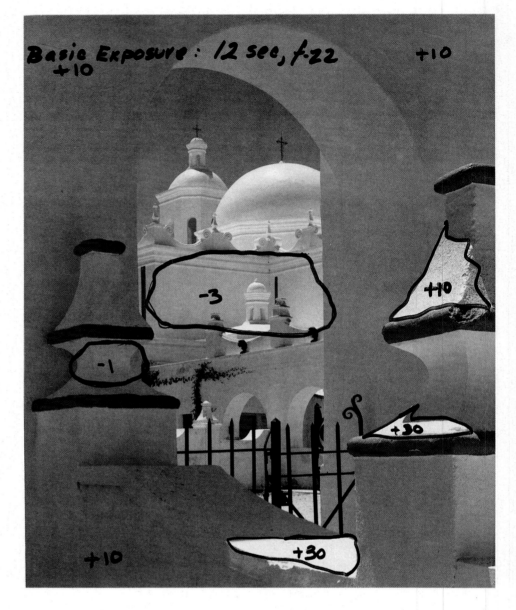

above the surface of the easel, you will be able to see the out-of-focus image projected on the card.

You can darken whatever areas of the print you wish by allowing light to spill through the hole after you have made your basic exposure. Be sure to keep the card in continuous and irregular motion to avoid the creation of an obvious edge.

Burn in so the affected area realistically blends with its surroundings. You will need to make a series of trial exposures on test strips to estimate the total time of extra exposure that the print area needs. I recommend that you write these times on the work print itself or on a sketch of the print that you make in your notebook.

Dodging—If there are areas of the print that need to be lightened selectively, you must resort to *dodging*. Make a set of dodging tools by cutting out a few circles and ovals from lightweight mounting board. Take some thin stiff wire and shape it by bending with a pair of pliers. Glue the various cardboard shapes to the circular end of the wire and allow the glue to set. Four or five of these in assorted shapes and sizes can deal with most problems you are likely to encounter.

Dodge during the basic exposure. As with burning in a print, it is important to keep the dodging tool moving at all times so the shadow created will not generate an obvious white blemished area in the print. You will need to make some trial exposures to determine the length of time that each area of the print should be dodged.

Proper dodging and burning must be so subtle that they are undetectable in your final print. Do not attempt to salvage a print by burning and dodging if your basic problem is using the wrong contrast grade of paper. These techniques should be reserved for fine-tuning, not for basic corrections.

7) Dodge and burn the print until you achieve a print that expresses what you felt and previsualized when you exposed the negative.

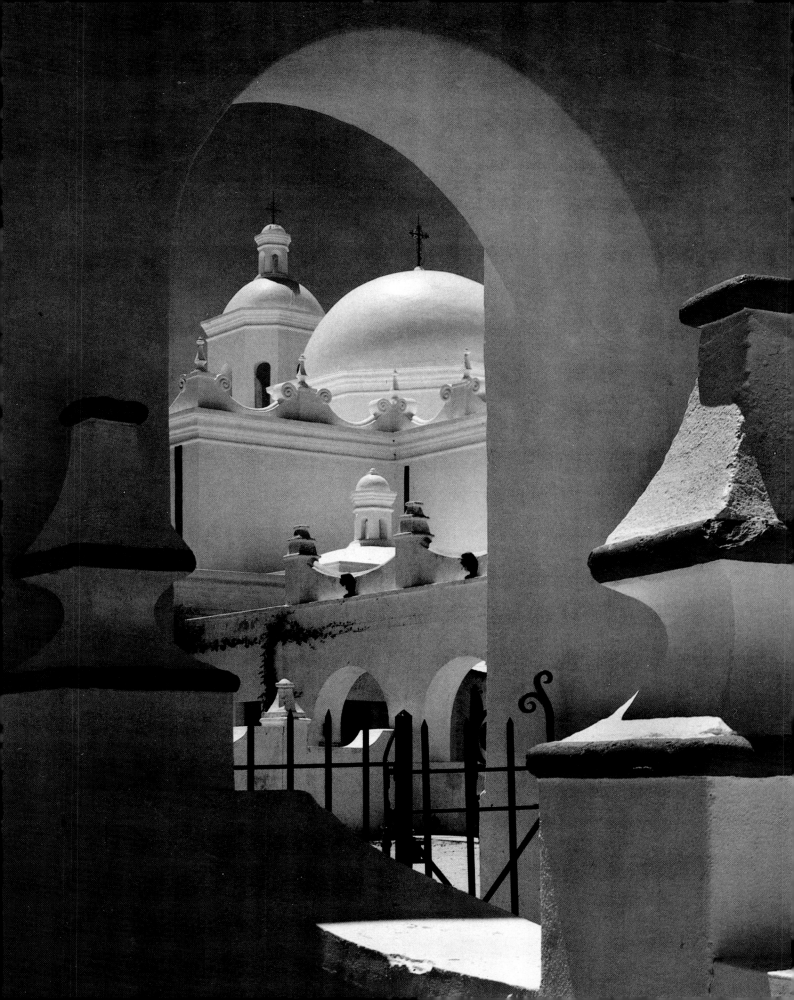

Burning is selectively darkening portions of a print by giving additional exposure. One good way to do it is through a hole in a cardboard. Keep the card in constant motion so you won't see any sharply defined edges near the burned area of the print.

Use dodging on an area of a print that is too dark. Correct it by holding back the amount of light that falls on that region. Make your own dodging tools for the job at hand. Use thin wire and opaque pieces of cardboard. Be sure to keep them in constant motion while you make the basic print exposure. Most prints can be improved by careful dodging and burning.

The print at left is an unmanipulated enlargement. The full-page print at right is a fine print made with some dodging and burning. The hair and left side of the face were dodged. The background and edges were burned in. The effects are subtle, but not trivial.

This portrait of Laura Gilpin was made in a room lit by a skylight and soft light from a side window. Because of the dim light, an exposure of two seconds was required, and the normally developed negative was "thin" due to slight underexposure. A longer exposure would almost certainly have resulted in blurring due to subject movement.

Nonetheless, all of the important values are recorded on the negative and it printed well on a grade 3 paper. When similar circumstances force you to make compromises, be sure that you give enough exposure to capture all important shadow details in the negative. And be prepared to do a good job of printing.

DRYING DOWN

You will learn, probably to your considerable dismay, that the print that looked so good when you took it out of the wash water lost much of its sparkle after it dried. This happens because the reflectance of a wet print is considerably higher than a dry one. As a consequence, a dried print will be *darker* than a wet one. You need to allow for this *dry-down* effect when you make the print.

Do it by giving the final print 5% to 10% less exposure than what you think is ideal when you look at the wet print. Each type and brand of paper will have its own dry-down characteristics, so you will need to evaluate the effect yourself for each paper. It is also affected by toning, so be sure to tone the print before evaluating dry down.

To determine the dry-down effect precisely, make two identical fine prints. Tone and dry one of them after a brief wash. A blow dryer or a microwave oven will dry your print rapidly. Compare the dried print with the wet one and guess at how much you should reduce your exposure. Usually, a 5% reduction in the basic exposure is almost correct. Make another print using the new exposure time, tone and dry the print and compare the new print to your wet print.

If the dried print is still too dark, decrease the basic exposure of your paper even more. If it is too light, increase the exposure a bit. With a little experience, you will find that it is a simple matter to correct for drying down of prints. The factor is a constant for a given brand of paper.

When you first do evaluations of drying effects, do not be surprised if you can see highlights in the dry print that are not visible in

the wet print. And don't be disappointed if those subtle textures in the shadow areas that are so nicely defined in the wet print have disappeared. It is far better to find out now—before you make 20 prints that won't meet your standards.

EXPOSURE NOTES

Finally, in your notebook or on the work print, make a crude sketch of the print you made. Record the basic exposure time, the size of the print, which areas you dodged and how many seconds of exposure were held back, and which areas you burned in and the additional exposure given. Also, record the developer(s) you used and the developing factor determined. This way, if you need to reprint a negative at a

later date, you'll be able to zero in on the final print more quickly than if you start from the beginning again.

When you make a fine print, I suggest that you make several extra copies at that time. The additional effort and paper required are much less than that needed to set up from scratch to reprint—even if you take good notes. The trade-off is that you will need to provide storage space for the prints you make. I recommend that you store them unmounted to conserve space because the number of prints that you will accumulate over the years will be substantial.

SELENIUM TONING

Make up a working solution of selenium toner by diluting one

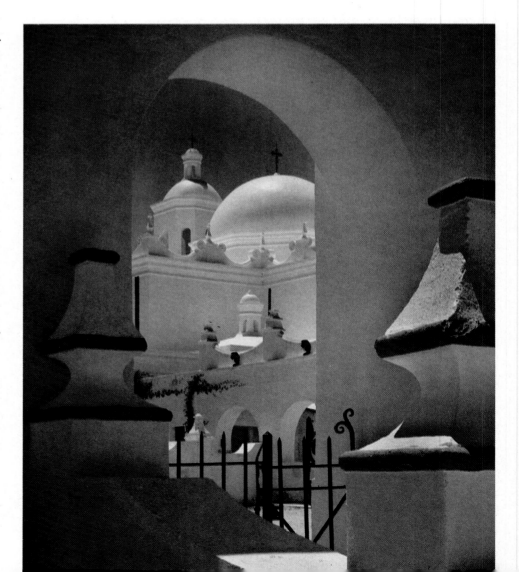

This print has the sparkle of good highlight detail you desire when printing. However, if this is the way the print looks wet, you're in for a surprise when it dries.

part of Kodak Rapid Selenium Toner with nine parts of washing-aid working solution. For example, to make one liter of working toning solution, add 100 ml of toner to 900 ml of washing-aid working solution.

After fixing prints, wash them for a couple of minutes in running water to remove excess fixer. Place pairs of prints back to back in a clean white tray and cover them with enough toning solution to immerse all of the prints. You can probably handle about 10 8x10 inch or 11x14 inch prints at one time in a tray that contains one liter of toning solution. Make sure that the tray area is well lit and keep an untoned print in a tray alongside for comparison.

Remove the bottom pair of prints by sliding them out, flipping them over, and placing them on top of the pile. Continue this procedure and keep a watchful eye on the prints. After about two minutes you will see that the blacks have become more blue-black. Highlights seem to sparkle much more.

When you get the image tone you desire, remove the prints and rinse them in running water. If you allow the prints to remain in the toner too long, they will begin to get a purple cast and, eventually, a red tone if you let them soak for several hours. The toning process is permanent.

Discard the toning bath by washing it down a drain after you have completed the toning process. Don't try to save it. Wash the prints thoroughly after toning.

IMPORTANT! Selenium compounds are poisonous, so you should be careful about using and discarding selenium toning solutions. Do not keep your hands in contact with the solution if you have a cut. Do not use the solution in an area where you are likely to be handling food. Wash your hands thoroughly after you have finished using the toning solutions. You need not be petrified about working with materials that are toxic. Just exercise common sense and good judgment and treat these chemicals with due care. Don't hesitate to use rubber gloves if you feel safer doing so.

If you know that your prints are going to require bleaching, it is important that you do it before you attempt to tone the print. If you are in doubt, omit the toning step and simply wash and dry the print. It is a simple matter to soak them later and tone them, although this necessitates rewashing.

POST-PRINTING CORRECTIVE PROCEDURES

Despite the care that you exercise during printing, some of your prints will have defects. The most common ones are white spots or black spots, a scratched or abraded emulsion, or a slight overall lack of brilliance. Some of these problems can be corrected.

Bleaching—If you find that your dried but *untoned* print lacks the brilliance you want, you may be able to remedy this by using Farmer's Reducer or another bleaching agent.

If the entire print needs to be lightened, first soak it thoroughly in water. When it is completely wet, transfer it to a tray containing a dilute solution of the bleach. Keep tilting the tray back and forth so the solution constantly washes across the surface. Have a reference print in a tray of water alongside for comparison.

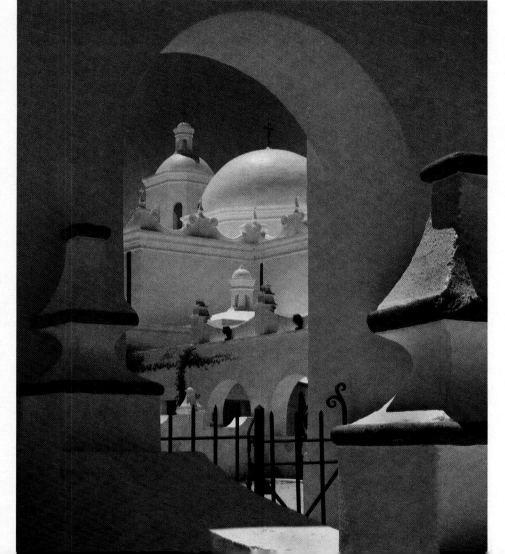

The dried print will look like this—a bit darker. Avoid the problem by testing for the dry-down effect as described in the text. It's a constant for a given paper.

Spotting a print is an important finishing step. It hides minor flaws in the image that would otherwise distract the discerning viewer.

It is easy to carry the bleaching process too far, so be patient and work slowly. Before the print has been reduced to the density you think is appropriate, re-fix the print, using the same procedure you would with a freshly developed photograph and rewash it. Typically, the print will noticeably lighten more in the fixer, so make allowances for this.

You can also use bleaching agents to lighten small areas of a print selectively by using a brush or a cotton swab. Wet the entire print and place it in a tray of clean water so the surface is barely covered. Tilt the tray so the area on which you want to work is out of the water and carefully begin to brush or rub the area you want to lighten with the bleaching agent. Slosh water over the surface frequently so brush or droplet marks won't form. Work slowly because there is a short delay between the time you put the bleaching solution on the print and when you see its effect in the fixer.

Bleach untoned prints only. For this reason, you should delay any toning until after you examine your dried prints—unless you are positive that bleaching is not required.

Spotting—The easiest way to deal with pinholes in your negative is to ignore them. They will produce tiny black spots in your print. You can use a very fine brush and a little Farmer's Reducer to bleach these from the print. The resulting white spots can be retouched with spotting colors. Unless you are very skillful at spotting, this is a better procedure than trying to retouch the negative.

Small white spots on the print are due to dust on the negative or a defect in the film emulsion. Cover these in the print by applying water-based dyes. *Spotone* is one product that works very well.

It is available in different colors, so you can match your print tone exactly by mixing colors if necessary.

Spotting must be done in a well-lit area. Patience is required if your spotting is to be undetectable. If someone tells you that you've done a nice job of spotting, you haven't.

A ceramic plate that chemists use for spot tests is ideal for mixing dyes for spotting prints. You can get one from a chemical-supply house. If you are unable to acquire one, use a white, glazed plate. Sprinkle a few drops of water on the plate and a drop of spotting color. With a #00 watercolor brush, mix a few drops until you have a pool of dye that is *lighter* than the area you need to spot. Moisten a sponge for wiping your spotting brush. Don't use the sponge for *anything* else but spotting.

Dip the brush in the diluted dye, wipe it with a twisting motion on the sponge to form a point, and begin applying the dye to the spot that you want to remove, using a stippling motion. You will find that until the print surface on

which you are working has been penetrated with moisture, the dye will not be absorbed. This occurs more quickly with unhardened prints, but the difference is not significant.

Do not attempt to brush the dye on—brush strokes will show and you won't be able to dye the print evenly. Be patient, and build up the tone slowly so it blends with the surroundings.

If you go too far in spotting and the area gets too dark, rewash the print and start again. If the dye persists during washing, you can remove the residual color by applying a small drop of diluted household bleach to the area, refixing the print, and then washing the print thoroughly. You will find that a good magnifying glass attached to a flexible gooseneck makes all spotting operations easier.

PRINT STORAGE

After you work in photography for a while, you'll accumulate substantial numbers of prints. You'll need to confront the problem of storing and retrieving photographs and negatives. This is something

that's easy to put off, but if you delay too long, I guarantee that you will regret it. Begin a system for filing and storing your work early on. Keep it up to date.

I index my negatives according to the year in which they were exposed and developed, and then number them in the order in which I took them during the year. For example, negative 80-24 (35mm) tells me that a picture was taken during 1980 and that it was the 24th roll of 35mm film that I processed that year. I store my negatives in chronological sequence and in the case of roll film, I write the frame number on the back of my work print, such as 80-24 (35mm) #21. If there are some unusual aspects to the exposure or developing conditions that I used, I will often make a note of this on the film-storage envelope.

I also keep a notebook that groups my photographs according to subject matter and I store my work prints according to subject

matter—landscapes, portraits, still-lifes, trees, sporting events and so on—to simplify retrieval.

It is essential to separate the storage of fine prints and work prints. You can store work prints in old photographic paper boxes and file them according to subject matter and dates. I will usually make three to five copies of fine prints to have a few extras on hand. I store these in special acid-free cases suitable for archival preservation of photographs.

Boxes of this variety and many other useful accessories for photographers, along with information on archival processing and storage of photographs, can be obtained from Light Impressions, 131 Gould Street, Rochester, NY 14610. Write for their catalog.

Acid-free boxes should also be used to store mounted prints. You put a lot of effort into making your prints, so take good care of them. Over the years, they will provide a fine collection for you and document your growth as a photographer. You will also learn from them if you study them occasionally.

DISPLAYING PRINTS

A fine print represents a lot of effort; show it off to its best advantage. If a print is going to be handled, it should be mounted and covered with an overmat. This serves to protect the print and enhance its presentation. If a print is going to be hung on a wall, it should be framed behind glass. Both matting and framing prints require you to consider a few things.

Mount-Board Color—The key factor in choosing a color for mount board is to select a shade that complements your print. Visually, the surrounding mat becomes part of the photographic print. You should choose a mat that confines your eyes to the print itself, not the area around it.

If you have a print that is predominantly white, a white mount may be a poor choice because the photograph may merge visually with the mount. In this case, a mid-gray may be a better color for the mount. For warm-tone photographs, cream-colored mats are usually better than white, while the opposite is true for cold-tone photographs. Some photographers prefer black mounts for their prints.

I recommend that you purchase mount boards of a few basic colors from an art-supply store and cut them into large L-shapes about 4 inches wide and 16 inches long. You can use these as temporary borders around most prints and judge how a particular color will work. Be conservative in your selections—white and cream work best for most prints.

Mounting Prints—There are two schools of thought about mounting prints. One holds that prints should be dry mounted, the other that they should be hinged or taped by the corner to a mat. I personally prefer to dry mount prints because taped prints will not always lay flat against the mat board, which can be visually distracting. When you dry mount a print, it is almost impossible to remove the print. On the other hand, if you process the print properly and use good quality, acid-free matting board, removing a print from its mat should not be necessary.

To avoid chipping the image at its edge, make prints with a generous border—at least an inch wide. For an elegant-looking presentation, you can *overmat* the print. An overmat is a piece of mount board that has a window cut out to show the print. It acts as a raised frame for the print. Frame the print in glass for extra protection. The surface of a print is delicate and cannot tolerate abrasion.

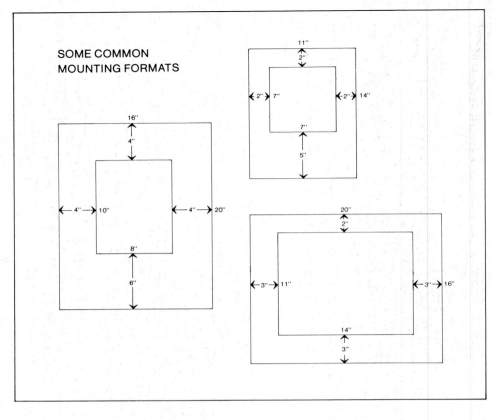

SOME COMMON MOUNTING FORMATS

1) Attach part of the dry-mount tissue to the print's back with a tacking iron.

2) Place the print on the mounting board and align it according to its position on the mounting board.

Mount an archivally-processed print on acid-free board. Acid is an enemy of paper, causing the paper to discolor and become brittle. Acid and sulfur from a mounting board will slowly penetrate a print and attack it. Therefore, be certain that any print you value is mounted on acid-free materials or buffered boards, usually available from local art-supply stores. Don't take a chance of ruining a fine print by fixing it to a poor-quality mount board!

Dry Mounting—Before dry mounting a print, make sure that the back of the print is free from grit or lint. Attach a piece of dry-mounting tissue to the center of the back of the print with a tacking iron. Use an X-shaped motion that spans a few inches along the diagonals of your print. Leave enough room near the corners so you can later lift a corner and tack the tissue to the mounting board.

Purchase a T-square, a metal ruler and a drawing board that has at least *one* right-angled corner. The ruler and smallest length of the drawing board should be at least as long as the smallest dimension of the mat size you usually use. A standard drawing board is 24x36 inches. This should handle most prints that you'll want to mount. Attach the ruler to the bottom edge of the drawing board, using double sticking tape

or a glue that can bind metal to wood. Be sure that the ruler is centered and that it runs exactly along the edge.

For this setup, the lower-left corner of your board must be square. Accompanying photos illustrate the arrangement I describe. You'll also see some common layouts for mounting prints on mats in either a horizontal or vertical format. Unless you have some compelling reason for doing so, you should avoid mounting your prints in the dead center of your mat. Too much symmetry gets boring.

To mount your print, lay the mounting board against the ruler and center it. This is easy to do because a 16-inch mounting board, for example, must extend 8 inches from center in each direction. Therefore, with a 24-inch ruler, the edges of the board will fall at 4 and 20 inches, respectively. I recommend that you mark the ruler with a pen at the point where the edges of all common sizes of mounting boards fall. If the borders of your print are even, center the print in the same way you centered your mounting board and place the edge of the T-square alongside the left edge of the print. Slide the print up along the edge of the T-square until the bottom edge is at the height you wish. With a gloved hand, hold

the print firmly in place by pressing your fingers on the center of the print.

While holding the print firmly so it doesn't shift, lift one corner of the print—but not the mounting tissue—and tack the tissue to the board with your tacking iron. Do this with all four corners and then check to see if the print is square and mounted where you want it on the board. If it is not, gently peel it off the board and start again.

Wipe the print surface free of any dirt, grit or lint and cover it with a sheet of heavy acid-free paper. Preheat your dry-mount press to the temperature specified by the manufacturer of the dry mount tissue you are using.

Two pieces of two-ply, acid-free mounting board should be kept in your dry-mount press at all times. Slip your print into the press between the mounting boards so the print faces the heating platen. Close the press. About one minute of hot pressure is enough to bind the print to the mounting board. Remove the print from the press along with the cover sheet and flex the board slightly to make sure the print has adhered firmly to the mounting board. If it pops off at one of the edges, place it in the press again and increase the mounting time.

If you do not own or have

3) Tack the print to the mounting board.

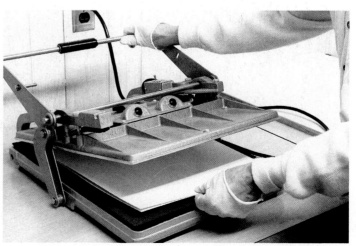

4) Place the print between two pieces of two-ply acid-free board in the heated dry-mount press for about a minute at the recommended temperature.

access to a dry-mount press, you can use an iron. Heat the iron to the *cotton* setting. Make sure that the print surface and your covering sheet are free of grit and lint. Place the print and cover sheet on a steady table. Press the iron down gently but firmly on the sheet in the center of the print and move the iron slowly to the edges of the print. Keep the iron moving! Repeat this until the entire print is secured to the mounting board. This technique is slow, but simple.

In all dry-mounting operations, you must be careful to avoid getting any kind of grit under or on the surface of the print. These will either raise a little nub on the surface or pit it. Such damage cannot be repaired. If the defect stands out like a mountain or a crater, you'll have to discard the print.

Overmatting Prints—Prints that you want to exhibit should be overmatted. A mat enhances the photograph for viewing and also protects the print from abrasion and wear. Store overmatted prints with a sheet of acid-free tissue between the mounting board and the overmat for additional protection.

Making an overmat is simple. Take the piece of mounting board you want to use and place it on top of the board on which your print has been mounted. Make sure all edges and corners of the two coincide. Mounting board is usually cut in batches; if all corners are not 90° angles, the boards will superimpose in only one orientation.

When you have two pieces of board that superimpose, remove the board to be the overmat by turning it as if you were opening the cover of a book. Lay it alongside the board containing your print.

Measure how far from the top and bottom edges of the mounting board the print lies and mark these distances on the overmat. If you want to leave a border between the edges of your print and the mat, make the appropriate allowance. Use your T-square and draw two horizontal lines. Now measure the distances from the edges of the print to the edges of the mounting board.

If the left and right margins are not exactly the same, be sure to mark the left margin on the right side of the mat and *vice-versa.* You need to reverse the edges because you are marking and cutting your mat from the backside of the board and the side edges will be reversed when you place the cut

With the Dexter Mat Cutter, you can cut a bevelled edge in the overmat. The cutter is contoured to comfortably fit your hand to make straight cutting easier.

on the overmat and use your T-square to draw two vertical lines on the mat. Use a heavy-metal straight edge with a Dexter Mat Cutter to cut the mat. The Dexter Mat Cutter is designed to fit your hand comfortably and is easy to use. These items can be obtained from an art-supply store or from Light Impressions.

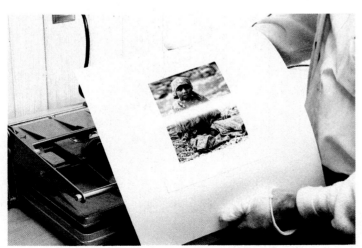

5) After time's up, remove the mount board and flex the print to check for a firm bond on the mounting board.

6) Cut a window for the overmat. If using double-weight board, a Dexter Mat Cutter (shown) is ideal. If using single-weight board, a razor knife is OK.

A bevelled edge lends a professional touch to your mounted prints. It looks best with double-weight boards.

Tape the overmat to the mounting board by butting them together and joining them with linen tape. Fold over the mat as if you were closing a book and align all of the edges of your boards.

Framing Prints—A print that you plan to hang in your home or a gallery should be framed. You can purchase polished or brushed-aluminum sections that are precut and beveled to all common mount-board sizes. They are available in silver, gold and other colors and can be assembled quickly. You may or may not have to purchase the glass separately. Check with local art-supply or framing stores.

Wash all of the frame parts and glass in warm soapy water, rinse and dry them thoroughly. This is necessary to remove any oil or grease that may adhere to the surface. Assemble the frame according to the instructions provided with the framing materials and carefully place the glass in the frame. I recommend that you use clean cotton gloves when you handle the glass. You'll keep everything clean and avoid cutting yourself.

Make sure the inside surface of the glass—the part that faces the print—is dust-free. Next, place the print in the frame, back it with a piece of heavy mounting board if necessary to keep it flat, and insert the clips supplied with the frames to keep the print in place.

Wooden frames are available from stores that specialize in print framing. These are often less expensive and can be quite attractive, although not always of archival quality. Choose a frame that goes well with your photograph and keep it plain and simple. If people start admiring your frame, you better take a closer look at your photograph or change the frame.

You have now completed the making and presentation of a fine print. Sit back and enjoy the sight—it is what you have been working toward.

7) The board holding the mounted print is taped to the overmat with the cutout. I prefer to use archival-quality linen tape.

8) The fine print, mounted and overmatted is now suitable for framing.

12

Polaroid Land
B&W Photography

You acquire skills through practice. Reading about an activity helps you understand the principles involved, but it isn't a substitute for doing it. How fast you learn is limited by the time between an activity and the moment you obtain and evaluate the results.

In b&w photography, using Polaroid films can reduce the delay between tests and results to a matter of seconds. This speeds up your ability to master concepts of previsualization. You can evaluate how color will translate into b&w tones. See the effect of filters are on a b&w scene, as well as composition, lighting, focus and depth of field and the many other things that concern you.

However, there is much more to Polaroid than instant feedback. A well-executed Polaroid photograph is a fine print in its own right, the modern equivalent of the Daguerreotype. Because it occupies an important place in photography, I discuss aspects of its use and application in this chapter.

A more definitive treatise on the subject is *Polaroid Land Photography* by Ansel Adams. Consult it if you want more detail about the theory and practice of Polaroid photography.

B&W Polaroid Land prints made with 50-series films for 4x5 cameras can be fine prints in their own right. Consider mounting and framing them. This one is reproduced life-size.

THE POLAROID PROCESS

In conventional b&w photography, you develop the negative first and fix the image second. You can combine these two steps by using a *monobath*—a formulation that combines developing agents and fixer in a single solution. Making a monobath is tricky, because the developer and fixer react with the exposed negative simultaneously. Concentrations of chemicals must be precisely controlled, otherwise exposed silver-halide grains are dissolved by the fixer before they develop.

Despite the obvious appeal of being able to combine all of the reagents for negative processing into a single solution, monobaths

have never been very popular. They don't let you control negative density range. With equivalent exposure, every negative has a fixed average determined by the composition of the monobath.

Dr. Edwin Land took the monobath concept and adapted it so that a print is produced as an end product. During negative development, unexposed silver-halide crystals are converted to soluble silver-thiosulfate complexes. These complexes are transferred to a sheet of paper and the silver salts are subsequently reduced to silver crystals on the surface of a specially coated *receiver sheet*.

Depending on the type of film used, you can obtain a negative or a positive. With b&w films, typical processing times are between 15 and 20 seconds at 70F (21C) and warmer.

POLAROID EQUIPMENT

Polaroid makes cameras in addition to film products. The Polaroid EE 100 Special Land Camera and Polaroid Model 600 SE are two cameras that use b&w film.

The EE 100 is an inexpensive automated camera designed with the amateur photographer in mind. The camera provides an easy way to evaluate scenes and is an excellent accessory for the serious beginner in b&w photography. If you use a 35mm camera exclusively, an EE 100 is helpful because you can get a quick idea of what a b&w print will look like. If you use a medium- or large-format camera, there are better options.

The 600 SE is a high-quality medium-format camera with interchangeable lenses that is currently made for Polaroid by Osawa. With Polaroid's positive/negative film, you can use the camera to obtain a fine-grain negative for enlarging. The print and negative format is about 3-1/4x4-1/4 inches.

More universally applicable are sheet and roll-film backs that are available for most medium-format and a few 35mm cameras. A special film-pack holder and a sheet-

The Polaroid EE 100 Special Land Camera is a simple automatic-exposure camera that accepts 600- and 80-series Polaroid films. Use it to learn how to see in b&w.

The Polaroid 600 SE camera has aperture and shutter-speed controls. With it, you can see how a particular set of exposure-control settings will reproduce a scene in b&w. It's a useful device if your camera does not accept a back that uses Polaroid film.

film holder are available for 4x5 cameras. By purchasing one of these accessories, you can use the entire array of Polaroid b&w films with your own equipment.

Film-pack holders attach to the back of the camera and are loaded with Polaroid film-packs. These are an assembly of eight sheets that you can expose and process sequentially. After each exposure you pull two tabs to move the film through rollers, which begins development. When development is complete, you peel apart the positive/negative sandwich to obtain the final image.

If you photograph with a 4x5 camera, you can use a Polaroid Model 545 sheet-film holder. The sheet-film holder accepts a single sheet of film that you load and process in daylight. The actual photograph is 3-1/2x4-1/2 inches and is slightly off-center on the camera focusing screen. You will need to mark the ground-glass with a pencil or transparent marking pen to achieve precise framing. Detailed operating instructions are included with each type of holder. Read them carefully before you begin.

USING POLAROID FILMS

Polaroid b&w films consist of a negative protected by a dark-slide

of some type, an image-receiving sheet, and a sealed pod of chemicals. After exposure, you begin development by pulling the film packet between two precisely spaced steel rollers. This breaks the pod and spreads a thin layer of chemicals between the negative and print paper.

A key to obtaining Polaroid prints and negatives free of processing errors—for example, streaks or undeveloped corners or edges—is to pull the film through the roller smoothly. Pull the packet with a moderately quick and steady motion so the packet emerges from the slot without bending. The time to breathe out a gentle "ahh. . ." is just about the time it should take for you to pull the packet through the rollers.

You must be certain that the rollers are kept free of dirt and excess developer. Over time, small amounts of reagents may accumulate on the rollers, changing the spacing between them and causing processing problems.

Check the rollers after using the film holder with about 10 sheets of film. If rollers aren't clean, wipe them with a damp piece of tissue and spin them to be sure they rotate freely. Avoid getting the caustic developer on your skin.

Clean the rollers thoroughly after each photographic session

and store the holder in a sealed plastic bag when you are not using it. Grit and dirt on the rollers must be avoided at all costs.

Temperature control during processing of Polaroid films is important, though it is not nearly as critical as when you develop conventional films. Instructions are packaged with each box of film and tell you how to adjust the processing time as a function of temperature. Remember, it is the temperature of the chemicals in the pod that matter, not the ambient temperature.

To remove any uncertainties you may have about the processing temperature, you should try to work under conditions where the film and film-holder have been given enough time to reach ambient temperature.

If this temperature varies by more than 10F from a mean of 70F (21C), you should delay processing or take steps to control the processing temperature to 70F. An insulated container is useful for this when you are working outdoors. You can store the film and Polaroid back in the container when not using them.

Temperature influences the quality of Polaroid images too. Using the film at temperatures below 60F (16C) or above 90F (32C) is not recommended. If controlling processing temperature creates serious problems, I recommend that you make your exposure and process the film later when you can control the temperature within acceptable limits. Unfortunately, delayed processing of several exposures is possible only with individual sheets of film, not film packs. Obviously, the disadvantage of delayed processing is that it delays your ability to evaluate the image.

POLAROID 4x5 SHEET FILMS

The tonal properties of a Polaroid print are distinctive and are not the same as those you would obtain from the enlargement of a negative. Typically, maximum

At left is the Polaroid 545 Land Film Holder. It accepts individual sheets of 4x5 Polaroid film. At right is the model 550 film holder that accepts 550-series 4x5 pack films.

density is about 1.7 and the gray tones have a pearl-like quality and unique luminescence. Care for them as you would a fine print.

Polaroid uses code numbers in the 50s to designate sheet films for the 4x5 format. They are sold in packages of 20 sheets. Prints must be coated for permanence, so each package contains four print coaters for that purpose. Coaters deposit a clear plastic film on the surface of the print, protecting the image from abrasion and the atmosphere.

To coat a print, lay it on a flat, clean surface and hold it by the tab. Remove the coating swab from its container and wipe the surface of the print in a series of swift, parallel strokes until the entire surface of the print is covered with a thin, uniform layer of the coating agent. Let the print dry

in a dust-free area. This takes from 1 to 10 minutes, depending on temperature and humidity. If possible, coat prints within a few minutes of development. If this is impractical, place the prints in a box and coat them as soon as you can. Polaroid prints will lighten in tone if they are not coated within 2 to 3 hours. They'll also scratch easily.

500-series films are 4x5 film-packs for the model 550 film holder. Emulsions are identical to some 50-series films, as described here. Packs contain eight 4x5 sheets.

Type 51 Film—This is a high-contrast, blue-sensitive film that produces prints only. It is sensitive to blue light only and is intended primarily for line copying. A brightness range of two steps

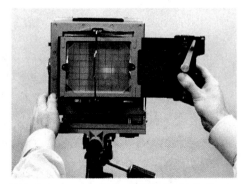

This is how you put the 545 holder into the back of your view camera. It fits in front of the ground glass, like a regular film holder.

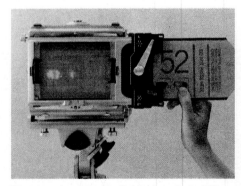

Then you insert an individual packet of film into the holder when the lever is set to L. Complete directions for using the holder come with the holder and are briefly illustrated on the back of the holder.

At left is a contrasty rendition on Type 51 film. The same subject was photographed on normal-contrast Type 52 film at right. Type-52 film is good for checking exposure because it has an ASA speed of 400, the same as a conventional fast-speed film I use.

separates maximum black from paper-base white in the print. As a consequence, there is very little exposure latitude.

Because of its high contrast, it's useful for pictures of subjects with a very short brightness range. An example of this might be a subject in deep shade or a dimly lighted interior. In addition, if a subject benefits from a high-contrast photographic interpretation, Type 51 film is useful. Recommended speeds are ASA 320 for daylight and ASA 125 for tungsten illumination.

Type 52 Film—Polaroid's medium-speed panchromatic Type 52 film is rated at ASA 400. (Type 552 is equivalent.) The film's exposure range will reproduce textured print values that cover a brightness range of about 5-1/2 steps. The film produces prints that are most satisfactory if the brightness range falls within these limits. Otherwise, details will be missing from either the shadows or the highlights.

Pre-exposure is useful with Type 52 film because it adds a semblance of detail to shadow areas of the print. This can help you to deal with subjects that have a brightness range longer than about 5-1/2 exposure steps.

Type 57 Film—This film is rated at ASA 3000. It is useful in low-light situations and allows you to photograph in a normally lit room without a flash. It is also useful outdoors if you need to stop fast action. For normal outdoor photography with this film, you may need to use ND filters to reduce the effective film speed.

The exposure range of Type 57 film is more limited than Type 52, spanning a brightness range of only four steps—from about zone II to VI.

Type 55 Positive/Negative Land Film—This extraordinary film produces both a print and a usable fine-grain negative! The negative will record detail over a brightness range of seven zones, but the print is limited to a brightness range of only four zones.

The official film speed for Type 55 is ASA 50, but typically the print is a bit faster and the negative slower. You will have to determine working speeds for yourself because they vary slightly with each pack of film. Fortunately, this is not a problem, because you will have both the negative and positive in hand almost immediately and you can tell by inspection

what exposure corrections are needed.

Type 55 negatives require additional treatment after development. The negative must be immersed in an 18% solution of sodium sulfite to remove all traces of excess processing solution. This must be done within three minutes after development. Polaroid sells premeasured packets of sodium sulfite that you can add to a specified volume of water to make the required solution. Alternatively, you can weigh out 180 grams of anhydrous sodium sulfite and add it to enough water to make 1 liter.

Agitate the film gently in the solution until all traces of the chemicals used for development have been washed off. The developer end products are a brown slime, so the clearing process is easy to follow. The developer is quite caustic, so if you get any on your skin, rinse the area with cold water immediately. Negatives can be stored in the sodium sulfite bath all day if necessary.

Freshly developed negatives are easily scratched, so handle them carefully. After the negative has been cleared in the sulfite bath, it should be hardened. A hardening solution recommended by Polar-

oid can be prepared by adding 250 ml of 28% acetic acid to 500 ml of water at 70F (21C). To this solution, add 16g of potassium alum and enough water to bring the total volume to 1 liter. A two-minute immersion in this bath with gentle agitation is sufficient to harden the negative. Wash and dry the negative in the usual way.

In field work, with all of these solutions sloshing about, it is relatively easy to make a spectacular mess of the trunk or floor of your car. You'll need a portable processing tank with a lid. Polaroid used to make a portable plastic bucket that had a lid and a built-in rack for up to eight sheets of film. It was ideal for field work, but may be difficult to find in stores. Contact Polaroid Industrial Marketing for details.

Use separate baths for the sulfite clearing bath and another for fresh-water storage of the processed negative. Transport all of your solutions in containers that can be tightly closed to minimize the problem of spillage. And take along a jug of water to rinse your hands free of processing solutions.

It is possible to postpone processing of a 4x5 sheet of positive/negative film until you get to a darkroom. After you make an exposure, reinsert the film envelope into the Polaroid film holder and depress the film-release lever at the top of the holder. Gently withdraw the entire envelope from the holder. To process the film later, simply reinsert the film in the holder, move the control arm to P, and pull the film through the rollers as usual.

Postponing processing enables you to work in controlled conditions that are more comfortable than out in the field, but you lose the advantage of being able to evaluate your images instantly.

Type 55 film is also an excellent alternative to carrying around a lot of conventional loaded film holders. If you are backpacking with a 4x5 camera, film holders represent far more weight and volume than

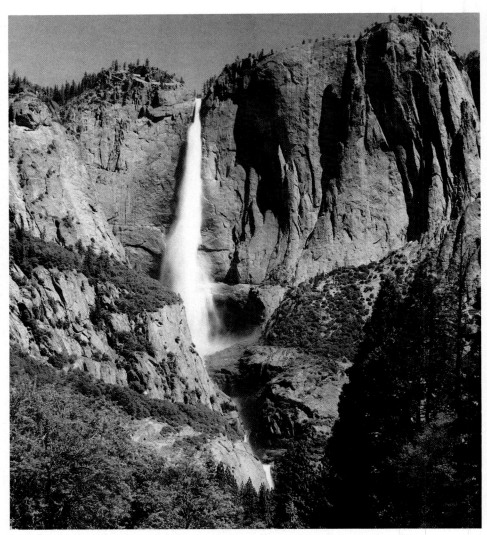

I made this print of Yosemite Falls from a 4x5 negative made on Polaroid Type 55 positive/negative film. Exposure was based on a meter reading of a gray card. I used a green filter to lighten the foliage and darken the clear blue sky.

a comparable quantity of Type 55 positive/negative film.

POLAROID PACK FILMS

Polaroid films are available in film packs containing eight sheets of film. The packs can be used in the EE 100 Special Land Camera—or in any of the older, discontinued models—or with specially designed holders that are made for all medium-format cameras accepting interchangeable backs.

The Model 405 holder is made for 4x5 cameras. It can be locked in place for cameras that accommodate Graflok backs or it can be inserted under the ground glass screen like a conventional film pack or sheet-film holder. With

the Model 405, the image is only 2-7/8x3-3/4 inches and is slightly off-center, so you will need to mark the ground-glass viewing screen to assure precise framing of the image.

Using Pack Films—Each back or camera designed for film packs has detailed instructions for loading the film pack and attaching the back to the camera. Read these carefully before you attempt to use the film. Be certain to check the steel rollers each time you insert a new film pack into the holder. If they are not clean, wipe the rollers carefully with a moist tissue.

To use a film pack, open the door of the holder and inspect the

Some medium-format camera manufacturers, such as Hasselblad, use Polaroid-supplied parts to make an interchangeable back that accepts 600- and 80-series Polaroid film. At right is the size of the 6x6 cm image made on Type 667 film by the Hasselblad Polaroid back.

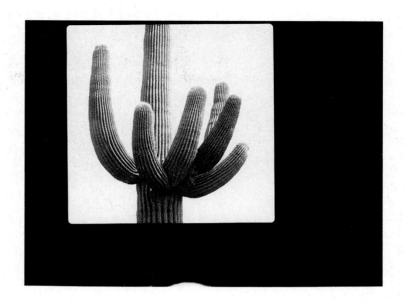

holder carefully to make sure it is clean. This is especially important with the back for the Hasselblad camera. It contains a piece of optically flat glass against which the film rests to insure precise alignment of the negative in the film plane. Any dust on the glass will show as a black spot on the print or a pinhole on the negative.

To insert the film pack into the holder, hold it by the edges and sliding it under the lip of the holder so the dark slides of the holder and film pack are face to face. Do this in shade or dim light to minimize the possibility of fogging the film. Next, make sure that all of the tabs are extended and free and then close the door of the holder. Pull the black tab all the way out. A white tab will appear with the number 1 on it. You are now ready to make an exposure.

Attach the back to the camera and remove the dark slide from the back. Make the exposure. Pull the white tab to position the film for processing and a yellow tab will appear. Development will begin when you pull the yellow tab. Pull the tab out straight from the holder at a steady and fairly rapid rate. A steady motion is important for consistent results and

images free from defects.

Begin timing the duration of development as soon as the packet is free of the holder. When development is completed, peel the print free of the negative by grasping a corner of the print and pulling it away from the negative with a quick steady movement. Do not let the print fall back into contact with the negative. Carry a bag with you to discard all of the waste paper that you generate.

If you are using positive/negative film, separate the negative from the surrounding paper and complete processing by soaking the negative in a sodium sulfite bath as described for Type 55 film. Notice that with Type 665 positive/negative film, a 12% sodium sulfite solution is recommended rather than the 18% solution used with sheet film. No adverse effects will result if you use the more concentrated solution.

If the rollers become fouled during the use of a film pack, you can open the back in dim light and remove the pack from the holder. Clean the rollers with a moist cloth or tissue and replace the film pack. With care you should lose no more than one exposure.

The maximum size of the image that you can obtain with film

packs is 2-7/8x3-3/4 inches. With medium-format cameras, the size of the print or negative will correspond to the size of camera's film gate.

Type 665 Film—This is the pack film that corresponds to Type 55 positive/negative film. It has similar capabilities to the latter and can be used in the same way.

Type 667 Film—This panchromatic pack film corresponds to Type 57 sheet film, with the exception that the prints do not need to be coated. The suggested ASA rating is 3000.

Type 612 Film—This special-purpose panchromatic film has an ASA rating of 20,000. It is a high-contrast film intended for copying images from dim light sources. The exposure range of the film is narrow. Prints must be coated after development. Its use for making fine prints is obviously limited.

Type 611 Film—A special-purpose film with a speed rating in the range of ASA 10 to 50, depending on the light source. It is designed for recording images from a video screen and is a low-contrast panchromatic film with a wide exposure latitude. Prints from this film do not need to be coated.

A PHOTOGRAPHIC READING LIST

The following books contain quality reproductions of fine photographs. I recommend that you look at some of these to learn from acknowledged masters of the craft.

Adams, Ansel. *Yosemite and the Range of Light.* Intro. by Paul Brooks. Boston: New York Graphic Society, 1979.

Beaton, Cecil, and Buckland, Gail. *The Magic Image: The Genius of Photography from 1839 to the Present Day.* Boston: Little, Brown, 1975.

Cartier-Bresson, Henri. *The Decisive Moment.* New York: Simon and Schuster, 1952.

Coe, Brian. *Colour Photography: The First Hundred Years, 1840-1940.* London: Ash & Grant, 1978.

The Daybooks of Edward Weston. Vol. 1: *Mexico.* Intro. by Beaumont Newhall. Forword and technical note by Nancy Newhall. Rochester, NY: GEH, 1961. Vol. 2: *California 1927-1934.* Intro. by Nancy Newhall. New York: Horizon Press, and Rochester, NY: GEH, 1966. Reprint (both vols.), Millerton, NY: Aperture, 1971.

Emmet Gowin: Photographs. New York: Knopf, 1976.

Enyeart, James L. *Bruguiere: His Photographs and His Life.* New York: Knopf, 1977.

Gernsheim, Helmut. *Creative Photography: Aesthetic Trends, 1839-1960.* London: Faber & Faber, 1962.

 Creative Photography, 1826 to the Present: An Exhibition from the Gernsheim Collection. Detroit: Wayne State University Press, 1963.

 The History of Photography: From the Earliest Use of the Camera Obscura in the Eleventh Century up to 1914. New York: Oxford University Press, 1955. Rev. ed., New York: McGraw-Hill, 1969.

Green, Jonathan, ed. *Camera Work: A Critical Anthology.* Millerton, NY: Aperture, 1973.

Johnson, William S., ed. *W. Eugene Smith: Master of the Photographic Essay.* Millerton, NY: Aperture, 1981.

Lyons, Nathan, ed. *Photographers on Photography.* Englewood Cliffs, NJ: Prentice-Hall, and Rochester, NY: George Eastman House, 1966.

Maddow, Ben. *Edward Weston: Fifty Years.* Millerton, NY: Aperture, 1973. Bibliography. Another ed., Boston: New York Graphic Society, 1978.

 Faces: A Narrative History of the Portrait in Photography. Boston: New York Graphic Society, 1977.

Newhall, Beaumont. *The History of Photography from 1839 to the Present Day.* New York: Museum of Modern Art, 1949. Rev. ed., 1964.

Newhall, Nancy. *P. H. Emerson: The Fight for Photography as a Fine Art.* Millerton, NY: Aperture, 1975.

Paul Strand: Sixty Years of Photographs. Profile by Calvin Tomkins. Millerton, NY: Aperture, 1976.

Places: Aaron Siskind Photographs. Intro. by Thomas B. Hess. New York: Light Gallery and Farrar, Straus & Giroux, 1976.

The Portfolios of Ansel Adams. Forward by John Szarkowski. Boston: New York Graphic Society, 1977.

Scharf, Aaron, *Art and Photography.* Baltimore: Penquin, 1969. Rev. ed., 1969.

Szarkowski, John. *Looking at Photographs: 100 Pictures from the Collection of The Musuem of Modern Art.* New York: Museum of Modern Art, 1973.

Taft, Robert. *Photography and the American Scene: A Social History, 1839-1889.* New York: Macmillan, 1938.

Tucker, Anne, ed. *The Woman's Eye.* New York: Knopf, 1973.

Walker Evans. Intro. by John Szarkowski. New York: Museum of Modern Art, 1971.

White, Minor. *Mirrors, Messages, Manifestations.* Millerton, NY: Aperture, 1969.

Witkin, Lee D. *A Ten Year Salute: A Selection of Photographs in Celebration, The Witkin Gallery, 1969-1979.* Danbury, NH: Addison House, 1979.

EXPOSURE-RECORD FORM

Film: _____
ISO: _____
Camera and Lens: _____
Developer: _____

Development Time: _____
Developer Temperature: _____
Film b+f: _____
Exposure Index (Measured): _____

Frame	Aperture	Shutter Speed	Exposure Zone	Density	Density −(b+f)
1)					
2)					
3)					
4)					
5)					
6)					
7)					
8)					
9)					
10)					
11)					
12)					
13)					
14)					
15)					
16)					
17)					
18)					
19)					
20)					

RECORD FORM FOR DEVELOPMENT-TIME TESTS

Film: _____ Developer Temperature: _____
EI: _____ Agitation: _____
Developer: _____ Development Times: _____

Frame	Aperture	Shutter Speed	Zone	D	D-(b+f)	D	D-(b+f)	D	D-(b+f)	D	D-(b+f)	D	D-(b+f)
1)													
2)													
3)													
4)													
5)													
6)													
7)													
8)													
9)													
10)													
11)													
12)													
13)													
14)													
15)													
16)													
17)													
18)													
19)													
20)													

Index

A

Accelerators, 70
Acufine, 79
Acutance, 41
Agitation, 72
Alignment, 113
Anti-oxidants, 70
Aristo cold lights, 115
Average scene, 30

B

Bleaching, 141
Blocking, 63
Bromide paper, 123
Burning in, 134-138

C

Camera meters, 28
Camera systems, 14-20
Characteristic curve, 42
Chloride paper, 123
Chlorobromide paper, 124
Chromogenic films, 80-81
Cold lights, 115
Compensating effect, 71
Composition, 5
Compression, 61
Condenser enlarger, 114-115
Contact prints, 131
Contrast, 12
 inherent, 41
 negative, 41
Contrast-control filters, 93
Covering power, 20
Curve family, 56-59

D

Dark cloth, 20
Darkroom design, 109-112
Darkroom methods, 113-119
Densitometer, 24
Density, 21-23
 measuring, 24-26
 range, 47
Developer temperature, 72
Development time, 72
Development-time testing, 49
Diafine, 62-63, 78
Diffusion enlarger, 115
Dilution, 73
Displaying prints, 144
Dodging, 134-138
Dry mounting, 145
Dryers, 119
Drying down, 140

E

Easel, 117-118
Electricity, 112
Enlarger, 112-116
Enlarging lenses, 114
Expansion, 60
Exposure Record, 37
Exposure
 index (EI), 39
 latitude, 65
 notes, 140
 range, 48, 121
 record form, 45, 155
Exposure-step equivalency, 87

F

Factor method, 128
Farmer's reducer, 83
Fast film, 67
FG7, 80
Fiber-base paper, 120
Field camera, 19-20
Field work, 98-108
Film
 characteristics, 38-43
 developers, 66-85
 development times, 47
 holder, 51
 speed, 23, 38, 43-46
Filters, 86-97
 contrast-control, 93
 factors, 87-89
 ND, 93
 polarizing, 95
 skylight, 90
 table, 93
 UV, 90
 viewing, 8, 99
Fine printing, 132-147
Fixing,
 film, 74
 prints, 129-130
Flare, 68
Flash fill, 108
Flatbed camera, 19
Focusing aids, 118
Folding rangefinder, 18
Framing prints, 147

G

Grades, 121
Grain size, 39
Graph paper, 157, 158
Gray card, 9, 43

H

Handheld meters, 29
HC-110, 64, 79
High-contrast scene, 13
Hypo test, 130

I

ID-11 Plus, 79
Image circle, 20
Incident-light meter, 28
Infrared films, 69
Inherent contrast, 41
Instant cameras, 149
Intensification, 82
Interchangeable backs, 17
Intermittency effect, 52
International Optical Service, 68
ISO, 23

L

Landscape photography, 98
Large-format
 camera, 19-20
 lenses, 20
Latent image, 70
Leaf-shutter lenses, 18
Lens coating, 68
Light Impressions, 143
Lighting, 110
Low-contrast scene, 12
Luminance, 8

M

Magnification, 39
Matte box, 90
Maximum development time, 123
Medium-format
 cameras, 17-19
 lenses, 18
Medium-speed film, 67
Meter calibration, 46
Metering patterns, 28, 33
Metering, 27-37
Meters, 27-37
Microdol-X, 64, 79
Middle gray, 9
Mission San Xavier, 11, 100-103
Monobath, 148
Monochromatic viewing filter, 8
Monorail camera, 19
Mounting prints, 144

N

ND filters, 91
Negative carrier, 116
Negative contrast, 24, 41
Neutral Test Card, 9

O

One-shot developers, 73
Opacity, 22
Ortho films, 68, 87
Overexposure, 23

P

Pack films, 152
Pan films, 68, 87
Paper, 120-122
 developers, 126
 grades, 121
 surface, 123
Pinholes, 84
Placement of zones, 10, 12
Placement, 31, 35
Point-source enlarger, 115
Polarizing filters, 95
Polaroid films, 150-153
Polaroid photography, 148-153
Pre-exposure, 61
Presoak, 72
Press camera, 18
Previsualization, 4
Print
 drying, 119

FRONT COVER PHOTOS
Mission—John P. Schaefer
Mushroom—Theodore DiSante
Anne-Marie Dechâlus (née Chaux)—
 Theodore DiSante

BACK COVER PHOTO
John P. Schaefer

METRIC AND U.S. CUSTOMARY EQUIVALENTS

EQUIVALENT WEIGHTS

Grams (g)	Kilograms (kg)	Ounces (oz.)	Pounds (lbs.)
1.0	0.001	0.035	0.0022
1000.0	1.0	35.3	2.2
28.4	0.028	1.0	0.06
453.6	0.454	16.0	1.0

CONVERSION FORMULAS

g = ounces x 28.4 g = pounds x 454
oz. = grams x 0.35 lbs. = grams x .0022

EQUIVALENT VOLUME

Milliliters (ml)	Liters (l)	Ounces (oz.)	Quarts (qt.)
1.0	0.001	.034	.001
1000.0	1.0	33.8	1.06
29.6	.03	1.0	.03
946.3	.95	32.0	1.0

CONVERSION FORMULAS

ml = ounces x 29.6 ml = quart x 946.3
oz. = milliliters x .034 qt. = milliliters x .001

EQUIVALENT TEMPERATURES

CONVERSION FORMULAS

$$°F = 32 + (°C \times 9/5) \qquad °C = (°F - 32) \times 5/9$$